The National Gallery

El Greco to Goya

The Taste for Spanish Paintings in Britain and Ireland

Introduction and Catalogue by
Allan Braham

Published by Order of the Trustees
Publications Department, The National Gallery
London, 1981

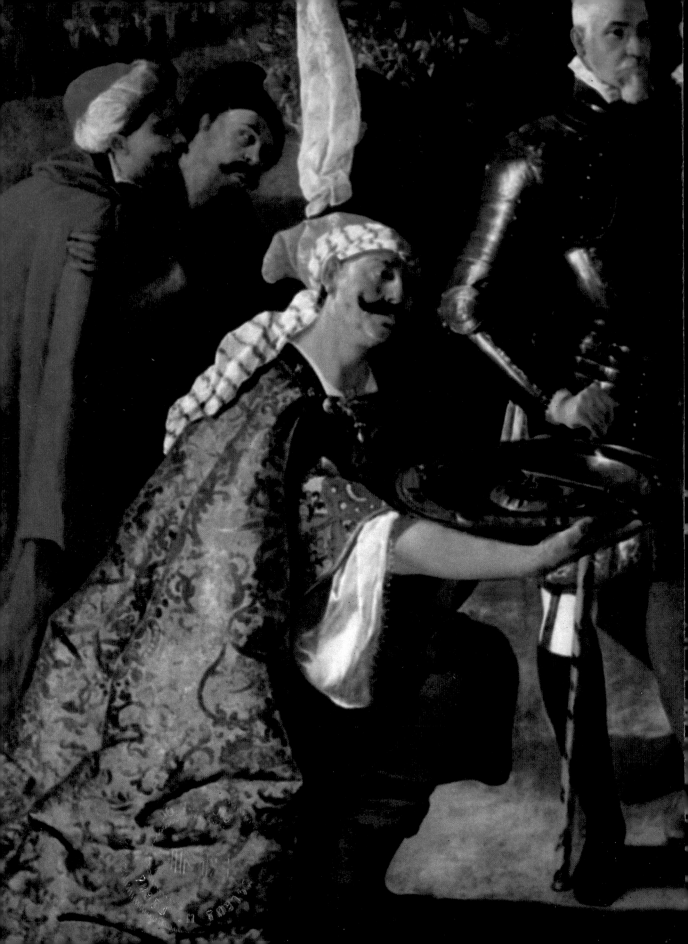

Foreword

This is the fourth in the regular series of large-scale loan exhibitions held at the National Gallery in recent years, each treating of a different national school of painting.

This year the theme is Spanish painting, not merely surveyed but sharply defined by being illustrated through examples drawn from private and public collections in Britain and Ireland. British taste for Spanish painting is at once a fascinating and little-explored subject with roots that go far deeper than is suggested by stock references to the Peninsular War. The exhibition reveals the enthusiasm and discrimination of certain much earlier collectors, as well as later, better-known ones. An overall historical context is provided by Allan Braham's absorbing and well-documented account of the history of British interest, taste and collecting from Tudor times up to the present. That essay will in itself give lasting value to this catalogue.

We are very much indebted to all the owners, private and public, who generously responded to our request for loans. Her Majesty The Queen has graciously lent two paintings, including one of the first Spanish pictures (No.56) to enter the Royal Collection. Other owners have allowed us to borrow fine and significant works, and without their co-operation and support this exhibition would not have been possible.

I am deeply grateful to Allan Braham for organizing and cataloguing this exhibition – and all the more for his doing so amid his multifarious official duties. Though a great institution, the Gallery remains a perilously small organisation; I am conscious of the amount of extra work an exhibition like this gives to so many members of our staff. To all of them I – as indeed everyone visiting the exhibition – must be duly grateful. In his preface, Allan Braham records his specific debts of gratitude, not least to the Gallery's own designer, Robin Cole-Hamilton, who has once again solved the problem of creating an effective setting within severe restrictions not only of space but of cash.

Michael Levey, *Director*

(*Opposite*) Zurbarán, *The Surrender of Seville* (detail), No.32

(*Front Cover*) El Greco, *Allegorical Night Scene* (detail), No.9

1

Preface

In devising and planning the present exhibition, which will be on display (admission free) in Rooms 34 and 41 of the National Gallery from 16 September to 29 November, I have been particularly fortunate in being able to turn for continuous advice and support to Michael Levey, whose Foreword so generously explains the purpose of the exhibition, and to many other colleagues at the National Gallery, beginning with Alistair Smith, Keeper of Exhibitions and Education. Sheila Waller most patiently typed and helped to edit the manuscript of the catalogue, suggesting many improvements and passing on to me ideas about several of the religious paintings, which I have incorporated into the catalogue; Dillian Gordon and Sarah Brown kindly shared in the editing of the catalogue, and Michael Helston the checking of many of the references it contains. Amongst other colleagues I am particularly indebted to Robin Cole-Hamilton, the designer of the exhibition, to Margaret Stewart, Sarah Kelly, Elspeth Hector, Angelina Bacon, Betty Churchyard and the staff of the Photographic Section, and to the staff of the Conservation and Publications Departments.

Outside the building my gratitude is especially due to Mr James Shurmer, the designer of the catalogue and of the exhibition 'graphics', and to Mr Eric Young, who so kindly interrupted work on his own book on Spanish painting from El Greco to Goya to look through the catalogue, and to save me from many errors and omissions. Dr Michael Kauffmann most kindly put at my disposal typescript entries from his forthcoming catalogue of the Apsley House paintings, and Miss Hilary Macartney gave me the benefit of her extensive knowledge of William Stirling and the pictures at Pollok House. Sir Oliver Millar provided much advice about paintings in the Royal collection, Mr Peter Day about those at Chatsworth, and Mr Michael Wynne about the paintings borrowed from Dublin.

Leonée and Richard Ormond have generously shared with me their knowledge of Victorian literature and art with reference to Spanish painting, and amongst those who have shown a sympathetic interest in the exhibition, I am also particularly indebted to Miss Enriqueta Harris (Mrs Frankfort), Mr Brinsley Ford (who provided me with much guidance about Richard Ford), Mrs Viola Hall (who helped me to discover more about her ancestor, William John Bankes), Professor Mary Crawford Volk, Mr John Ingamells, Professor J.H. Elliott, Mr John Kerslake, Mr Richard Kingzett, Mr Harley Preston, Miss Kate Eustace, Mr Julian Stock, Sir John Eden, Professor Pierre Gassier, Mr Denys Sutton, and Mlle Jeannine Baticle, who – by a most happy coincidence – is organising an exhibition about the Louis-Philippe collection, which is due to open at the Louvre in October.

A special debt of gratitude, acknowledged in the Foreword, is due to all those who have so kindly agreed to lend to the exhibition, and in the selection of furniture and sculpture I am particularly indebted to Mr Peter Thornton and Mr Anthony Radcliffe and their staff at the Victoria and Albert Museum for much kindness and help. The catalogue entries for the sculpture have been drafted on the basis of information kindly supplied by Mr Malcolm Baker.

To coincide with the exhibition a series of lunch-time lectures has been planned and four speakers from outside the Gallery have most kindly agreed to talk. Beginning on 16 September when Professor J.H. Elliott will speak on the subject of Art and Decline in 17th-century Spain, the series will cover the themes of Velázquez as Connoisseur, by Mrs Frankfort (23 September); 18th-century British Travellers in Spain, Allan Braham (30 September); Sir William Stirling Maxwell, by Miss Hilary Macartney (7 October); Richard Ford in Spain, by Mr Brinsley Ford (14 October), and Goya's prints and their reception in England, Colin Wiggins (21 October). An audio-visual programme on the Spanish paintings in the National Gallery collection, by Paul Spencer-Longhurst, will be shown while the exhibition is on show.

Outlining in the introduction to the catalogue the history of the taste for Spanish paintings in Britain and Ireland, I have included as illustrations some of the most important Spanish paintings in these countries, paintings which – for various reasons – were not available as loans. I have also illustrated a number of major Spanish paintings in the National Gallery collection for which space was not available in the exhibition itself. In the final selection 20 paintings from the permanent collection are set beside 54 paintings on loan.

Allan Braham

Introduction

'It is hard to account for that singular attachment which many of us foreigners, who come from better countries contract for this of Spain, and having once lived there, makes us long to return to it as to a native land . . . The warm predilection, observable in many of the English in particular, for this country may proceed from some secret sympathy, and similarity of character and taste.' The sympathy of the British for Spain, so confidently expressed by Alexander Jardine in a travel book of 1788, when visitors from abroad were inclined to think themselves in some sense 'better', has shown itself in the last two hundred years in many different ways, and not least in the enjoyment and interest felt for the paintings of Spain. It is a sympathy that has cast upon the market countless books of travel, beginning in 1763 and still continuing to flourish, and one that has motivated many distinguished British historians, writers on art and even scientists, studying the natural history of the Peninsula.

Though the British have not been alone in their affection for Spain, the wealth of Spanish painting that remains in Britain and Ireland is unrivalled in Europe outside Spain itself. When in the later 19th century the American Charles Curtis compiled his pioneering catalogue of the works of Velasquez and Murillo, the author discovered that more paintings by Murillo survived in British than in Spanish collections. The overwhelming popularity of Murillo was then being eclipsed by admiration, almost equally intense, for Velasquez. Amongst the other great painters of Spain, El Greco and Goya were only just beginning to be appreciated, and their work is in consequence less well represented in the British Isles than in the more recently formed collections of the United States.

The story of British interest in Spanish painting is a theme that has never been fully explored. Indeed the appreciation in one country of the art of another might provide matter for many lengthy volumes, books that have so far remained unwritten. The history of the export of works of art from Spain has meanwhile been considered, and likewise the influence exerted by Spanish painting on the Romantics in France. The reasons why Britain and Ireland should still harbour such a range of Spanish painting, including so many masterpieces, furnish a theme that is not without its share of human interest, cultural, intellectual and social, but it should be recognized that the history of taste, now so popular a field of enquiry, is rarely illuminating about works of art and their creators. Indeed, artists are forced to take second place to those who may be merely rich and anxious to appear fashionable. The collecting and promotion of Spanish painting has its own share of such doubtful heroes, but it has always remained a more specialized interest than most other schools of painting and is distinguished for the contribution of several individuals of interest in their own right, notably Richard Ford (fig.34), the author of one of the most famous of all guide books, *A Hand-book for travellers in Spain* (1845), and William Stirling (Sir William Stirling Maxwell) (fig.40), a prolific collector and the writer of a classic history of Spanish art, the *Annals of the Artists of Spain* (1848).

Until the end of the 18th century foreigners rarely visited Spain and paintings from the country were comparatively rare in collections in the British Isles. The impact that they had on English artists, most clearly to be seen in the influence of Murillo on the rustic scenes of Gainsborough, but also traceable in echoes of Velasquez in British portraits, was out of all proportion to the numbers of Spanish pictures in the country. At the time of the Peninsular War the situation began to alter, and as a result of several famous sales in Paris and London during the 1840s and 50s the market was flooded with Spanish paintings. Velasquez and Murillo, though they were by no means the only Spanish painters adequately represented in British collections, retained their ascendancy, with Murillo promoted to unrivalled supremacy in the earlier part of the century. 'Run my dear fellow to Seville,' Disraeli wrote from Spain to a friend in England in 1830, 'and for the first time in your life know what a great artist is – Murillo, Murillo, Murillo!'

The wealth of Spanish paintings in Britain in the middle years of the 19th century emerges most clearly in the pages of the surveys of British collections by the German scholar, Dr Gustav Waagen, the director of the Royal Picture Gallery in Berlin: *Treasures of Art in Great Britain* (1854) and *Galleries and Cabinets of Art* (1857). Himself a devotee of Murillo, and with a commendably wide range of

sympathies that included many other Spanish painters, Waagen shows in his useful summary of British collecting habits that Spanish painting, like the earlier-flowering schools of the Netherlands and Germany, had hitherto been comparatively neglected in this country. After the reign of Charles I and the dispersal of the king's own great collection, Waagen noted a decline in collecting, which revived only in the earlier 18th century, when 'it was not encouraged either by the Crown or by Parliament, but solely by private individuals, who, at the same time, introduced the custom of placing their collections for the most part at their country seats.'

'These collections,' Waagen wryly continues, '. . . are . . . of a very different character from those of the time of Charles I. They betray a far less pure and elevated taste, and in many parts show a less profound knowledge of art. We, indeed, often find the names of Raphael, Correggio and Andrea del Sarto, but very seldom their works. The Venetian school is better represented, so that there are often fine pictures by Titian, Paul Veronese, Tintoretto and the Bassanos. Still more frequent are the pictures of the Carracci and their school, of Domenichino, Guido [Reni], Guercino, Albano; but there are among them but very few works of the first rank. Unhappily the masters of the period of the decline of art in Italy are particularly numerous'. Waagen goes on to name painters working in Italy in the later 17th century, listing those for whom a particular affection had been shown, 'Carlo Dolce, Sasso Ferrato, Salvator Rosa, Claude Lorraine and Gaspar Poussin, pictures by the two latter being frequently the brightest gems of these galleries.' His panorama of English taste Waagen rounds off with reference to the French, Flemish and Dutch painters most avidly collected: Nicolas Poussin and Bourguignon (Jacques Courtois, the battle painter), Van Dyck, Rubens and Rembrandt, van der Velde, Ruisdael, Hobbema and Teniers.

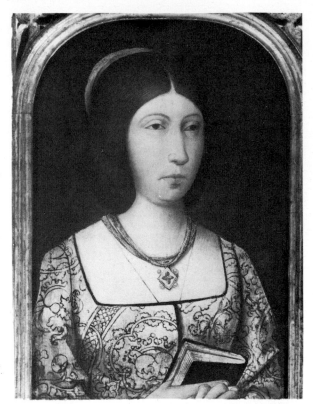

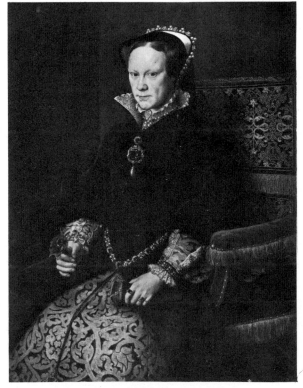

1. Queen Isabella of Castille, Spanish School, 15th century (Windsor Castle). From the collection of King Henry VIII, and one of the very first Spanish paintings to reach this country.

2. Queen Mary Tudor (1554), by Sir Anthony Mor (about 1517–75) (Prado Museum, Madrid). Painted in the year of her marriage to Prince Philip of Spain, by the prince's painter.

The earliest Spanish paintings in Britain (1542–1763)

Not a single Spanish painter is included in Waagen's survey of British collecting, but there was, by the time of the Peninsular War, a limited range of paintings from Spain, including several of major importance, in this country. From the medieval period, though visits of pilgrims, knights and traders to the Spanish peninsula had not been infrequent then, few if any surviving works of art, and least of all paintings, are known to have been imported to this country. Following the final campaign against the Moors in Spain and the conquest of Granada in 1492, diplomatic relations between Spain and her foreign neighbours could be more intensively pursued, and Anglo-Spanish cooperation culminated in the first years of the 16th century in the marriage of Catherine of Aragon, daughter of Ferdinand and Isabella, first to Arthur, Prince of Wales, and then to his brother, Henry. A small portrait of Isabella of Castille, now at Windsor, which belonged to King Henry VIII, is probably the earliest surviving Spanish painting to have reached this country (fig.1). Though more than a little schematic compared with Netherlandish portraits, from which it derives in style, and somewhat repainted, the picture shows a degree of ornamental embellishment, combined with the isolation of the image itself, which conveys something of the astringent and haunting idiom – tending

neither to comprehensive 'naturalism' nor to classical idealization – that was to persist in Spanish art and form the basis of its later appeal.

A further alliance – marking the progress of Anglo-Spanish relations – was the marriage in 1554 of King Henry's daughter, Mary Tudor, to Philip, the son of the Emperor Charles V, who ruled in Austria, the Netherlands and Spain, a kingdom he had inherited on the death of Ferdinand in 1516. Mary was painted in the year of her marriage by the Netherlandish painter Anthony Mor (fig.2), who was the chief court artist in the early years of Philip's rule in Spain, and who founded a school of portraiture that continued to flourish until the lifetime of Velasquez (Nos.20-22 in the present exhibition).

Hope of a permanent union between Spain and England foundered with the death of Mary in 1558, and the accession of Elizabeth to the throne of England. A policy of isolation, distinguished by religious bigotry and almost continuous warfare with England, marked the later years of Philip II's reign. Peace was not finally concluded until after the king's death, its terms settled by the meetings of Spanish and English diplomats at the Somerset House Conference of 1604. The famous painting recording the treaty (fig.3) is possibly by a Netherlandish artist, yet it bears prominent gold inscriptions in Spanish, listing the assembled noblemen: the English to the right headed, from the window, by 'Thomas C[on]de de dorset', the Spanish to the

3. The Somerset House Conference (1604), by an unidentified artist (National Portrait Gallery). Recording the conference that settled the peace between Spain and England, the painting is inscribed with the name of Pantoja de la Cruz (about 1553–1608), court painter to King Philip III of Spain (1598–1621).

4,5. King Philip III of Spain, and Margaret of Austria (1605), by Pantoja de la Cruz (Royal collection). The portraits, in the fashionable but anonymous style of late 16th-century court portraiture, were probably owned by James I.

left with 'Juan de Velasco, Condestable de Cast[il-l]a. Duque de frias', at their head. Beside the inscription is the name of the court painter of King Philip III of Spain, Juan Pantoja de la Cruz, together with a false date, 1594. Though able as a portraitist, working in the idiom compounded of Italian and Netherlandish styles that had become internationally valid in the later 16th century (fig.74, No.22), Pantoja became an almost forgotten artist after his death, and the presence of his name on the picture can hardly indicate an act of wilful forgery. The inscription remains an historical mystery, though it may be that the picture is indeed by Pantoja, or that he was charged to supply the names of the sitters in the picture, which he then signed and dated ten years too early. The portrait is not, however, known to have been in Spain or the artist in England.

In the earlier years of the 17th century relations between the Spanish and the English courts remained cordial, and portraits by Pantoja – paintings which suggest the intervention of studio assistance – of Philip III and his wife, Margaret of Austria, were probably in the royal collection during the reign of James I (figs.4 and 5). Of much greater artistic significance, though now lost beyond the hope of recovery, is the portrait that Velasquez himself painted, shortly after his appointment to the court of King Philip IV, of Charles I when he visited Madrid in 1623 in the hope of finding a Spanish bride. The portrait is mentioned by Velasquez's father-in-law, the artist, Francisco Pacheco, in his book *Arte de la Pintura*, published in 1649. He refers to the portrait as a sketch, which suggests a modest, bust-length portrait, no doubt rather cautious in handling like Velasquez's early portraits of his own monarch.

Well-known as an obsessive collector even in his youth, Charles was presented by Philip with

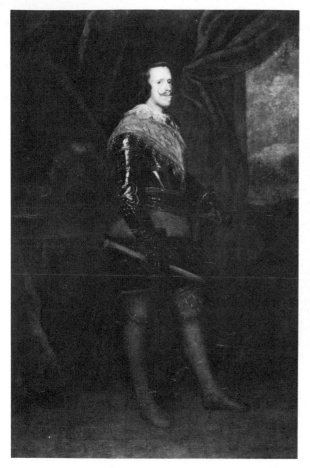 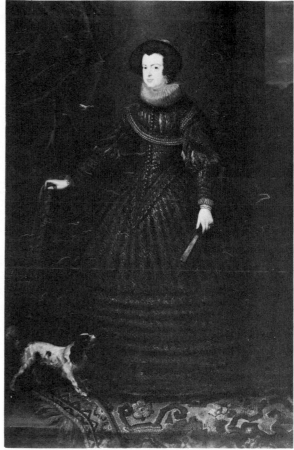

6,7. King Philip IV of Spain, and Isabella of Bourbon, studio of Velasquez (1599–1660) (Hampton Court Palace). Portraits of the Spanish king and queen were sent to Charles I in 1638; Velasquez had painted Charles when he visited Madrid in 1623.

Titian's 'Venus del Pardo' (now at Vienna) on his departure, and he may have acquired other pictures in Spain, but the only Spanish painting listed in the partial inventory of his collection which Abraham van der Doort compiled, largely before 1639, was a still-life by Juan Fernández, 'El Labrador' (fig.108, No.56), which Sir Francis Cottington, British Ambassador in Madrid from 1629, had presented to the king. Cottington's colleague in Madrid, Sir Arthur Hopton (fig.9), continued to patronize 'El Labrador', who was apparently difficult to contact, visiting Madrid only at Easter time, and he acquired from the artist further paintings for Lady Cottington.

Though rarely essayed by any artist in England, still-lives were not uncommon in Spain at this time, and the most prolific practitioner of the art was a painter of Netherlandish extraction, Juan van der Hamen. The work of 'El Labrador', a very much rarer artist, is distinguished not by the amount of detail accommodated in his pictures, a criterion of excellence still characteristic of van der Hamen, but by the very modesty of the objects depicted and their incorporation into livelier and more dramatic designs. Still a little-known painter, 'El Labrador' was evidently one of the few who approached Caravaggio, though with a distinctly Spanish independence, in the intensity of his style, and the well-documented incidence of English patronage of the artist suggests unusual discrimination on the part of the Cottingtons and their royal master.

Charles' bride was eventually found, not at the Spanish Court, but in France, and in marrying Henrietta Maria (1625) he became the brother-in-law of Philip IV, who had married Henrietta's sister, Isabella, in 1615. Still enlarging his collection in the later 1630s, after the purchase of the Gonzaga collection from Mantua, the greatest of all his acquisitions, Charles was in contact with the

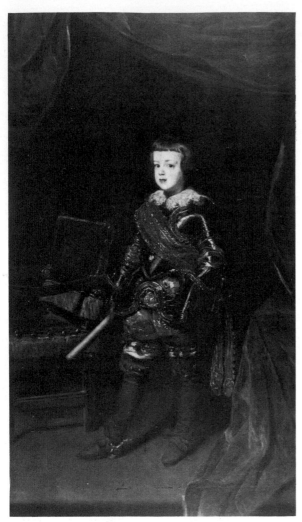

8. Prince Baltasar Carlos, studio of Velasquez (Hampton Court Palace). A portrait of the son of Philip IV, probably sent to England in 1639, before plans for his marriage to Princess Mary were abandoned.

Philip IV, his wife, and their son, which were ready for despatch to England at the end of 1639, are probably the paintings now stored at Hampton Court (figs.6–8). Though originating in the studio of Velasquez, and striking in design, the paintings seem at close quarters weak even for the assistants of Velasquez, especially in the treatment of the heads. They can have given the English court painter, Van Dyck, no very clear impression of the 'iugement' of his Spanish counterpart, even if the apparent objectivity in the presentation of the sitters is in its subtle way more commanding of respect than the overt flattery that permeates Van Dyck's own approach to portraiture.

The first to comment on Velasquez, Sir Arthur Hopton also appears to be the first English sitter represented in a surviving Spanish portrait (fig.9).

9. Sir Arthur Hopton, Spanish School, about 1640 (Meadows Museum, Dallas). Painted when Hopton was Ambassador to Madrid, and once attributed to Murillo, the picture is probably the earliest surviving portrait of an English sitter by a Spanish painter.

Spanish Court to have moulds made of classical marble heads at the royal palace of Aranjuez, and to acquire portraits of the Spanish king and queen, and of their son, Baltasar Carlos, who was talked of as a possible husband for Charles' daughter, Princess Mary. As chief court artist and adviser in artistic matters, Velasquez was directly involved in both commissions, and the letters of Sir Arthur Hopton contain the earliest of the many comments that the English were to make on the greatest painter of Spain. 'Diego Velasquez the kinges painter a man of great iugem[en]t' was Hopton's opinion, though he also commented on the well-known 'lazynesse' of Velasquez, which is also fundamental to his style as a painter. The portraits of

This is a picture now in the Meadows Museum at Dallas which was formerly attributed to Murillo. Painted probably about 1640, it shows Hopton's coat-of-arms on the spine of one of the two books upon the table. The influence of Velasquez is apparent in the painting, although the self-conscious busyness of the ambassador, no doubt true enough to life, shows nothing of the 'lazynesse' of Velasquez's approach to portraiture.

Apart from the painters represented in the royal collection, another 'Spanish' artist was featured in one of the major English collections formed during the early 17th century. This was El Greco, a painter not again appreciated in England for almost two centuries. An early version of his treatment of 'Christ driving the Traders from the Temple', now at Minneapolis (fig.10), painted during the artist's early years in Italy, was in the collection of George Villiers, second Duke of Buckingham (1628–87). The picture is of particular interest in showing (bottom right), and in a notably ambiguous context (see under No.6), portraits of four famous artists whose work was well-known to El Greco: Titian, Michelangelo, Giulio Clovio and Raphael. The presence of this item in the Buckingham collection must, however, have represented a predilection not for Spanish but rather for Venetian painting.

Buckingham's collection was dispersed at the time of the Commonwealth, and in 1651 the treasures of Charles I were also put up for sale, so that the Spanish paintings now in the royal collection became permanent acquisitions only during the course of later centuries. Using the ambassador in London as his agent, Philip IV of Spain was one of the main buyers at the Commonwealth sale, and eleven cartloads of works of art are said to have made their slow triumphal progress from England to Madrid. One of the pictures acquired from the collection of Charles I remained until the 19th century much the most famous painting in Spain, imposing a standard that few Spanish works of art were ever admitted to approach. This was Raphael's 'Holy Family' (fig.11), now in the Prado, which had formed part of the Gonzaga collection. Exhibited with other paintings by Raphael in the Escorial, the monastery near Madrid that had been built for King Philip II, the picture came to be known as 'La Perla' because Philip IV regarded it as the pearl of his entire collection.

During the course of the 17th century the work of Velasquez, and the very different paintings of his younger contemporary, Murillo, who had worked exclusively in Seville, became known in most European countries. Velasquez had twice visited

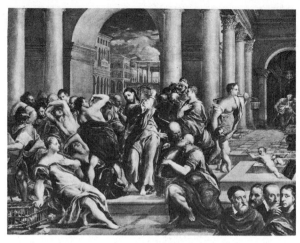

10. **Christ driving out the Traders from the Temple**, by El Greco (1541–1614) (Minneapolis Institute of Arts). El Greco was little known until the 19th century; this early work, painted in Italy, belonged to the Duke of Buckingham (1628–87).

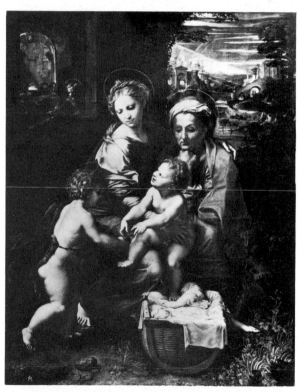

11. **The Holy Family ('La Perla') by Raphael** (1483–1520) (Prado Museum, Madrid). Bought by Philip IV of Spain at the Commonwealth sale, the picture was the most famous work of art in Spain for over two centuries.

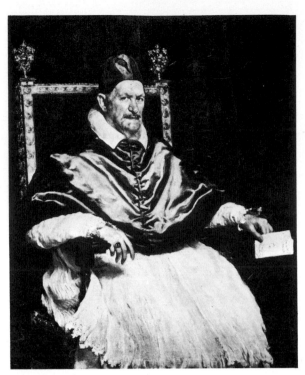

12. Pope Innocent X, by Velasquez (Doria Gallery, Rome). Painted in Rome in 1650, the portrait was admired by British travellers in Italy (including Reynolds), few of whom ever visited Spain.

Italy, leaving there abundant evidence of his supreme ability as a portrait painter, above all in his likeness of Pope Innocent X (Doria Gallery, Rome) (fig.12). Some of the greatest of his later court portraits, now in the Kunsthistorisches Museum, Vienna, had been sent to Austria, where the cadet branch of the Hapsburgs ruled, and lesser portraits were at the French court. Works by Murillo had been commissioned for Genoa, and two of the most famous of his paintings of the Virgin and Child were already in Italian collections: in the Corsini Gallery in Rome, and the Medici collection in Florence. His self-portrait (fig.95, No.43) had been engraved in Brussels, where several of his paintings were to be found, and in France there was an altarpiece in the château of Bussy-le-Grand, belonging to Roger de Rabutin, Comte de Bussy (1618–93), cousin and correspondent of Mme. de Sévigné. In 1683 when the German painter Joachim Sandrart published biographies of major European painters in his *Academia Artis Pictoriae* an entry, together with a portrait, was included for Murillo, though not for Velasquez.

Murillo made his appearance, apparently for the first time, in the literature of this country with an entry in the diary of John Evelyn for 21 June 1693: 'My L: Godolphin bought the boyes of Morella the Spaniard for 80 ginnies, deare enough.' This was at a sale of the possessions of John Drummond, Lord Melfort (1649–1714), a Scottish nobleman whose goods had been seized in 1691 after he had fled the country at the time of the deposition of James II. (A strong personal link with Spain is suggested by the marriage of two of his daughters to successive Marquesses of Castelblanco.) Two pictures which could be the 'boyes of Morella' are listed in the catalogue of Melfort's sale, and they are probably identical, not with the famous pictures at Dulwich (figs.97,98, Nos.45,46), but with a pair of Murillos in a Godolphin sale of June 1803.

During the early years of the 18th century other Spanish paintings began to make their appearance on the walls of the great British country houses. Such houses were themselves a peculiarity of English social and political life, noblemen in most other European countries being more deeply committed to continuous attendance at Court, and the comparative absence of country houses (as distinct from medieval castles) in Spain – and the paintings to go with them – was a source of considerable surprise to early travellers in the Peninsula. The most important group of Spanish paintings in this country must have been those at Houghton Hall in Norfolk, belonging to the Prime Minister, Sir Robert Walpole (1676–1745). The pictures survive now in Leningrad, having been sold by Walpole's grandson to Catherine the Great in 1779. From about 1720 Walpole had collected together Old Master paintings for the decoration of his house, where he lived in other ways too in the greatest style, hunting and entertaining the local gentry and government colleagues: 'Up to the chin in beer, venison, geese, turkeys, etc. and generally over the chin in claret, strong beer and punch.' According to the catalogue of the Houghton pictures (one of the first such inventories to be published), which was written by Horace Walpole, Sir Robert's youngest son, there were no less than five Murillos in the collection, as well as two paintings by 'Velasco', a 'S. Joseph' and a head of Pope Innocent X.

One of the Murillos was, according to Horace Walpole, a present from Sir Benjamin Keene, who had been active in Madrid as agent for the South Sea Company, and later Consul and Minister Plenipotentiary (1724–39), and it is likely that Keene had been instrumental in acquiring some or all of the others. 'The Assumption of the Virgin' (fig.13) was one of the first of many Murillos of this subject (and of the closely related theme of the Immaculate Conception) to arrive in this country,

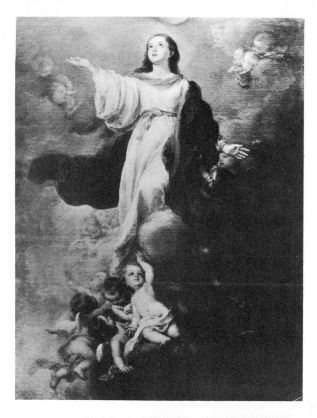

and all too soon to depart, leaving scarcely a single example behind (see No.41, fig.93). Images that must have struck the English as distinctly 'popish', Murillo's visionary paintings, considered purely as aesthetic propositions, were nevertheless eminently suited to the rapturous and buoyant style of the artist. Walpole's taste for Murillo would have formed part of the contemporary liking for painters of the later 17th century, Murillo being the greatest amongst them, who conformed with the taste of the early 18th century, which they had indeed influenced, above all in their consciously attractive colouring, lightness of handling and in a well-bred confidence, both in manner and in matter. The artist who took pride of place at Houghton was Murillo's contemporary, the Roman painter Carlo Maratta (1625–1713), who had a room there dedicated to his work, where three of the Murillos were also placed.

Other famous Murillos that passed at this time into English collections are paintings at Belvoir Castle and the celebrated self-portrait now in the National Gallery (fig.95, No.43). The 'Holy Family', installed as the altarpiece in the chapel at Belvoir (fig.14), blends not altogether uncomfortably with the well-intentioned Gothic architecture, which itself reflects early 19th-century devotional fervour. It is one of a group of paintings by the artist apparently brought back from Spain by the famous diplomat, Keene's superior in Madrid, William Stanhope, Lord Harrington. He had been sent to Spain in 1717, where he espoused the cause of British and Irish merchants trading there, and it was he who brought about the Treaty of Seville in 1729, which settled many of the differences that had disturbed Anglo-Spanish relations in the first years of the 18th century, and created a climate more favourable to trade with Britain.

Murillo's self-portrait (fig.95) was acquired, probably with other works by the artist, by one of the merchants protected by Lord Harrington, Daniel Arthur, 'a rich Irish merchant who died in Spain', and it had passed by 1729 to the husband of Arthur's widow; by 1740 it was in the collection of Frederick, Prince of Wales. Quite apart from its

13. The Assumption of the Virgin, by Murillo (1617–82) (Hermitage Museum, Leningrad). One of the famous Murillos belonging to Sir Robert Walpole (1676–1745), which were sold to Catherine the Great in 1779.

14. The altar of the chapel at Belvoir Castle, Leicestershire, where Murillo's 'Holy Family', a painting imported from Spain by the diplomat, Lord Harrington (1690–1756), is on exhibition.

own aesthetic and historical importance, the early presence of the picture in this country is of particular interest for British art, since the composition was apparently used by Hogarth for the design of his own self-portrait, now in the Tate Gallery (fig.15). A reticent composition, like the majority of Murillo's portraits, it was perhaps designed specifically to form a suitable basis for the engraving that was made of it in Brussels. The closeness of Hogarth's adaptation suggests a degree of conscious homage and identification with the great Spanish artist, whose paintings, though innocent of social satire, amply fulfil the aesthetic demands which Hogarth stressed in his self-portrait by reference to the famous serpentine 'Line of Beauty'.

By this time the British public had had the opportunity of discovering more about Murillo and

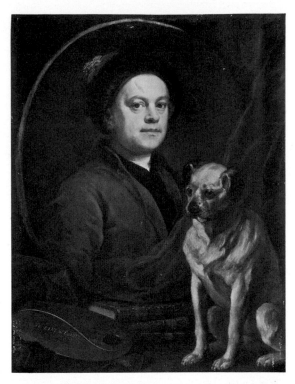

15. Self-portrait, by William Hogarth (1697–1764) (Tate Gallery). Recalling Murillo's Self-portrait (fig.95, No.43), and probably a deliberate act of homage.

16. The Marriage at Cana, by Murillo (Barber Institute, Birmingham). One of the most famous Murillos in 18th-century France; imported before 1816.

over 200 other Spanish artists through an abridged translation of the first major source book for the history of Spanish painting. This was *El Museo Pictórico*, by Antonio Palomino ('the Vasari of Spain'), which had appeared in Madrid in three large folios in the years 1715–24. A small volume of biographies of painters extracted from Palomino, *An Account of the Lives and Works of the most Eminent Spanish Painters, Sculptors and Architects*, was published in England in 1739, with an edition appearing ten years later in France, where Murillo in particular was avidly collected (fig.16). The *Lives* begin with a selection of artists of the 16th century (including Mor and Morales), and continue until the early years of the 18th century. All are brief, but Velasquez, Murillo and Luca Giordano of Naples, who came to Spain in 1692, are conspicuously the longest, the praise reserved for Murillo being the most striking: 'Accordingly at this very Time, out of *Spain*, a Picture of *Murillo's* is more esteem'd than one of *Titian's* or *Vandyke's* so powerful is the Blandishment of Colouring, to attract the popular Breath and Applause of the many.'

By the middle years of the 18th century the taste for Murillo, and other Spanish painters, including Ribera, who had passed his working life in Italy and whose work features prominently in the English pursuit of Seicento painting, is clearly reflected in the activities of London dealers and in the scattered accounts that have survived of English collections. The dealer John Blackwood was responsible for the importation of many Spanish paintings, including Murillos which remained until recently in the Cartwright collection at Aynhoe Park. George Vertue mentions in his notebooks the Murillos that belonged to Arthur's widow, remarried to Mr Bagnall, and those at Houghton, and one of '2 beggar boys finely painted' in the collection of the Earl of Essex at Cassiobury, and he lists several paintings by Ribera ('Lo Spagnoletto'), including ones of Prometheus, and Cain and Abel. About Ribera collectors had already been amusingly warned in Dryden's translation of du Fresnoy's *The Art of Painting* (1695): 'he was wonderfully strict in following the life; but as *ill-natur'd* in the *choice* of his *Subjects*, as in his *Behaviour* to poor *Domenichino*, affecting generally something very *terrible* and frightful in his *Pieces*.'

The paintings at Houghton were also singled out in the survey of English collections published in 1766 as *The English Connoisseur*. Other Spanish pictures mentioned in these discriminating pages included two attributed to Velasquez in the Earl of Burlington's villa at Chiswick (including No.27, fig.79 here), Murillos belonging to Sir Samson

Gideon, a Murillo portrait and a Ribera belonging to General Guise at Oxford, and further works by these artists in the Methuen collection.

Sir Paul Methuen had been envoy and later ambassador in Lisbon and in 1714, preceding Benjamin Keene and William Stanhope, he had been posted to Spain and Morocco. Active, like Stanhope, in the promotion of Anglo-Spanish commerce, he is remembered for familiarizing the English with port wine through the 'Methuen' treaty of 1703. Though not mentioned in these early sources, one final group of Spanish paintings that had reached England by the early 18th century is of particular interest. The series of canvases showing Joseph and his brethren, all but one belonging to the Bishop of Durham at Auckland Palace (fig.87, No.35) by the then almost unknown painter, Zurbarán, are recorded here before 1748 and are believed to have been captured earlier still from a Spanish ship sailing to the New World.

The 'discovery' of Spain; travellers and connoisseurs of the later 18th century (1763–1808)

By the middle years of the 18th century the pattern of the 'Grand Tour' had been clearly established, and was even at the start of its decline. Many of those sufficiently wealthy to form collections had been sent in their youth to Paris and to Rome to widen their education, and there they had found many Catholic families exiled from England, whom they were warned to avoid. Spain, though it attracted an occasional traveller, had never formed part of the itinerary of the Grand Tourist (fig.17). It was widely regarded as a primitive and inhospitable country, the Spaniards suspicious of foreigners. One English traveller had reported in 1664 that he and his companions were pelted with melon rind in the streets of Valencia.

There were, however, in addition to the diplomats serving in Spain, and the British merchants active there, a group of expatriates in the service of the Spanish Crown. One painter who had resided in Madrid was the portraitist of German extraction, for long active in England, Johan Baptist Closterman, who spent the years 1696–1699 in Madrid, sending back to England letters on the state of the arts. After the death of Charles II, the last Hapsburg king of Spain, and the War of the Spanish Succession (1700–12), which established the Bourbon Philip V (1700–46) on the throne, the Court assumed an altogether more international

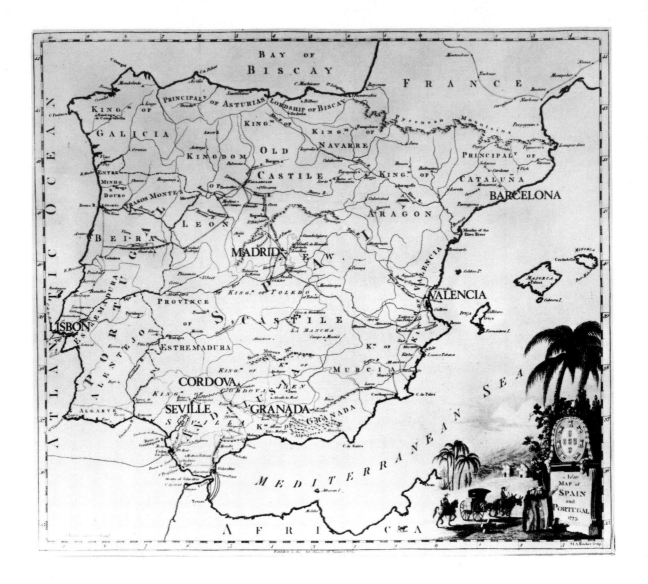

character. Later in the century the Irish expatriate, Richard Wall, rose to become a Secretary of State during the reign of Philip's son, King Charles III (1759–88).

The 'discovery' of Spain by travellers in the later 18th century was by no means an isolated phenomenon; rather it formed part of that investigation of the whole Mediterranean world and its classical past, which was itself a microcosm of the age of 'Enlightenment'. Motives both scholarly and 'romantic', in so far as the two can be distinguished, each played their part in this exploration, which was dominated by the English and the French, with a respective bias towards historical accuracy and a visually more imaginative response.

The earliest of the almost countless English

17. Map of Spain and Portugal in the later 18th-century, from Twiss (1775). Spain began to attract travellers and writers in the later 18th-century; they lingered in the centre of the Peninsula – in Madrid and its neighbourhood – where the Court remained, and explored the Moorish and classical past (chiefly in the south, at Granada, Seville and Cordova).

books on the Spanish Peninsula, confined as they are to a single subject and factual in their general emphasis, show a particularly fascinating range of human personality and interest, and they nearly all reveal a pronounced interest in the arts of Spain. The first to appear was the *Letters concerning the Spanish Nation written at Madrid during the years 1760 and 1761,* by Edward Clarke, rector of Pepperharrowe in Surrey and chaplain to the British Ambassador,

Lord Bristol. Published in 1763, the book is partly historical in character and confined as a guide entirely to central Spain. Those who used the book questioned many of Clarke's opinions, and William Beckford, in the course of a short stay in Madrid, found the volume 'ponderous'. Following Clarke there appeared one of the liveliest of all descriptions of Spain, *A Journey from London to Genoa* (1770), by Joseph Baretti, Secretary for Foreign Correspondence to the Royal Academy in London, and then the *Travels through Portugal and Spain in 1772 and 1773* by Richard Twiss, whose own particular interest was in paintings. Major Dalrymple (*Travels through Spain*, 1777), 'dry' in Beckford's opinion, stressed matters military, while Henry Swinburne in one of the most popular of the guides *(Travels through Spain in the years 1775 and 1776)*, took a special interest in Moorish architecture and classical remains.

Richard Cumberland, who supplied in his memoirs (1807) an account of a secret mission to Spain in 1780 was, like Twiss, a connoisseur of painting, though also a well-known opportunist, who published in 1782 a notoriously shoddy book on Spanish art: *Anecdotes of Eminent Painters in Spain.* Alexander Jardine's more philosophical survey, wherein the 'secret sympathy' of the English for Spain is noted, appeared anonymously in 1788 *(Letters from Barbary, France, Spain, Portugal, etc.),* and this was followed by a more detailed account of the Peninsula (*Journey through Spain,* 1791) by George Townsend, whose bias was towards geology. Other travellers to Spain before the onset of the Peninsular War who committed their impressions to paper included the poet, Robert Southey, later to write a history of the War, Lady Holland, travelling in Spain with her family in 1802–05 and 1808–09, Matthew Whittington, and William Jacob, present in the south of Spain in 1809, when the French army advanced to Seville.

Cumberland's book was fortunately not the only publication of the time to supply information about the history of Spanish art. Following Palomino's pioneering study of 1715–24, two Spanish writers made important contributions to the study of the subject, Antonio Ponz, whose 18-volume guide to Spain *(Viage por España)* was available in print in 1772–84, and Juan Augustín Ceán Bermúdez, a friend of Goya whose dictionary of Spanish artists, *Diccionario histórico de los más ilustres profesores de las bellas artes en España,* appeared in 1800, and was followed by a short account of painting in Seville (*Carta . . . sobre el estilo y gusto en la pintura de la escuela sevillana,* 1806). Outdated by Ponz and Ceán, Cumberland's book was also not the only British

contribution to Spanish studies that appeared in the later 18th century. Interest in this country in the natural history of Spain began with William Bowles, who published in 1775 an *Introducción a la historia natural . . . de España,* which was made known in an English translation (1781) by Sir John Talbot Dillon, the author of a history of poetry in Spain (also published in 1781). British readers were also introduced at some length to *A Civil, Commercial, Political and Literary History of Spain* (1793) by Wyndham Beawes, British Consul at Seville, and William Robertson, the famous Scottish historian, precursor of William Stirling, produced his classic history of the reign of Charles V in 1769.

The civilization of Spain was thus by no means unfamiliar in the later 18th century, and the paintings to be found there formed one of the main attractions of the country. Few visitors before the turn of the 19th century positively welcomed the hardships of travelling in Spain, though inns and roads improved as the years passed and fears of bandits, snakes and even aggressive lizards proved

18. Castles in Spain, and the bridge at Ronda, engraving from Twiss (1775). Though admiring the castles of Spain, English visitors were puzzled by the absence of country houses.

unjustified. The landscape, almost entirely neglected by the painters of Spain, was not much praised, though regional differences were noted. Later writers responded more positively – especially Southey, and Cumberland, who commended in retrospect the beauty of the Douro valley, of which he used the word 'romantic' in his memoirs (1807). Castles, later to be described as 'picturesque', were frequently to be seen (fig.18), though visitors were puzzled by the absence of country houses: 'Throughout the whole of Spain I cannot recollect to have seen a single country residence, like those which everywhere abound in England' (Townsend).

Architecture and decoration in Spain appealed little to 18th-century travellers, though the remains of Roman civilization, like the great aqueduct of Segovia, evinced excited comment. The Moorish influence on the arts was generally deplored, but Moorish monuments, above all the Alhambra at Granada (fig.19), which had recently been restored by Richard Wall, were beginning to establish themselves as sites eminently worthy of curiosity and interest. Like the inns of Spain, many of the towns were also deplored, and Madrid itself, until cleaned up in 1765, was described by Baretti as stinking like 'a Cloaca Maxima.' Underlining the obscurity that was still felt to shroud the Peninsula, Cumberland went so far as to compare Madrid as a site with Palmyra, 'being almost as closely environed with a desert as Palmyra is in its present state of ruin.'

Though Spanish painters, unlike their counterparts in Italy, had not guided travellers towards the appreciation of the landscape of their native country, images of their fellow-countrymen, both rich and poor, created a lasting impression of national character, which the British, themselves 'phlegmatic' and uncomplaining by reputation, were not slow to seize. 'The Spaniards are very commonly reproached with three faults: an excessive pride, manifesting itself in a gravity that becomes ridiculous; a great degree of indolence and inactivity, and a superstition equal to that which prevailed in the dark ages' (Whittington). 'I think', wrote Jardine 'the Spaniards can dance, sing, shave and make chocolate, with any people in Europe; but I fear there are but few other of the useful or ornamental arts which they now possess .to any degree of perfection . . . All this leads to the usual text and conclusion, – that these people might exert themselves, and emerge from their present poverty, indolence and political insignificance, if they were properly governed.'

The pride and honesty of the poorer Spaniards

indeed seemed to many visitors preferable to the indolence of the 'governing' classes, whose time was spent at clearly rather gloomy social occasions, and in hunting, gambling, 'gallantry', and the theatre (generally held to be poor in quality). Bull-fighting (fig.20) excited the curiosity and the condemnation of most visitors ('a remnant of *Moorish*, or perhaps *Roman* barbarity', Clarke), as much as the music and dances of Spain delighted them. The practices of the Catholic religion, and especially the nation's devotion to the Virgin, so clearly expressed in painting, remained a lasting source of wonder: 'Exactly at sunset the bells of the churches and convents give the signal for repeating the evening prayer to the Virgin. In an instant the busy multitude is hushed and arrested as if by magic.' (Whittington in the Prado park in Madrid, 1803). The same author formed the impression that 'Every Spaniard regards the Virgin in the light of his friend, his confidante, his mistress, whose whole attention is directed to himself, and who is perpetually watching over his happiness.'

Most English visitors were presented at Court, usually at the palace of Aranjuez, where the king moved after Easter (the autumn being spent at the Escorial, Christmas in Madrid and the early spring at the nearby palace of El Pardo). Descriptions by British visitors of the royal family and of society in Madrid highlight a world now well-known in the portraits of Goya (see No.69): King Charles III, amiable, shrewd and not unprogressive, but an obsessive hunter, dressed usually for the chase; his equally amiable but ineffectual son, Charles IV (1788–1819), devoted to shooting birds; Queen Maria Luisa, and her lover Manuel Godoy, Prince of the Peace; Count Floridablanca, principal minister, and Jovellanos, the first truly 'liberal' minister; all these and many others are delineated by British visitors, enlarging upon the visual acuity of Goya's portraits.

The major collections of paintings in Spain, about which no traveller failed to comment, were housed at the Escorial, and, from 1764, in the new palace (the Palacio de Oriente) in Madrid, which had been newly built and decorated with the help of the Italians, Giaquinto and Tiepolo. The old palace (the Alcázar) had been destroyed by fire in 1734 and with it had perished a part of the royal collection, including many portraits. The churches of Madrid provided less to interest the connoisseur, but in Seville it was the churches, and especially that of the Caridad, where Murillo's most famous cycle of paintings then hung, that became the principal centres of attraction. The works of El Greco in Toledo were almost completely ignored, Cum-

(*Opposite*) El Greco, '*The Tears of S. Peter*' (detail), No.5

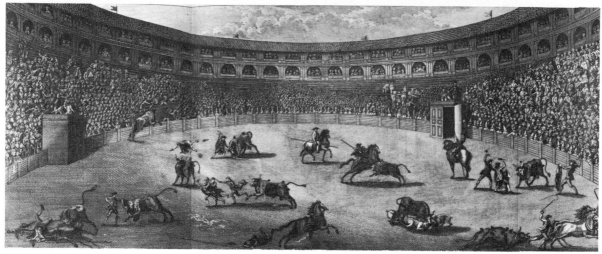

berland recording in his *Anecdotes* the opinion that was to persist for a century: 'in his efforts at originality he has exposed himself to the ridicule of all good judges.'

With a few exceptions, including the collection of the Dukes of Alba, little of particular note was discovered in private collections, and the houses of the wealthy appear to have been furnished in the later 18th century largely from French and English sources. Twiss noted even in Cordova 'that a great part of the furniture of these houses was English, such as mahogany chairs and tables, Wilton carpets, etc.' Before the 18th century furnishing had tended to be sparse in Spanish dwellings, and either remarkably plain in character, as paintings themseves show, or highly ornamented like the exuberant decoration that fitfully adorned buildings, reflecting the ill-suppressed persistence of Moorish styles (see Nos.79–82). Even the carriages of the nobility reflected this impulse, 'they are yet in a Gothic taste;' as Major Dalrymple noted, 'they are loaded with a profusion of ornament, and dazzle the eye with gilding.'

The art of ceramics had not obviously flourished

19. The Alhambra at Granada, engraving from Twiss (1775). The earliest of many descriptions of the Moorish palace at Granada are by travellers of the later 18th century.

20. A bull-fight, engraving from Twiss (1775). One of the earliest representations of a bull-fight, a subject later explored by Goya, which English visitors usually found distasteful.

in Spain since the Middle Ages, or metalwork after the achievements of the 16th century, but efforts were made in the 18th century, following the example of France, to establish royal manufactories for the encouragement of the crafts. There was the tapestry factory of Santa Barbara in Madrid, for which Goya's cartoons were produced (see No.63, fig.115), and visitors often referred to the porcelain created at the Buen Retiro palace and the mirrors made at San Ildefonso.

As all travellers agreed, however, painting was the art that had flourished above all others in Spain. 'It seems to me [Clarke, 1763] to be a great error, in imagining ITALY to be the only school for painters: SPAIN, if visited by some of our artists

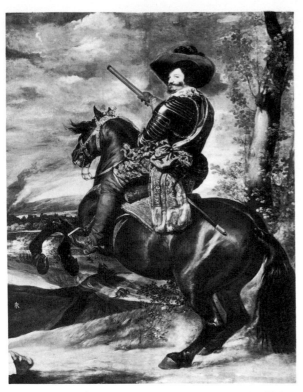

21. The Count-Duke of Olivares, about 1635, by Velasquez (Prado Museum, Madrid). The most 'Rubensian' of Velasquez's portraits and particularly admired in the later 18th century.

would, I am persuaded, open new, astonishing and unexamined treasures to their view.' Velasquez and Murillo were inevitably, though not exclusively, the painters most frequently mentioned, yet they were esteemed for very different reasons from those which provoked the admiration of later generations. It was felt that painting in Spain had declined steeply from their high standards, and comments on recent Spanish works are scarce.

Goya himself is apparently not mentioned by an English writer until Lady Holland referred to him in her journal as late as April 1809: 'in his room [General Palafox's] there were several drawings done by the celebrated Goya, who had gone from Madrid on purpose to see the ruins of Saragossa.' The foundation of the Royal Academy of San Fernando in Madrid to promote painting, sculpture and architecture in Spain is noted by several travellers, but the scene continued to be dominated by foreigners. According to Baretti (1770); 'Mengs is by far the best painter, and his invention is not much inferior to Corrado's [Giaquinto], his design much more correct, and his colouring quite magick. The King thinks him the greatest painter

of the age.' Amongst contemporary Spanish painters Baretti commended only Meléndez (see Nos.60,61), a specialist in the low-ranking art of still-life, who was then apparently living in obscurity and poverty: 'Those [still-lives] painted by Don Luis Melendez especially are superior to anything of that kind.'

Admiration for the 'classical' tradition in painting, reflected in Baretti's opinion of Mengs and in the whole British tradition of collecting, largely coloured the response of late 18th-century travellers to the work of Velasquez and Murillo. The paintings now regarded as the supreme achievements of Velasquez ('Las Meninas', 'The Surrender of Breda,' etc., figs.29,37) were passed over largely in silence, and attention focussed on the equestrian portrait of the Duke of Olivares (fig.21), and 'Joseph's coat brought to Jacob' (fig.22), on exhibition at the Escorial, where Raphael and Titian were in any case predominant. 'Esteemed the best picture of Velasquez', 'that most profoundly pathetic of pictures . . . the loftiest proof in existence of the extraordinary powers of Velasquez in the noblest work of art,' were the opinions of Swinburne and Beckford on 'Joseph's coat', while the portrait of Olivares, 'allowed to be the finest of its kind of any extant', according to Twiss, was judged by Swinburne 'the best portrait I ever beheld: I know not which most to admire; the chiaro scuro, the life and spirit of the rider, or the natural position and fire of the horse'.

Neither of these paintings would now be placed amongst the very finest of Velasquez's works, the portrait of Olivares being the most Rubensian of the artist's equestrian portraits, and 'Joseph's coat', painted during Velasquez's first visit to Italy, very much an essay in the Italian style of history painting. Like his Dutch counterpart, Rembrandt, Velasquez was by temperament – and in his handling of paint – better engaged with more passively descriptive subjects, in placid portraits and scenes of repose (even sleep), but it was not until the early years of the 19th century that paintings showing his real strength were given priority. Of all the opinions of later 18th-century travellers, that of Townsend, whose bias was not towards connoisseurship and its fashions, seems the most prescient: 'as far as relates to imitation of nature, the Spanish painters are not behind the first masters of Italy and Flanders; whereas, in point of light and shade, and what has been called aëreal perspective, which is only the modification of these, *Velasquez* leaves all other painters far behind him.'

In Seville Murillo also was judged in relation to Italian painting, to which indeed he more closely

conforms than Velasquez: 'his manner puts me much in mind of Guercino;' Swinburne wrote, 'but the characters of his figures are often mean, and copied from models in the lowest class of citizens; the design of his hands and arms is also generally faulty, as he gives them rather too great a length; however there is such expression, such truth of colouring, and intelligence in the composition of his groupes, that a trifling defect of that kind is easily overlooked.' Other writers were less critical of Murillo than Swinburne, who here anticipated Ruskin in commenting unfavourably on the social 'meanness' of Murillo's types. For Twiss, Murillo was much the greatest of the Spanish painters ('His style is in the manner of Paul Veronese, whom he sometimes nearly equalled'); Twiss was one of the few to see in Cadiz the painter's 'Two Trinities' (No.54, fig.106), which he described as 'the best picture I ever saw painted by a Spaniard', and, like English visitors of the early 19th century, he parted from Seville only with the greatest reluctance, 'fearing lest too long a stay might attach me too much to it.'

The pursuit of Murillo by Twiss was not, however, always successful, and a few paintings he was unable to see 'by reason that some are never uncovered but on particular days of the year, and in the convents where I went to see them, the friars were either asleep, or so lazy that they would not give themselves the trouble of shewing them to me'.

Less concerned than Twiss with searching for unfamiliar paintings, Jardine more boldly compared the two great artists whose works had so deeply impressed all early visitors to Spain, 'it appears to me, as if Velasquez and Murillo should stand next to the very first of the Italian school, not only as faithful imitators of nature but sometimes soaring above her, towards the true sublime, and particularly the former; the one seems to dignify, the other to beautify nature.'

Many other Spanish painters are briefly acknowledged by early English travellers, particularly by Twiss, who commends, for example, Valdés Leal (see No.37), though consigning Zurbarán to his list of 'second-rate' painters. The high standard of painting in Spain in the later 17th century compared with contemporary Italy was not noticed by travellers, and is perhaps still not fully appreciated. Claudio Coello (see No.38, fig.90) was one of the better-known painters, because of his famous canvas of 'The Mass of Charles II' in the sacristy of the Escorial, which Cumberland greatly admired (fig.23). Alonso Cano (sometimes described, not very happily, as 'the Michelangelo of Spain'), paintings by whom are still comparatively rare outside Spain, was singled out by William Jacob. Travelling only in the south of Spain, Jacob was one of the first to consider Zurbarán seriously: Zubaran [sic], an artist whose works are highly valued in Spain, though they are scarcely known in

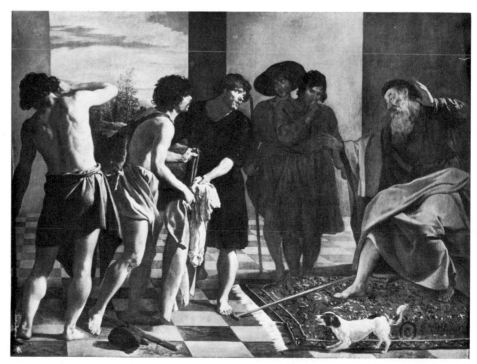

22. Joseph's coat brought to Jacob, by Velasquez (Escorial). An essay in dramatic narrative, painted by Velasquez in Italy (1630), and regarded as his best work in the later 18th century.

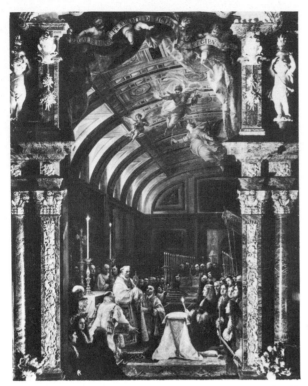

23. The mass of Charles II, by Claudio Coello (1642–93) (Escorial). Begun in 1684, by a still little-known artist, and noted favourably in the later 18th century.

any other part of Europe . . . [His] manner somewhat resembles that of Caravaggio; his outlines are correct, and his compositions simple; they contain only a few figures which are arranged in grave and natural attitudes.'

Of all these travellers only one is known to have acquired paintings in Spain, and there was in the later 18th century a form of export control, introduced by the government in 1779, because of the exodus of works, especially Murillos, that had occurred in the earlier years of the century. Cumberland, however, seems to have returned to England with paintings, including one attributed to Murillo (fig.101, No.49) that was later acquired by Gainsborough. Not many Spanish paintings, however, appear to have entered British collections immediately before the upheavals consequent upon the French Revolution and the rise of Napoleon.

A Mr Rose Campbell of Cadiz began, apparently in the 1790s, to form a collection containing many Spanish pictures, including one of Prince Baltasar Carlos as a hunter (see No.25, fig.77), which were sold in London in 1812. The Murillo at Dyrham (fig.99, No.47), which was copied for an early owner, probably by Gainsborough, may have

been an importation of the later 18th century, while the Spanish paintings at Dulwich (figs.97,98, Nos.45,46), later to be so greatly admired in England, form part of the collection which the French-born dealer, Noël Desenfans, was commissioned in 1790 to assemble for Stanislaus Poniatowski, King of Poland.

In their own paintings both Gainsborough and Reynolds show unmistakable signs of admiration for Murillo. Both copied paintings by him, and Gainsborough – more than Hogarth – responded to the handling of Murillo and to the 'vaporous' style of his later works. With the affection that began to develop in the later 18th century for worlds of lost innocence, both artists also discovered Murillo to be a pioneer of what is now regarded as 'sentimentality' in subject-matter. The Holy Families and the beggars of Murillo are of the same kin, created by Murillo alone, though not without the influence of earlier artists (like Ribera), and clearly reflecting the painter's own temperamental simplicity. With Reynolds and Gainsborough, however (figs.24,25), the gulf that separates the artist and the subject of childhood innocence is much greater than with Murillo. An element of self-conscious condescension is more apparent, and in their outlook is rooted the literary, almost 'non-visual', approach to Murillo that was soon to raise him above all other painters, and then to cast him down again.

Reynolds refers to Murillo once in his correspondence, when in 1785 he recommended the Duke of Rutland to purchase a portrait by the artist (probably No.43, fig.95). Rembrandt, who clearly shared in the inspiration of 'The Infant Samuel' (fig.24), is more fulsomely acknowledged than Murillo in Reynolds' writings, and his opinion of Velasquez was almost equally high. The portrait of Pope Innocent X (fig.12) which he had seen in Rome, Reynolds remembered over thirty years later in 1786 as 'one of the finest portraits in the world', and he was also credited with the saying (true only on the surface), which Ruskin was to take up and develop: 'What we all do with labour, he [Velasquez] does with ease'.

24. The Infant Samuel, by Sir Joshua Reynolds (1723–92) (Tate Gallery). Reynolds admired Velasquez and Murillo, whose influence is apparent here, together with Rembrandt's.

25. Girl with a Pitcher, by Thomas Gainsborough (1727–88) (Beit collection). Gainsborough copied several Murillos, and painted rustic scenes in his manner, though from a greater social distance.

The Peninsular War and its aftermath (1808–30)

By the end of the 18th century Spanish painting was still not fully represented in collections in Britain and Ireland, but when Waagen toured England in 1835 and again in the early 1850s, many of the houses he visited could boast a few examples of Spanish art and several had outstanding groups of pictures of the school. The exodus truly began at the time of the Peninsular War, continuing in the 1820s and reaching a peak in the mid-1830s when the collection of Louis-Philippe was formed. These were also the years when Spain attracted so many of its most famous travellers, and those who wrote most memorably about the Peninsula: Théophile Gautier, the American Washington Irving, and from Britain, Byron, David Wilkie, Disraeli, Richard Ford and George Borrow.

By the beginning of 1808 French troops had occupied the northern part of Spain, and Napoleon, taking advantage of the conflicts that had divided the Spanish court between the heir to the throne, later Ferdinand VII, and the queen and her lover, Manuel Godoy, proclaimed his own brother, Joseph Bonaparte, King of Spain. Led by Murat, the French moved on to Madrid in May 1808, causing the uprising immortalized in Goya's famous canvases in the Prado Museum. The French were soon forced to withdraw, and it was not until December that the capital finally surrendered, during Napoleon's brief journey into Spain. Having settled affairs in the capital, Napoleon wrote shortly after to his brother on the subject of paintings: 'I wish you to seize all you can find from confiscated houses and suppressed convents and to make me a present of fifteen masterpieces.' Joseph himself assembled a collection of paintings, partly with the idea of creating a museum of Spanish painting, and he also rewarded his generals, including Dessolle (see No.23) and Sebastiani, with major works of art.

The Spanish government with Jovellanos restored to power, had withdrawn to Seville, but in just over a year the French, under Maréchal Soult, overran the south of the country and on 1 February 1810 King Joseph entered Seville. The government again retreated, this time to Cadiz, leaving the whole of the south at the mercy of the French; after a triumphal progression through the country, stopping in Málaga and Granada, Joseph returned to Madrid in May. The French were in Seville until the summer of 1812 and there they seized 999 paintings from the religious foundations of the city (including Nos.44 and 51 in the present exhibi-

tion), which King Joseph intended for his public museum. The best of these paintings, however, passed into the personal possession of the rapacious Soult, who sought continuously to undermine the authority of his good-natured master.

By August 1812 the Duke of Wellington, who had been four years campaigning in the Peninsula, had advanced to Madrid following his victory at Salamanca and King Joseph withdrew towards Valencia. Here he was joined by Soult who had left Seville in August, bound ultimately to assist Napoleon in Saxony. During his brief stay in Madrid, Wellington sat for his portrait (No.74, fig.126) to Goya, who had remained in the capital during Joseph's occupation of Spain. Goya may have tried to undermine the advice that the Frenchman Frédéric Quillet gave to Joseph about the choice of paintings to be confiscated. Like other Spanish 'liberals' he must have welcomed the deposition of the existing and notoriously corrupt Spanish régime, even though it was the French who were to reform the country. Goya had not escaped to the south, and was thus present in Madrid when Wellington made his triumphal entry. Wellington, however, cannot have much liked Goya's portrait, so much more direct than anything in the British tradition of portraiture, and it found its way into the possession of one of his sisters-in-law.

At the end of October 1812, the British withdrew from Madrid to winter in Portugal, emerging in the spring of 1813 to begin the campaign that culminated in June in the victory of Vitoria, which finally drove the French from Spain. According to Wellington 'The night of the battle instead of being passed in getting rest and food to prepare for the pursuit of the following day, was spent by the sol-diers in looking for plunder.' Joseph had fled in haste, leaving his own carriage behind and with it a group of paintings, including Velasquez's 'Water-seller' (fig.67, No.15), from the Spanish royal collection which fell to Wellington himself. The duke's ownership of this plunder was confirmed by Ferdinand VII when restored to the Spanish throne, and the paintings survive now at Apsley House (see Nos.14,15 and 38). Ferdinand also presented to Wellington's brother Velasquez's 'Boar Hunt' (fig.26), later to be the first of his works in the National Gallery, and it was also rumoured that General Sebastiani had, at this time, offered his collection to the Prince Regent. After the war Wellington continued to add to his collection, though his interest in painting seems to have been mainly in the Dutch school, and the Spanish pictures that he purchased were not outstanding.

The opportunity for profit and plunder offered by the Napoleonic Wars in Europe was quickly grasped by picture dealers, and almost before the French had entered Spain a young Scotsman, William Buchanan, one of the main dealers of the time in paintings, who had already made extensive acquisitions in Italy with the help of William Irvine, sent an agent to the Peninsula to look for paintings. This was the landscape painter George Augustus Wallis, who left England for Lisbon in October 1807, reaching Madrid before May of 1808, when he witnessed the riots that were later to inspire Goya: 'In the late unfortunate affair some thousand Spaniards have been killed: the French behaved with the greatest moderation imaginable.' Wallis remained in Madrid until 1813, and amongst the pictures he had then acquired for

26. Philip IV hunting Wild Boar ('La Tela Real'), by Velasquez (National Gallery). Presented by Ferdinand VII of Spain to Lord Wellesley, brother of the Duke of Wellington, before 1818, and the first Velasquez in the National Gallery (1846).

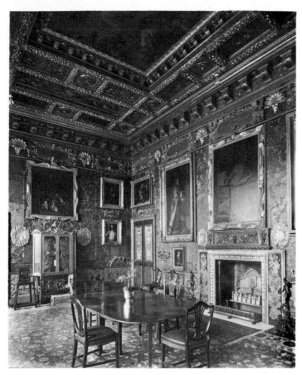

27. 'The Spanish Room', Kingston Lacy, Dorset; under a ceiling attributed to Veronese, hang the paintings acquired in Spain by William John Bankes in 1812–13.

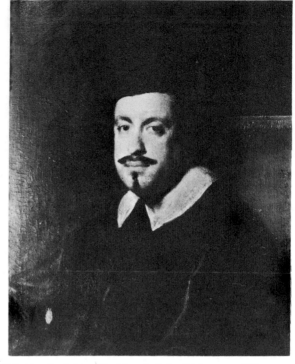

28. Cardinal Camillo Massimi, by Velasquez (Kingston Lacy, Dorset). Acquired by Bankes, probably in Italy in 1819–20.

export to Britain was 'The Rokeby Venus' (fig.78, No.26), which Godoy had acquired from the Alba collection.

Wallis was deeply impressed by the painters of Spain, not only Murillo and Velasquez, and he was one of the very first to mention El Greco with unqualified praise: 'Of the Spanish school we have no idea whatever in England. If they could see the two or three best Murillos of the St. Iago family, and some of the fine pictures of Velasquez, Alonzo Cano, Pereda, Zubaran, Caregni [Carreño], and del Greco, really first-rate men, whose works are quite unknown out of Spain, some estimate of the high excellence of the school might then be formed.' The Murillos from the Santiago collection, including a series showing the story of Jacob, Wallis apparently managed to buy, and some of them were amongst the most famous Murillos in England in the 19th century, but he is not known to have acquired any paintings by 'del Greco'.

During the years of the War paintings were as readily available in the south of Spain as in Madrid. The British diplomat, Bartholomew Frere, Minister Plenipotentiary to the Spanish government in Seville in the winter of 1809–10, a figure frequently mentioned in Lady Holland's diary,

acquired from López Cepero, Dean of Seville cathedral, two of Velasquez's early masterpieces (figs.68,91, Nos.16,39). Buchanan himself managed to acquire paintings in Seville, and amongst them the famous Murillo (fig.106, No.54), which Twiss had so much admired.

The collection of Spanish paintings that most impressed Waagen ('I know of no other collection in England containing so many valuable pictures of the Spanish school') is the one at Kingston Lacy in Dorset (figs.27,28), which was begun in Spain in the later years of the Peninsular War by William John Bankes. A figure of the age much resembling William Beckford, though not an author, Bankes is now chiefly remembered as a friend of Byron, whose acquaintance he made at Trinity, Cambridge, where Bankes was apparently known as 'father of all mischiefs'. Byron had set out on his voyage through the Mediterranean in 1809, travelling first across Portugal and Spain, from Lisbon to Seville. His impressions of the country, which were to play an important part in the popularization of Spain, especially in France, are contained in the first part of his poem *Childe Harold*. Bankes left England in 1812 and spent longer than Byron in Spain, meeting Wellington after the Battle of Salamanca

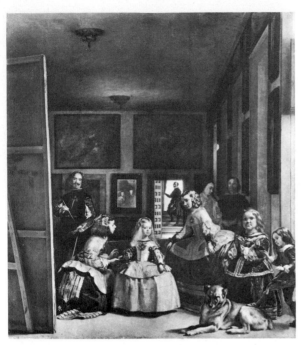

29. The Maids of Honour ('Las Meninas') (1656), by Velasquez (Prado Museum, Madrid). The Prado opened in 1819, and 'Las Meninas' began to be recognized as one of its greatest treasures.

and then living in Granada 'in a beggarly, eccentric fashion'. The heir to an already distinguished collection of paintings, especially of family portraits, Bankes began to acquire paintings in Spain: a Murillo he is supposed to have discovered on a battlefield, two Zurbarán saints believed to have been in the vestry of Seville Cathedral, and a striking portrait by Espinosa that he acquired in Valencia.

Bankes travelled on to Greece and Egypt where he arrived in 1815, penetrated Mecca dressed as an Arab, and explored extensively in the Levant. By 1819 he had rejoined Byron in Italy, and there he made two of his most important purchases: a Rubens portrait acquired in Genoa, and the famous 'Judgement of Solomon', sometimes attributed to Giorgione, which he discovered in Bologna. The rarest of his Spanish paintings may also have been acquired at this time, the portrait of Cardinal Camillo Massimi, which Velasquez painted during his second visit to Italy (fig.28). It hangs high in the 'Spanish Room' at Kingston Lacy, much obscured by darkened varnish and, as with other masterpieces in private houses, it poses the problem, happily unknown with music and with literature, of the approachability of major works of art. Another picture of Velasquez's second Italian

journey, the portrait of Juan de Pareja (fig.52), belonging before 1801 to Sir William Hamilton, was one of the first undoubted masterpieces of the painter to arrive in this country.

'The great traveller', Bankes returned to England in 1820 and took up his seat in the House of Commons. With the help of Barry he began to alter and 'improve' the house at Kingston Lacy. In 1841 however, he chose to live in exile rather than to face trial for an act of homosexuality and he died in Venice in 1855, having continued in his years of exile to add to the collection he had formed.

Growing interest in the painting of Spain resulted in the first years of the 19th century in the publication of several books devoted to the subject, including the first history of Spanish painting, a German book which Stirling found tolerable, the *Geschichte der Mahlerey in Spanien* by Fiorillo, volume four of a general history of painting that appeared in 1806. Quillet, who had advised King Joseph in Spain, published a dictionary of Spanish painters in 1816, and in 1819 there appeared the first monograph on a Spanish artist. Devoted inevitably to Murillo, the book is a confusing compilation of earlier published material on the painter by an Edward Davies, 'late Captain in the Life Guards.'

Following the final defeat of Napoleon and the restoration of Ferdinand VII to the throne of Spain, diplomatic relations with England again resumed their normal course, but the first part of the 19th century proved a time of great political complexity and upheaval in Spain. Having returned from exile in 1814, Ferdinand was to prove one of the most reactionary and unpopular of all Spanish kings, continuously in conflict with his subjects, many of whom were forced to seek refuge abroad, in England and in France, where Goya spent the last four years of his life. The king was childless until shortly before his death in 1833, when a daughter was born who frustrated the claim to the throne entertained by Don Carlos, the king's brother. Intermittent warfare (the Carlist Wars) between Don Carlos and the dowager queen, Maria Christina, ruling the country on behalf of her daughter, Isabella II (1833–68) marked the decades of the 1830s and 40s, a hazard to be considered by the many travellers tempted to visit the Peninsula. Isabella was finally forced into exile, and a republic was declared which came to an end with the accession of Alfonso XII, then a cadet at Sandhurst, to the throne in 1875.

Despite the unstable political climate there was no shortage of British diplomats and visitors to Spain in the 1820s. The collection of Lord Heytesbury was formed in the early part of the decade,

30,31. The Guerilla's Departure, and The Guerilla's Return by Sir David Wilkie (1785–1841) (Royal Collection). Two of the four canvases begun by Wilkie in Spain (1827) and influenced by Spanish painting, mainly in their 'picturesque' details.

when the Irishman, Michael J. Quin, was also in Madrid to study the political situation, and later in the 1820s David Wilkie and Washington Irving were both in the Peninsula. Well before 1830, when Disraeli visited the south of Spain, the British consuls, John M. Brackenbury and Julian Williams, were both installed there busily collecting paintings, together with the eccentric Frank Hall Standish (fig.33), whose large collection was later left to King Louis-Philippe.

Travellers to Spain in the years after the Peninsular War found a very different situation from that which earlier visitors had experienced and this was reflected in the state of the Spanish patrimony. Quin set out in 1822 to witness for himself the current political crisis in Spain, and 'to see the theatre of so many British victories.' In Madrid King Joseph's hopes for the creation of a public gallery of Spanish painting had been realised with the opening of the Prado Museum in 1819 (enlarged in 1821). There the masterpieces of Velasquez were on show, and Quin was one of the first to draw particular attention to 'Las Meninas' (fig.29), 'with the exception of La Perla in the Escorial, the finest production of the pencil which I have seen.' Preferring 'Las Meninas' to the earlier

works by Velasquez which 18th-century travellers had most esteemed, Quin wrote of the painter as 'above all his age . . . a master perfectly original, and inimitable in his tints, in his transcripts of nature, and particularly in his singular faculty of making distance and airy space appear in his pictures.'

Quin placed Murillo second to Velasquez, and noted in passing his inability to 'represent a voluptuous figure': 'Next to Velasquez, stands the graceful Murillo, who in his early productions imitated him; but who had the courage to depend ultimately upon his own genius, and formed a new style remarkable for sentiment and elegance.' The achievements of Spanish still-life painting also particularly struck Quin: Meléndez 'who would have succeeded admirably in such representations, if he had not introduced into them a little too much of the artificial grace of the French school. The same remark applies, in some degree, to the flower pictures of Bartolome Perez, whose tulips, hyacinths, and lilies are, however, incomparable. He, as well as Arellano [figs.109,110, Nos.57,58], Espinos, and other Spanish flower painters, has contrived to animate his works by decorating the vases, in which the flowers are placed, with scenes from history and romance.'

While in Madrid Quin was hospitably received by the British Minister, Sir William A'Court, one of the first of many 19th-century British diplomats who were able to form collections of Spanish paint-

ings. Waagen discovered in the house of Lord Heytesbury, as he had by then become, an impressive group of pictures that included one of Murillo's few essays in the voluptuous, his celebrated painting of a girl and her duenna on a balcony ('Las Gallegas'), now in Washington.

The political climate was more settled in 1827 when David Wilkie, believing wrongly that he was the first British artist to visit Spain, journeyed to Madrid during the course of a convalescent tour in Europe. He spent five months there and began a group of four canvases which George IV later bought for the royal collection. 'Illustrations of the wars of independence', as Wilkie described them (figs.30,31), the pictures suggest that Wilkie had not looked in vain at Spanish painting. Though over-weighted with much 'picturesque' detail – a pretension to 'literary' values that few artists could then avoid – and also indebted to Dutch art, something of the handling of Velasquez seems apparent in the treatment of the draperies, and more than a hint of Murillo in the character of the not-well-integrated secondary figures. Even the idea of a pair of paintings showing defiance and retribution may owe much to Goya, though Wilkie's brave 'guerilla' might almost be victim of what was no more than a hunting accident.

In his letters home Wilkie appears poised in an instructive way between Velasquez and Murillo, though admiring Correggio better than either Spanish painter. Both seemed to him great 'and yet to have formed two styles so different and opposite,

that the most unlearned can scarcely mistake them; Murillo being all softness, while Velasquez is all sparkle and vivacity.' Though not himself primarily a portrait painter, Wilkie shrewdly observed that 'in painting an intelligent portrait Velasquez is nearly unrivalled; but where he attempts simple nature, or sacred subjects, he is far inferior to Murillo.' According to Wilkie, Lawrence regarded Velasquez's work as 'the true philosophy of art' and Wilkie himself felt that the Spanish painter had strongly influenced British artists, 'Reynolds, Romney, Raeburn, Jackson and even Sir Thomas Lawrence', who seemed to him 'whether from imitation or instinct . . . powerfully imbued with his style.' In the Prado Wilkie understandably admired 'Los Borrachos', one of the most anecdotal of Velasquez's works (fig.32), and he apparently managed to buy at least one painting by the artist. Echoing Reynolds' dictum, and approaching the modern view of Velasquez, Wilkie came to feel that he 'does at once what we do by repeated touches, . . . this master is one that every true painter must in his heart admire.'

In Seville (6 May 1828) Wilkie expressed a liking for Zurbarán, and said of Murillo that 'for female and infantine beauty, scarce any has surpassed him; his pictures in private hands are not to be had for love or money Here even among the lower classes he is venerated as if he were a patriot and benefactor of the city.' Wilkie had travelled to Seville in company with the American writer, later ambassador to Madrid, Washington

32. The Topers ('Los Borrachos'), by Velasquez (Prado Museum, Madrid). An anecdotal painting much admired by Wilkie.

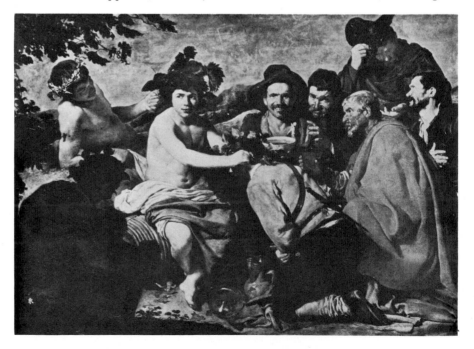

Irving, who had settled in Spain in 1824. There he devoted books to the voyages of Columbus (1831), the conquest of Granada (1829), and in 1832 appeared *The Alhambra,* 'a series of tales and sketches of the Moors and the Spaniards', which is dedicated to Wilkie. Irving's book was the first to exploit the popular interest in Spain that was rapidly growing throughout Europe, and he himself was the first of a series of distinguished Americans to devote studies to the history of Spain, a group that included W.H. Prescott and George Ticknor. Prescott's *History of the Reign of Ferdinand and Isabella* appeared in 1836, to be followed by histories of the conquest of Mexico (1843) and Peru (1846), and Ticknor's volumes on Spanish literature followed ten years later (1855–56).

When Irving and Wilkie reached Seville in 1828 the paintings for which the city had been renowned were there no longer. In 1822 Quin had reported that he 'looked about for several hospitals, convents and parochial churches, in which I learned from Townsend there were several pictures by Murillo and Zurbaran. But in no one instance did I succeed. The hospitals and convents in which those treasures were, have either been plundered by the French, or suppressed by the Cortes [the Spanish Parliament].' The atmosphere of Andalusia had, however, remained unchanged: 'Indeed, in many respects, the Andalusians seem to be quite a different race from the people of La Mancha and the two Castilles. They have an oriental fondness for gay colours, which they display chiefly in the selection of their neck-kerchiefs.' The oriental character of Andalusia, now that so many travellers were tempted to Africa and the East, held increasing fascination for the British.

The triumph of Murillo: Spain, Paris and London (1830–53)

One of the first and most positive in his response to southern Spain was Disraeli, who lingered there in the summer of 1830 at the start of a Mediterranean tour: 'It helped' according to an early biographer 'to definite purpose and significance to that Oriental tendency in his nature which, vaguely present before, was henceforth to dominate his imagination.' Spain itself Disraeli described as 'a country of which I have read little and thought nothing – a country of which indeed nothing has been of late written, and which few visit.' The Andalusians delighted him; in Seville he felt that 'Figaro is in every street; Rosina in every balcony', and, unprompted by Velasquez, he considered that 'A

Spanish lady with her fan might shame the tactics of a troop of horse.' Feeling that Murillo would show his friends in London 'for the first time what a great artist is', Disraeli featured him prominently in his impetuous encomium of Andalusia: 'Oh, wonderful Spain. Think of this romantic land covered with Moorish ruins and full of Murillo! ah that I could describe to you the wonders of the painted temples of Seville! ah that I could wander with you amid the fantastic and imaginative halls of the delicate Alhambra.'

While in Spain Disraeli met three of the main British collectors of Spanish painting, all living in the south of the country, and all later to become known to Richard Ford, when he arrived in Seville in November 1830. John M. Brackenbury, later Sir John, was British consul in Cadiz, 'great enough for an ambassador', according to Disraeli, who added that he 'lives well enough for one'. Brackenbury assembled a large collection of Spanish paintings, including Murillo's portrait of Don Andrés de Andrade (now in the Metropolitan Museum, New York), and most of his pictures were sold in London in 1848. The collection of Julian Williams was as remarkable as Brackenbury's, though Williams seems to have been partly a dealer, and no sale of the collection, or catalogue, is known. Living in Seville where he later became British consul, Williams befriended Disraeli, who described him as 'an English merchant married to a Spanish lady, and considered the greatest connoisseur in paintings in Spain'.

The most talented and probably the most curious of the three collectors seems to have been Hall Standish (fig.33), who had been born in Durham in 1798, the only child of Anthony Hall. 'Standish' was added to his name after the death of his unmarried cousin, the baronet Sir Frank Standish, in 1812. He took to travelling and to writing at an early age, *The Life of Voltaire* appearing in 1821, when Standish was no more than twenty-three. This was followed by *The Shores of the Mediterranean* (1837–38), and *Notices on the Northern Capitals of Europe* (1838). His late years he passed in Spain, where he died at the age of forty-one in 1839, the year before the publication of his final book, a guide to Seville (dedicated to Julian Williams). Standish amassed a large collection of paintings, drawings and engravings chiefly of the Spanish school (fourteen paintings attributed to Murillo, four to Velasquez, and eleven to Zurbarán), and a famous library. It was rumoured that he had offered this collection to his native country, on condition that the Standish baronetcy be revived for him, but Lord Melbourne declined, and in his

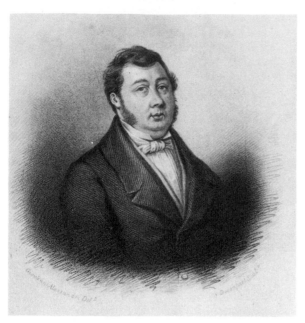

33. Frank Hall Standish (1798–1839), lithograph after G. Alessandri. The eccentric whom Disraeli met in Spain; he bequested his collection to King Louis-Philippe.

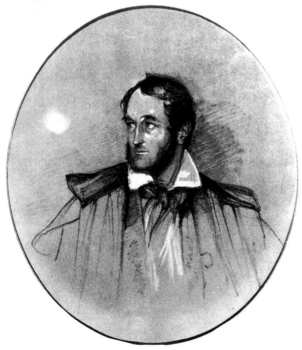

34. Richard Ford (1796–1858), by John Frederick Lewis (1805–76) (Brinsley Ford collection). Ford was in Spain in 1830–33 and published his famous *Hand-book* in 1845.

will of July 1838 the collection was left to the French king, Louis-Philippe, 'in token of my great esteem for a generous and polite nation, one that is always ready to welcome the traveller, and relieve the stranger, and one that I have ever gone to with pleasure and quitted with regret.'

An earlier will of 1831, written before Louis-Philippe had begun to assemble his own collection of pictures, is said to have contained much the same terms. When Standish died Louis-Philippe allowed his cousin, Mrs Standish, to retain a painting of her choice from the collection (she took one of the Murillos), and the remainder he added in 1841 to the collection of his own pictures on exhibition at the Louvre, all of which were destined to be sold in London in 1853. Forming a friendship with Standish in Spain, Disraeli had described him as 'excessively fantastic and odd, but a good fellow. The Spaniards cannot make him out and the few English that meet him set him down only as exceedingly affected.'

When Richard Ford (fig.34) arrived in Spain a few months after Disraeli's departure, he too was welcomed by Brackenbury and Williams and he settled in a house belonging to Standish in Seville (Plazuéla San Isidoro, no.11). He was then 34, born in London in 1796, the eldest son of the magistrate and MP, Sir Richard Ford, and Marianne Booth, the daughter and heiress of Benjamin Booth, a well-known patron of the arts and particularly of Richard Wilson. He had been educated at Winchester and Oxford and destined, like his father, for a legal career, but he 'soon forsook Lincoln's Inn for the Louvre and the Vatican, recently opened to Englishmen by the close of revolutionary war.' He travelled extensively and began to collect, returning to England where he married his first wife, the beautiful Harriet Capel, natural daughter of Lord Essex, and then he moved with his family to Spain where he remained for three years.

In the Peninsula he immersed himself, as no earlier traveller had done, in Spanish life, exploring the whole country, making notes and sketches (figs.35,36). In Seville he described life as 'dull enough for people inclined to balls and dinners; but we are very well pleased. The climate delicious beyond description, open doors and windows with the sun streaming in . . . of course I am considered to be a milor[d], and am known by the name of Don Ricardo . . . The natives are interested and surprised at all our proceedings and verily believe we have all arrived from the moon.' In May 1831 the family moved to Granada and lodged at the Alhambra, while Ford explored Valencia and east-

35. Richard Ford and J.F. Lewis on a shooting excursion, by J.F. Lewis (Brinsley Ford collection).

36. View of Seville Cathedral and its tower ('La Giralda') by Richard Ford (Brinsley Ford collection).

ern Spain and Madrid. The following year they stayed again in Seville, while Ford travelled to Salamanca and north-west Spain. From Granada in 1833 Ford briefly visited Africa, and he returned to England with his family in September.

Ford's growing appreciation of Spanish painting appears very clearly in his letters. 'We are all crazy here about pictures, such buying and selling . . . In short, we are buying things here at double what they are worth in England.' In Valencia he purchased a major work by Ribalta (fig.63, No.11) and others by Zurbarán and Murillo were added to his collection, but the true obsessiveness of the collector seems not to have formed a part of Ford's make-up ('the pleasure is in the *acquisition*, not in *possession*'), and he later put up some of his pictures for sale (1836). The works of Velasquez ('more extraordinary every time I meet them') particularly impressed him in Spain, and he was the first Englishman to write a life of the painter (in the *Penny Cyclopaedia*, 1843). What also surprised him in Spain was the attitude of the Spaniards to paintings: 'if you ask for the Virgin of Juanes, the sacristan or curate knows nothing about it; but ask for the Purissima and up goes a curtain in a minute.'

Returning to England, Ford settled near Exeter, where in 1834 he acquired Heavitree House, the grounds of which he proceeded to transform into a Spanish garden, and he began work on a book on Spain, though without immediate success. His wife died in 1837 and he married again in the following year, and then in 1839 he was approached by the publisher John Murray to contribute to a series of guide books, itself symptomatic of the desire to travel being shown by the less wealthy, of which the first, covering Holland, Belgium and the Rhine appeared in 1836. Ford's *Hand-book* was published in 1845, and despite the functional and unattractive format of the volume, it was immediately greeted in England and in France as a work of genius in its own particular way, transcending the purpose for which it was conceived. Further editions quickly appeared, though in a shortened form, and the matter removed ('the author has not scrupled occasionally to throw Strabo, and even Saint Isidore himself, overboard') was incorporated into a more discursive book, the *Gatherings from Spain*, published in 1846.

The quality of the *Hand-book* is evident in Ford's approach to the paintings of Spain, which are covered in great detail, and always with wit and great good sense. Ford deeply mistrusted what has come to be called 'Neo-classical' painting and Jacques-Louis David especially, 'who trampled on the fine arts of cowed Europe.' Modern Spanish art

he disliked almost equally: 'Of Madrazo himself [Director of the Prado Museum], observe 564, "Death of Viriatus", transportation is loudly called for ... Goya alone, 1746–1828, shows talent.' Much given to analogy, he regarded Velasquez as 'the Homer of the Spanish School, of which Murillo is the Virgil.' Of the two painters he felt that Velasquez 'was less successful in delineations of female beauty, the ideal, and holy subjects; wherein he was inferior to Murillo', and of all the works of Velasquez he singled out the 'Surrender of Breda' (fig.37) as 'perhaps the finest picture of Velasquez; never were knights, soldiers or national character better painted.'

Ford wrote no major work after the publication of the *Hand-book* though he contributed reviews and articles to several periodicals. He was well known to his friends, including William Stirling who wrote an obituary of Ford, for his deeply conservative views and for his geniality and hospitality, which is described by Waagen, who enjoyed a Spanish dinner at the Fords' house in Park Street. He died on 31 August 1858 at Heavitree House.

During the course of his visit to Spain, Ford met many other travellers, mainly from Britain, who were to make their own contributions to the popularization of Spain and Spanish art. There was the painter John Frederick Lewis, who por-trayed Ford (figs.34,35) and later published *Sketches and Drawings of the Alhambra* (1835) and *Sketches of Spain and Spanish Character* (1836). 'He is about to make a sort of picturesque tour of Spain,' Ford wrote in July 1832 'having orders for young ladies' albums and from divers booksellers who are illustrating Lord Byron.' The artist David Roberts was also in Spain at this time, before going on to Egypt and the Holy Land, and he kept in touch with Lewis by letter, though the two never met in Spain. To Roberts are due some of the glossiest views of Spain as it then was (figs.38,39), and a famous series of prints, *Picturesque Sketches in Spain* (1837). The painter Delacroix visited Seville in May 1833 and he recorded in his journal admiration for the attractive Mrs Ford.

Diplomats with an interest in the arts also met Ford in Spain: Sir William Eden who formed a large collection of Spanish paintings, and to whom the *Hand-book* was dedicated, and Sir Edmund Head, later Governor of New Brunswick. Head published in 1848 a *Handbook of the History of the Spanish and French Schools of Painting* as a supplement to the volumes that had been written by Kugler on other schools. Though useful and competent, it was soon superseded by the *Annals* of Stirling, published in the same year. Ford himself had submitted a manuscript to Head in 1834, and had met

37. The Surrender of Breda ('Las Lanzas'), by Velasquez (Prado Museum, Madrid). Considered by Ford to be 'perhaps the finest picture of Velasquez.'

38,39. The exterior and interior of Seville Cathedral, by David Roberts (1796–1864) (Downside Abbey). Lewis and Roberts both published books of prints based on the drawings they had made in Spain in the early 1830s.

40. William Stirling (Sir William Stirling Maxwell) (1818–78), the author of *Annals of the Artists of Spain* (1848).

with a very discouraging response, which prompted him to write of Head as 'a learned, dry antiquarian; that is not exactly my line.'

Stirling was also far more of an antiquarian than Ford, but a scholar of greater depth and range than Head, a man of unlimited energy and curiosity, conscientious as a landowner and in later life a major public figure (fig.40). Born in 1818, the only son of Archibald Stirling of Keir, he was educated at Cambridge, graduating in 1839. The following years he spent abroad, visiting the Holy Land and Spain, where he travelled extensively, acquiring paintings and preparing the publication of the *Annals of the Artists of Spain*, which appeared in 1848, when Stirling was only thirty years old. His other major books were historical, in the tradition of the Scottish historians William Robertson and

J.C. Dunlop, who had published in 1834 a history of Spain in the 17th century. *The Cloister Life of the Emperor Charles V,* appeared four years after the *Annals,* and *Don John of Austria* posthumously in 1883.

On the death of his father in 1847 Stirling succeeded to the family estates, and began to remodel Keir, like Ford at Heavitree, laying out the grounds in a new and remotely Moorish style. A moderate Conservative, he became MP in 1852 for Perth, which he represented until the 1870s. His London house was, like Ford's, in Park Street (Grosvenor Square), where part of his library was installed. Stirling's collection, not only of paintings, but of drawings, prints and books was extraordinary in its scope, and he was also a pioneer in his interest in photography. Twenty-five copies of the *Annals* were accompanied by a volume of photographic illustrations, amongst the earliest of their kind. Stirling became a baronet in 1865 on the death of his uncle, Sir John Maxwell of Pollok House, whose name he added to his own. Many public offices distinguished the later years of his life: Rector of Aberdeen and Edinburgh Universities, Chancellor of Glasgow, Trustee of the British Museum and the National Gallery. After the tragic death of his first wife, Stirling married in 1877 his close friend, the poetess Caroline Norton, but she survived for only a few months after the wedding, and Stirling himself died in Venice in the following year.

The three volumes of the *Annals,* running to 1481 pages, cover the arts in Spain from the early Middle Ages to the time of Goya, with much the longest sections reserved for Velasquez and Murillo. Stirling is dismissive of most of the earlier literature on the subject, but he praised the work of Head and Fiorillo, and reserved a special place in his affection for Ford's *Hand-book* 'one of the most popular books in our language.' What emerges from Stirling's general remarks about Spanish painting is a great regard for the country and its people, and a formidable sense of puritan ethics (Blake was a favourite painter of his): 'The sobriety and purity of imagination which distinguished the Spanish painters is mainly to be attributed to the restraining influence of the Inquisition . . . Another cause . . . is in the character of the Spanish people. The proverbial gravity – which distinguishes the Spaniard, like his cloak – which appears in his manner of dress, and in the common phrases of his speech, is but an index of his earnest and thoughtful nature.' And Stirling goes on to contrast with Spanish morals the licence of the papal court in Rome: 'Whilst Alexander Borgia . . . polluted the

Vatican with filthy sensuality, whilst the epicurean Pope Leo banqueted gaily with infidel wits . . . the mitre of Toledo was worn by the Franciscan Ximenes.'

As an historian Stirling was particularly devoted to portraiture, 'the most useful and valuable department of painting, which lightens the labour and points the tale of the historian and the biographer.' Velasquez and Murillo, he felt, may not have equalled the achievements of Titian and Van Dyck, because 'the fields of their famous rivals was finer . . . than the degenerating nobility of the court of Philip IV and the clergy and gentry of Seville.' Their fame, he believed, 'long suffered from their geographical position. Till the present century little was known on this side of the Pyrenees, of the arts of the Peninsula.' Now, 'The private collections of England could probably furnish forth a gallery of Spanish pictures second only to that of the Queen of Spain [at the Prado].' Liking so much the 'solemn and religious' character of Spanish painting, Stirling's sympathies extended far beyond portraiture and he was deeply touched by monastic art: 'Spain being the elysium of monks, the various religious orders, "white, black and gray", were there delineated with unusual force and frequency . . . Murillo and Espinosa were much employed by the friars who wore the brown frock of St Francis; Carducho and Zurbaran most affected the Carthusians, whose white robes and hoods they managed with fine skill and effect.'

For Stirling, Spain had produced 'the painters whose works unite high excellence of conception and execution, with absolute adherence to nature, and are thus best fitted to please the most critical as well as the most uneducated eyes.' Velasquez and Murillo remained his favourite painters, each providing an alternative to the 'classical' tradition, which Ford also mistrusted: 'those who turn away, perplexed and disappointed from the Spasimo or the Transfiguration [of Raphael], would probably gaze with ever fresh delight on the living and moving captains and spearmen of Velasquez, or on Murillo's thirsty multitudes flocking to the rock that gushed in Horeb.' Stirling's pleasure in the two painters was never abandoned, and he devoted one of his shorter publications to Velasquez in 1855, and compiled a catalogue of prints after the two masters, a volume which appeared in 1873.

The majority of the paintings that Stirling collected, which were never fully catalogued, remain in this country, and seven are included in the present exhibition. The collection, rich in all but Velasquez and Murillo, passed by inheritance to Stirling's sons, Sir John Stirling Maxwell (1866–

1956), and Archibald Stirling of Keir. Part was given, together with Pollok House, to the city of Glasgow by Mrs Anne Maxwell Macdonald in 1966, while the portion at Keir has been partly dispersed.

Many of the paintings that Stirling acquired were bought at sales of Spanish pictures which took place at frequent intervals in London from the 1830s to the 1850s. In 1835 the Spanish government enacted a law suppressing the religious orders in Spain, which led to the dispersal of Church property and paintings. Among the chief benefactors was King Louis-Philippe of France. Intending to found at the Louvre a museum of Spanish art, he sent to Spain a Belgian agent, Baron Taylor, to acquire paintings for this collection, which was opened to the public in 1838. The pictures made a profound impression on the French, stimulating an interest in Spain that found expression in the famous *Voyage en Espagne* by Théophile Gautier (1845). More than their counterparts in England, painters in France responded to the aesthetic, as well as to the merely picturesque, character of Spanish painting, and in the work of Manet the lessons of Velasquez and Goya were fruitfully absorbed long before they created a lasting impact on painting in this country.

British collectors active in Spain in the 1830s included Lord Clarendon, a distinguished diplomat who was in Madrid in the later 1830s. Clarendon was amongst the first to acquire works by Goya, whose pictures were also bought by General John Meade, who formed a large collection of Spanish paintings (including No.59, fig.111). So little was Goya known in England that the examples of his work in Meade's collection, portraits of the Duchess of Alba and a friend, and of 'Charles, Prince of the Peace', were catalogued when sold in 1851 as being by 'Goza'. Of General Meade himself, a son of Lord Clanwilliam, little seems to be known, and even more obscure is the G.A. Hoskins who is mentioned by Waagen as another collector of Spanish paintings.

Following Richard Ford's own sale in 1836, it was the turn of the famous Galerie Aguado, sold in Paris in 1843. This had been formed by a rich Spanish banker, and included Velasquez's 'Lady with a Fan' (fig.41), which was bought for the Marquess of Hertford, the founder of the Wallace Collection, who was able in these years to form an outstanding collection of Spanish paintings. In 1847 occurred the first sale of the Meade collection, and in 1848 the major part of Brackenbury's collection was sold, including a few drawings by Goya ('the Hogarth of Spain'). In the year following the

41. The Lady with a Fan, by Velasquez (Wallace collection). Bought by Lord Hertford at the Aguado sale in Paris, 1843.

disposal of the second part of Meade's collection (1851) there took place in London the first of a series of sales of the Salamanca collection, pictures belonging to another rich Spanish banker, and then the Soult sale created a sensation in Paris at the end of May, 1852.

Soult had carefully guarded the plunder he acquired in Spain (including part of No.52, fig.104), consulting Buchanan about the possible sale of the collection in 1823, and offering a group of the finest paintings to Louis-Philippe in 1830. Three of his Murillos, (two from the Caridad series) he sold to the Duke of Sutherland in 1835, and in 1846 George Tomline acquired the canvas showing 'Christ at the Pool of Bethesda' (No.51, fig.103), which Waagen greatly admired. Soult was willing to show his collection to visitors and an amusing story circulated at the time of the sale describing the visit of a Colonel Gurwood to the house: he was told by Soult ' "I value that picture very much; – It saved the lives of two estimable persons." An aide-de-camp whispered in our countryman's ear – "He threatened to have them both shot on the spot unless they gave it up." ' The great

42. The Immaculate Conception, by Murillo (Prado Museum, Madrid). The 'star' amongst the pictures looted by Maréchal Soult in Seville (1810–13); bought by the Louvre at his sale for the record price of £23,400.

treasure of the Soult sale was the late 'Immaculate Conception' by Murillo (acquired by the Prado in 1940) which had been removed from the Hospital of the Venerables Sacerdotes in Seville (fig.42). The picture was finally secured by the Louvre at a cost of 586,000 *livres* (about £23,400), more than merely a token of homage to Murillo – an unheard of price at that time and one that remained for many years a record.

In the year following the Soult sale came the disposal of the Louis-Philippe collection. After the Revolution of 1848 the pictures in the *Galerie espagnole*, including the Standish collection, were adjudged the personal property of the deposed king and sent to London for sale at Christie's. There were 454 pictures in the main collection, including 8 Goyas, 19 paintings attributed to Velasquez, 38 to Murillo, and no less than 81 attributed to Zurbarán. The sale took six days and realised a total of just under £28,000, only a little more than the price of the Soult 'Immaculate Conception'. Among the

many to acquire paintings from the collection were Queen Victoria and Prince Albert, whose better purchases included two portraits by Sánchez Coello. In the present exhibition nine of the paintings are known to have formed part of the *Galerie espagnole* of Louis-Philippe.

Having failed to buy the Soult 'Immaculate Conception', the National Gallery purchased at the Louis-Philippe sale the most famous of the Zurbaráns in the collection (fig.85, No.33), and a celebrated painting of the 'Adoration of the Shepherds' (fig.43), a picture then attributed to Velasquez, and later to Zurbarán, which may well be an early work of Murillo, painted under the influence of the two other Sevillian masters. The Gallery had been slow to acquire Spanish paintings, though its first major Murillo, the famous painting that Twiss had admired in Cadiz, was purchased in 1837 (fig.106).

By 1853 there were three Murillos in the collection and one Velasquez, the 'Boar Hunt', which had been bought in 1846 (fig.26). The Gallery's acquisitions at the Louis-Philippe sale attracted

43. The Adoration of the Shepherds, ascribed to Murillo (National Gallery). Attributed to Velasquez in the Louis-Philippe collection and one of two paintings bought by the National Gallery at its sale (1853).

adverse comment, especially the Zurbarán, which was described in a letter to *The Times* from the MP William Coningham as 'a small, black, repulsive picture.' Joining forces for the occasion, Ford and Stirling composed a reply to this attack: ' "small" it may be, but it is large enough for the subject; and if it is to be thought "black and repulsive", the same depreciatory terms are equally applicable to some of the finest studies by Rembrandt of dirty Dutch patriarchs . . . In the Spaniard at least the sombre tones are enhanced by the poetry of the recluse.'

The triumph of Velasquez: the later years of the 19th century, and after

Though Velasquez's work had been described so memorably by Lawrence as 'the true philosophy of art', he had shared with Murillo the honour of being ranked as the greatest artist of the Spanish school, and in the popular estimation the far-from-'philosophical' Murillo was more warmly admired. Reporting on the Louis-Philippe sale, the correspondent of *The Athenaeum* (probably Richard Ford) felt bound to say that in Murillo 'English predilections towards Peninsular Art are mainly centred'. Hazlitt had written of one of the Murillos at Dulwich (figs.97,98) as being 'the triumph of this collection, and almost of painting. In the imitation of common life, nothing ever went beyond it, or, as far as we can judge, came up to it.'

There was, however, no sudden rejection of Murillo, whose popularity continued throughout most of the 19th century, but gradually his reputation declined, and one of the first to begin the assault was Ruskin. Ruskin appears to have shared the popular admiration for Murillo at first, but this slowly turned to a violent distaste for the painter, expressed in terms that are little creditable to Ruskin himself. In 1844 he wrote of intending 'some time in my life to have a general conflagration of Murillos, bye-the-bye; I suppose more corruption of taste and quenching of knowledge may be traced to him than to any man who ever touched canvas. I have never entered the Dulwich gallery for fourteen years without seeing at least three copyists before the Murillos. I have *never* seen *one* before the Paul Veronese.'

In *The Stones of Venice* (1853) Ruskin finally spoke out against Murillo in an extended description of the Dulwich pictures, an attack based almost entirely on a haughty response to their subject matter and as puritanical in its tone as Stirling's denunciation of the papal court in Rome: 'Look at

44. 'At the Piano', by Whistler (1834–1903) (Taft Museum, Cincinnati). Painted in Paris and admired – as a painting influenced by Velasquez – at the Royal Academy, 1860.

those two ragged and vicious vagrants that Murillo has gathered out of the street [fig.98] . . . Do not call this the painting of nature: it is mere delight in foulness.' In *The Two Paths* (1859) Murillo had become 'of all true painters the narrowest, feeblest, and most superficial, for those reasons the most popular.' For Velasquez, on the other hand, Ruskin had a high regard, and especially for his painting of dogs, though he never wrote at length of his work. In *Modern Painters* Velasquez was 'the greatest colourist' and 'the most accurate portrait painter of Spain', and in *Lectures on Art* (1870), Ruskin took up Reynolds' dictum: 'trained in a lower school, Velasquez, – produced the miracles of colour and shadow painting, which made Reynolds say of him, "What we all do with labour, he does with ease." '

From the middle years of the 19th century the academic, literary and anecdotal values that had ruled in matters of art in England and France were gradually undermined, and the influence of Spanish painting, personified by Velasquez and Goya, who had maintained themselves in relative freedom from academic restraint, was of fundamental importance to this significant change of taste. In France, with Manet, the challenge to academic art was clearly defined, as was the role played by Velasquez and Goya, but in England changes came about more slowly and in the work of painters not truly comparable in stature with their French contemporaries.

The arrival of Whistler in England in 1860 and the public exhibition of his painting 'At the piano' (fig.44) which had been rejected at the Paris Salon in the previous year, marked an early stage in the quarrel about the true nature of art that was to

rage, with Whistler often leading for the opposition, until well into the present century. Whistler's painting was admired by Thackeray, Rossetti, Millais, and Sir Charles Eastlake, first Director of the National Gallery, who had apparently thought it the best painting at the Academy. The critic of *The Times*, no doubt voicing the general view, gave it as his opinion that 'in colour and handling this picture reminds me irresistably of Velasquez. There is the same powerful effect obtained by the simplest and sombrest colours . . . The execution is as broad and sketchy as the effects are simple . . . this gentleman has a future before him.'

Born in America in 1834, Whistler was living mainly in Paris from 1855, and he studied Velasquez at the enormous 'Art Treasures' Exhibition in Manchester in 1857 (where at least six of the paintings in the present exhibition were on display). The first of the great showings of Old Masters of the later 19th century, the Manchester exhibition, which Waagen had helped to organize, was an indication of a new interest on the part of the educated public in the enjoyment of paintings, just as the guide books produced by Murray showed their concern to travel. Earlier public exhibitions, beginning with those organized at the British Institution from 1815, had comprised smaller groups of pictures from a more limited range of collections. The Manchester exhibition was followed by one at Leeds in 1868 and from 1870 the Royal Academy held an annual Old Master exhibition in London.

Having admired Whistler's painting in 1860, Millais produced his own 'Homage to Velasquez' in 1868 (fig.45): a girl in 17th-century Spanish dress sitting informally and holding an orange on a branch. Echoing Velasquez in the treatment of the dress, the painting is otherwise far from being truly a 'homage' to the Spaniard. Millais' feelings for Velasquez seem to have been highly equivocal. He is reported as saying to one of the many British artists (a group that included Leighton, for example, and Clarkson Stanfield) who made the journey to Spain: 'Look well at Velasquez – study him, but don't copy him, he won't knock you down'. The words suggest almost a fear of the Spanish artist's influence, and later Millais was said to have expressed the view that 'it is worse than folly for

45. 'Homage to Velasquez', by Millais (1829–96) (Royal Academy). Painted in 1868 as Millais' Diploma picture.

46. Head of Menippus, after Velasquez, by Sargent (1856–1925) (Private collection). Sargent was spellbound by Velasquez on his visit to Madrid in 1880.

young men to say . . . , as many do, that Velasquez is the only Old Master worth looking at.'

One young man whose work reflected the significant trend that Millais had sensed was John Singer Sargent. Like Whistler an American, Sargent had been born in Italy (1856) and trained in Florence and Paris. He visited Spain in 1880 and was overwhelmed by the work of Velasquez (fig.46), admiring his technique and his understanding of human physiognomy, which served him in his own later portraits of Victorian and Edwardian society figures.

No less than in the visual arts the emergence of Velasquez is reflected in the comments of English and American writers of the time, though the scarcity of references to painting by major British authors is striking in comparison with the visual responsiveness of the French, from Balzac to Proust. Browning wrote in 1846 to Elizabeth Barrett of the 'triumphant three Murillo pictures' at Dulwich, and at the 1857 Manchester exhibition Nathaniel Hawthorne mentioned that 'Some landscapes by Ruysdael, and some portraits by Murillo, Velasquez and Titian, were those I seemed most able to appreciate.' George Eliot was one of the few novelists of the age to visit Spain (1867), where she admired the Murillos at Seville and wrote from Madrid: 'We crowned our pleasure in Spain with the sight of the pictures in the Madrid Gallery.'

Velasquez appears as a distinct preference to Murillo in the pages of Henry James, almost the only novelist of his day to write at length about painting. Commenting on the Wallace Collection when it was put on exhibition at Bethnal Green in 1873 he wrote: 'There is a splendid array of Murillos . . . Four or five out of the eleven represent Murillo at his best – his ease, his grace, his dusky harmonies, his beggars and saints, his agreeable Spanish savour; but even these merits fail to make him seriously interesting. His drawing, though often happy, is uncomfortably loose and his intentions, somehow, fatally vague. Velasquez proudly outranks him. *His* intentions were distinct enough and his execution seldom betrayed him.' In the following year, from Boston, he reported on the Montpensier collection: 'That which looks out upon us from the canvases of Velasquez is a noble gravity and solidity; added to his magnificent handling it makes him one of the most powerful of painters.'

It was not, however, without protest that Murillo was finally eclipsed by Velasquez, and in the 1860s and 70s Murillo received some of the most rapturous of all the many tributes he was to be offered. John Philip's celebrated painting 'The Early Career of Murillo' (fig.47) was painted as late as 1865, inspired by the *Annals* of Stirling and showing the young Murillo, to the left, selling his work in the public market of Seville. Born in Aberdeen in 1817, John Philip, or 'Spanish Philip' as he came to be known, had travelled to Spain in 1851 and again in 1856, painting (partly under the influence of Wilkie) scenes of Spanish life. His pic-

47. 'The Early Career of Murillo', by John Philip (1817–67) (Forbes Foundation). Painted by 'Spanish' Philip in 1856 and based on the *Annals* of Stirling (1848).

ture of 'The Spanish Gypsy Mother' was acquired by Queen Victoria as a present for Prince Albert in 1852, and after the death of Richard Ford he painted a posthumous portrait at the request of Stirling. Other artists before Philip, both in France and in England, had discovered a vein of subject matter in the life of Murillo, and J.F. Lewis painted in 1838 a canvas of 'Murillo painting the Virgin in the Franciscan Convent at Seville'. In France it had been the theme of Murillo and his mistress (a fancy of the 19th century) that artists had preferred to represent, rather than the commercial enterprise of the painter which attracted Philip.

Some of the most famous of Murillo's paintings were acquired by British collectors in the later 19th century: the series illustrating the Parable of the Prodigal Son (No.48, fig.100), bought in Paris at the second Salamanca sale by Lord Dudley (1867), and 'The Triumph of the Eucharist' (No.50, fig.102), one of the series of canvases painted by Murillo for the church of Sta Maria la Blanca. This was in the Pourtalès sale in Paris in 1865, and then belonged to the English collector, Lyne Stevens.

The last English book to place Murillo above all other Spanish painters was *Murillo and the Spanish School of Painting* of 1873, written by the critic and friend of the Pre-Raphaelites, William Bell Scott, and dedicated to William Stirling. Protesting perhaps too emphatically, the author describes his hero as 'in the estimate of nearly every writer on the Spanish schools, and of every public and private collector in Europe, the greatest painter Spain has produced.' Bell Scott was not, however, blind to the merits of other Spanish painters, putting Velasquez 'next to Murillo, the most celebrated painter of Spain', and commending Zurbarán and Goya. The author was also one of the earliest to draw attention to works by El Greco, 'a little hard and sharp', including paintings from Stirling's collection which he mentions having seen at Manchester (1857) and Leeds (1868), and in the 1871 Royal Academy exhibition.

One of the earliest to show a more positive response to El Greco and to a whole range of hitherto relatively neglected Spanish art, including sculpture and the paintings of Spanish 'primitives', was Sir John Charles Robinson (1824–1913), who became the first Superintendent of the Victoria and Albert Museum in 1852. Robinson made several visits to Spain in the 1860s, when he acquired some of the most distinguished Spanish sculptures in the Museum's collection (Nos.75-78, figs.127-30). For his own collection Robinson bought a number of Spanish paintings, and published a short catalogue of six early pictures in his posses-

sion in 1912, when living in retirement at Swanage. The great altarpiece by Marzal de Sas was acquired by the Victoria and Albert Museum under Robinson's direction in 1864, and thirty years later, in 1895, he helped to organize the first comprehensive exhibition of Spanish art, at the New Gallery. In the same year he presented to the National Gallery its first painting by El Greco, which he had bought at Christie's in 1887 (No.6, fig.58). In the years that Robinson began to interest himself in early painting, the architect George Edmund Street was engaged on the study of medieval Spanish architecture and in 1865 appeared his famous book, dedicated to Gladstone, *Some Account of Gothic Architecture in Spain*.

As well as forming his own collection of paintings, Robinson acted as an advisor to the richer collector, Sir Francis Cook, who lived partly in Portugal and held the title 'Visconde de Monserrate'. The collection, now largely dispersed, was particularly rich in rare and less fashionable Spanish paintings, including the very early Velasquez of 'An Old Woman cooking Eggs' (No.13, fig.65), bought by Robinson in 1863 and then acquired by Cook. Also outstanding for the range of its Spanish painting, including El Greco and Goya, was the collection formed in the 1860s by John Bowes, the founder of the Bowes Museum (1885). His Spanish pictures came from Conde Javier del Quinto, who had been Chamberlain to the Spanish Regent, Queen Maria Christina, and director of a museum in Madrid, the Museo de la Trinidad. Quinto died in Paris in 1860, leaving a collection of 217 paintings mainly of the Spanish school; they were catalogued in 1862 for a sale that was finally cancelled and Bowes later purchased sixty of the pictures.

Robinson himself wrote very little and his view of the less fashionable aspects of Spanish art are largely unrecorded. In a catalogue of some of the Cook pictures, modestly entitled *Memoranda on Fifty Pictures* (1868) he wrote of El Greco as 'one of the most original and remarkable professors of the great cinque-cento period; possessed of true genius, this high gift was often dashed and mingled with extravagance, which has sometimes even been imputed to madness . . . As a painter or colourist . . . Greco is entitled to rank with Titian, Paul Veronese, Tintoretto, Rubens, Velasquez and Reynolds; that is, on a level in this particular respect with the greatest representative names in art.' Robinson also published a pioneering study of early Velasquez in *The Burlington Magazine* in 1906–07, explaining that 'The early works are darker and less vivacious than the later ones . . .

mainly solid painting with reliable unchanging pigments.'

Velasquez and Murillo formed the subjects of two of the most important books on Spanish painting, which both appeared in the 1880s – the catalogue of pictures by the two artists by the American, Charles B. Curtis, published in 1883, and Karl Justi's monograph on Velasquez, still in many ways much the best book on the painter, which was issued in German in 1888 and translated into English in the following year. Born in Pennsylvania in 1828, Curtis had been a captain with the New York volunteers in the American Civil War, and he later practised as a lawyer in New York. He describes in his catalogue his feelings on first visiting Spain: 'It happened that many years ago, in search of a new sensation, I turned my steps towards Spain. I found myself carried back in a day to the seventeenth century. I discovered a country that had preserved almost unchanged the habits, customs and traditions of a long-buried age.'

Without being exactly a lawyer's document, Curtis' catalogue has remained a mine of accurate information drawn from all the available sources about the works of the two artists. Of the two, Curtis seems to have given the preference to Murillo, though he was aware of the claims being made for Velasquez: 'It is much the fashion now-a-days with a certain class, to exalt Velasquez and decry Murillo. With such critics I have little sympathy. I find no difficulty in admiring both these artists . . . the best pictures of Murillo have sold, and will sell, for more than those of any artist except Raphael.' Curtis also declared, though his conviction was to prove unfounded, that 'Murillo has possessed, as without doubt he always will possess, the public esteem.'

The case for Velasquez was eloquently argued twelve years later in an influential, but perhaps of its kind rather over-rated book, by R.A.M. Stevenson (1847–1900), a painter and critic and cousin of Robert Louis Stevenson. *The Art of Velasquez* of 1895, as its title implies, is a book low on fact but giving a spirited impression of the character of Velasquez's art, rather in the manner in which the later portraits of Whistler and Sargent refer insubstantially in paint to Velasquez's work. Stevenson, like Ford and Stirling, compares Velasquez and Spanish painting, still in his view relatively neglected, with the classical tradition in Italy: 'You enter the Uffizi of Florence or the Academy of Venice with a crowd who look at their books no less than at the pictures. The Prado in Madrid is almost your own; a few students are there, and a

stray traveller like yourself but you may wander half a morning and see no other Englishman. . . . two hundred years after he had shown the mystery of light as God made it, we still hear that Velasquez was a sordid soul who never saw beauty, a mere master of technique, wholly lacking in imagination, so say those whose necks are stiff with looking at Italy and Raphael.'

Putting into words the nature of Velasquez's genius, an undertaking not easy to achieve, Stevenson concentrates on his handling of light and colour: 'This breadth of view led him in his later pictures to vary his manner of painting according to the sentiment of the impression, so that you will find in his work no pattern of brushwork, no settled degree of intimacy in the modelling, no constantly equal force of realisation in edges and no fixed habits or methods of expression . . . Greco opens a pit or hole of black asphalt [in his portraits]; Velasquez flushes the blacks of Menippus with a hundred nuances of greenish light . . . His colour is not the harmony of positive tints understood by a milliner, his brush changes with his impressions, as the tones of a man's voice with his emotion.'

Little is said by Stevenson about the strongly marked character of the society for which Velasquez worked, or the subject-matter of his paintings – the 'impressions' that caused his brush to 'change' – and the strict 'aestheticism' that prevailed in art appreciation until comparatively recent times weakens what would otherwise have been in its way a definitive book on the painter (one that still remains to be written on Velasquez, as on other Spanish painters). Among the most interesting passages in Stevenson's monograph are those in which he refers to the views of his own contemporaries in relation to the painter, beginning with a very illuminating comparison between 'Las Meninas' (fig.29) and religious painting in which he mentions those who had by then 'discovered' early Italian art: 'Could the gracious attitudes of these bending maids, the calm born pride of the Infanta, the solemn gravity of the environment, speak more eloquently to us if this were an Adoration of somebody by an early and religious Italian?'

Later on Stevenson reserves harsh words for conventional historical approaches to Velasquez and refers to the study of the painter that Sir John Lavery, like Whistler and Sargent before him, had made: 'Nothing astonishes a modern painter more than to see a historian ransack every gallery to find a precedent for the style of a hand in a picture, rather than to admit the possibility that an artist could choose one for himself in the vast magazine

of nature . . . It was some consolation, after leaving Madrid, to hear from the Scotch painter, Mr John Lavery, that he had not found six months of study and careful copying sufficient to settle his opinions on the pictures of Velasquez.' Finally Stevenson hints at the hostility of the Pre-Raphaelites to Velasquez and apparently compares the response of the Impressionists in France: 'he [Velasquez] could scarcely be expected to sympathise with the art of Raphael; and his outspokenness has been amply repaid in all ages by the frank dislike of all Raphaelites for his own work . . . English teaching has been contrary to the impressionism [sic], and Velasquez has not been sufficiently, or at any rate rightly, admired.'

With the gradual elevation of Velasquez more attention was also paid to the work of El Greco and Goya, whose styles are related in different ways to Velasquez's own, though as is the way in Spanish painting the three artists all represent extremes of their own particular kinds. Goya approaches Velasquez most obviously in the directness of his vision and El Greco in the liveliness of his brushwork. The attenuation of El Greco's figures, venerable and spiritual in its effect, is not unrelated to the aristocratic elongation in society portraiture in late Victorian England, and Sargent is recorded as the owner of an El Greco S. Martin, which he lent to the New Gallery Exhibition of 1895.

It was not, however, until 1908 that the first major book on El Greco was published, the pioneering Spanish monograph by Manuel B. Cossío, and a short book appeared on him in English in 1909 (by A. Calvert and C.G. Hartley). The first of El Greco's works in the National Gallery was the painting presented by Robinson in 1895 (fig.58) and the nation's first Goyas were purchased in Madrid one year later (Nos.66,67,71, figs.118, 119,123).

The first book in English on Goya, by William Rothenstein, was published in 1900, a brief account of his life interspersed with critical opinions: 'The humanity grafted on to the tree of beauty by the gentle Rembrandt, was cultivated by Goya in a more critical and aggressive spirit.' Goya had been relatively neglected in England during the course of the 19th century and appraisal of his prints was the cause of much dissension. Early collectors (Clarendon, Meade and Brackenbury) had shown some interest in his work and Ford and Stirling were moderately enthusiastic. By 1825, when many Spanish exiles were present in this country several sets of the *Caprichos* engravings are recorded here. In his book on Murillo, Bell Scott was surprisingly warm in his praise for Goya, but

many remained hostile and Ruskin apparently instigated the burning of a set of the *Caprichos* in 1872. One critic of the 1890s stressed the un-British character of the artist: 'Goya – who hesitates at nothing – does not commend himself to the ordinary Briton.'

In many ways Goya, Velasquez and other Spanish painters, are indeed not easily reconciled with the more obvious characteristics of British taste in the visual arts, and when Wilkie described the affinity betwen Velasquez and such painters as Reynolds and Raeburn, he overlooked the visual directness of Spanish art, to which English portraitists had rarely, even if they were capable, subjected the sitters in their portraits. Yet the 'secret sympathy' of the British for Spain, which Jardine described in the late 18th century was not merely a temporary phenomenon; the affection shown in Britain for the art of Spain, though not easy to define, appears not without its underlying reasons.

Only one study has been devoted to the elusive theme of the general character of Spanish art (by Oskar Hagen, 1943) and many of its outstanding qualities are well known, though what is also evident are the great extremes represented by the major painters – as Wilkie emphasized in his letters, Velasquez and Murillo seem totally unrelated. The sadness of Spanish art, dwelling often on death and the brevity of life (the 'tristeza española'), and the evidence it shows of pride, and stoicism (related to the concepts of 'caballerosidad' and 'sosiego') are amongst its most striking qualities. In style there is a tendency to ornamentation, little interest, even incompetence, in the use of perspective, but intensified concentration on the image to be represented, whether in portraiture, still-life or narrative compositions. Rather than any academic or aesthetic preconceptions the emphasis is upon religious or broadly 'ethical' purposes.

The absence of any clearly defined aesthetic discipline, supplied by the classical tradition in Italy and France, by the comprehensive 'naturalism' of the Netherlands, or the expressive priorities of German art, helps to explain the variety of painting in Spain within the generally accepted definitions of Spanish art, many of them more closely related to human than to purely artistic qualities. Murillo and Velasquez, though quite different as painters and in temperament, are alike to the extent that each was able to express his own view of the world uninhibited by the visual imperatives that prevailed elsewhere in Europe. Each conveys his own message with exceptional directness, that of Murillo being once as sympathetic as the art of Velasquez and Goya is today. No less extreme than

Murillo in its devotional character is the art of El Greco, although his painting has proved aesthetically more acceptable to modern taste.

One phenomenon that unites the work of Velasquez and Murillo is the incapacity shown by each painter to handle themes of violence. Neither was required to paint many dramatic subjects, but Murillo in such a picture as 'Joseph and his Brothers' (Wallace Collection) evidently had the same difficulties in conveying a moment of outward drama as Velasquez in his 'Joseph's coat brought to Jacob' (Escorial, fig.22), the painting that 18th-century visitors to Spain so much admired. The absence of any strong academic tradition in Spain must have been the main reason for painters neglecting the study of facial expressions, just as perspective itself was largely ignored. Unlike Murillo and Velasquez, Ribera showed his own extremism precisely in the depiction of violence, and he produced, shortly after his arrival in Italy, a number of curious etchings of details of facial expression. Goya too excelled at scenes of brutality and pathos, but of a directness that owed little to academic convention.

Like painting in Britain, Spanish art has been distinguished above all in portraiture. The absence of any strong tradition of landscape painting is, however, also one of the distinctive marks of painting in Spain, and likewise the brilliance of its still-life painting, an art almost unknown in Britain until a very late date. One obvious common factor is the absence in Britain, as in Spain, of an indigenous academic tradition, guiding painters and those who wrote about art, and it is significant that narrative was neglected in British painting until the later 18th century. The largely conventional views on art by travellers to Spain in those years were not immediately challenged, but after the Napoleonic Wars a writer like Ford, with all his conservatism and independence of mind, was able to consider Velasquez not in relation to Italian art but on his own very different merits. Believing that art in Europe had been 'cowed' by David, Ford's reaction against the classical tradition may not have been without strong political overtones, but Stirling too felt free to state his preference for Velasquez and Murillo and to diminish Raphael.

Though much Spanish painting is religious in purpose and decidedly Catholic in complexion, it nevertheless had a wide appeal to the puritan conscience of 19th-century Britain, as Stirling's own views demonstrate. This question was raised, probably by Ford, at the time of the Louis-Philippe sale: 'Our Protestant prejudices and predilections militate against subjects of a legendary, superstiti-

ous character.' Yet for Stirling the paintings of Zurbarán represented a more acceptable alternative to the luxuriance of the papal court, and for many who were not themselves Catholics, the more austere face of Spanish painting clearly coincided with their own ethical priorities. The sentimentality which is often seen to accompany extreme forms of puritanism could at the same time find expression in the worship of Murillo, which for long overlapped the rise of Velasquez and Zurbarán.

The declining fortunes of Murillo, and of Raphael and the painters of 17th-century Italy who were venerated long before him, is clearly reflected in the publications and exhibitions of the present century. The last book in English on Murillo was a volume in *The Spanish Series* (1907–12, and 1921), edited and many of them written by Albert F. Calvert, who also published several books about Australia and about Freemasonry. Calvert's volume on Murillo appeared in 1907, to be followed in 1908 by one on Goya, and in 1909 by his book on El Greco (the first English treatment of the painter), which was written jointly with Hartley. Velasquez was already known to British readers in the translation of Justi's monograph and in Stevenson's book, but there was little on Zurbarán until a translation which appeared in New York in 1918 of the pioneering monograph by J. Cascales y Muñoz (1911). The decline in interest in Ribera formed part of the general neglect of 17th-century Italian art; a book of 1908 by the German August L. Mayer, who proceeded in the 1920s and 30s to catalogue the works of Murillo, Goya, El Greco and Velasquez, was not followed up until 1952 (by Trapier). Early painting has been covered in depth in the many volumes of *A History of Spanish Painting* (1930–66) by the American scholar Chandler Rathfon Post. Up to the present day Goya is the Spanish painter who has had by far the most catalogues and books consecrated to his work.

Exhibitions devoted exclusively to the theme of Spanish art began with the show of almost 200 paintings and over 700 items of furniture and the applied arts at the New Gallery in London. This was followed by a smaller exhibition at the Guildhall in 1901, partly reserved for modern Spanish painting (nos.137–208), and one at the Grafton Galleries in 1913–14, with 193 Old Master paintings, drawn mainly from British collections. In 1920–21 the Royal Academy had its winter exhibition on the theme of Spanish painting, including a large group of the works of living artists, and in 1928 a Goya centenary exhibition was held at the Burlington Fine Arts Club. During the 1930s the public were able to see smaller exhibitions

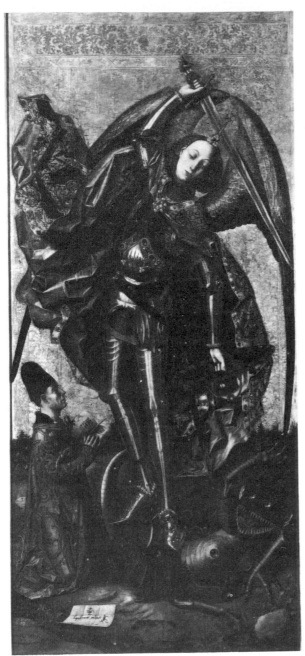

48. S. Michael, by Bartolomé Bermejo (active 1474–98) (Wernher collection, Luton Hoo). A major work by a Spanish 'primitive', imported about 1900.

49. Princess Beatrice (1908), by Joachím Sorolla y Bastida (1863–1923) (National Portrait Gallery). The sitter was the youngest daughter of Queen Victoria.

50. The Countess of Chinchón (detail), by Goya (1746–1828) (Duke of Sueca, Madrid). Exhibited at the Royal Academy, 1963–64.

mounted by the dealer, Tomás Harris, at his 'Spanish Art Gallery' (1931 and 1938).

In the early part of the century a wide range of Spanish painting and applied arts could be studied in the country, from the earliest to the most recent times, though Picasso was only very slowly accepted as a serious artist. One of the few undoubted masterpieces of 'primitive' painting, the 'S. Michael' by Bartolomé Bermejo (fig.48), was imported and acquired for the Wernher collection at Luton Hoo, and one of the most famous of living Spanish artists, Joaquín Sorolla y Bastida (1863–1923), 'the chief Spanish Impressionist', painted Princess Beatrice, the youngest daughter of Queen Victoria (fig.49).

Between the wars, El Greco finally took a prominent place amongst Spanish painters, partly for the curious reason that an affinity was seen between his work and that of Cézanne, who was also then slowly coming into fashion. Roger Fry in an essay of 1920 on El Greco stressed the 'unnaturalistic' character of his work, and wrote of Cézanne taking 'from El Greco his great discovery of the permeation of every part of the design with a uniform and continuous plastic theme.' Otherwise Spanish painting held little appeal for Fry, though in his short book on Spain (*A Sampler of Castille*, 1923) he excepted Velasquez: 'He dwelt entirely and completely in the realm of pure vision.' Further attention was drawn to El Greco in 1925, in *Southern Baroque Art* by Sacheverell Sitwell.

Like Fry, Aldous Huxley also devoted an essay to El Greco (in *Music at Night*, 1931). He had seen the so-called 'Dream of Philip II' from the Escorial (see fig.55, No.3) at the Royal Academy (presumably in 1920–21, no.30), and though feeling that it was not the best El Greco, he wrote at that time: 'I like it for the now sadly unorthodox reason that the subject interests me', adding later 'For myself I am very sorry that El Greco did not live to be as old as Titian. At eighty or ninety he would have been producing an almost abstract art – a cubism without cubes, organic, purely visceral.' The poet Roy Campbell, was also deeply impressed by El Greco in the early 1930s before the Spanish Civil War, as described in the pages of one of the latest and most moving of the many books about Spain – Laurie Lee's *As I Walked Out One Midsummer Morning* (1969).

Since the Second World War, exhibitions devoted to Spanish art have not become less frequent. A selection of the greatest paintings in this country and Ireland was organized by the Arts Council and shown at the National Gallery in 1947, and one at Edinburgh in 1951 had as its

nucleus many of the paintings from the Stirling collection. Some of the greatest of paintings by Goya, including many from private collections (fig.50), came to London in 1963–64 for the showing of Goya's art at the Royal Academy.

Other recent exhibitions have also been more concentrated in theme, or more even in their range. Many Spanish 'primitives' were included in an exhibition of Spanish painting at the Bowes Museum in 1967, while 'Richard Ford in Spain' was the theme of a display in London in 1974. A further exhibition at the Royal Academy, in 1976, covering 17th-century painting, was particularly memorable for the section showing still-life painting. The study of Spanish drawings, a field which tempted a few 19th-century collectors, especially Stirling, was reflected in exhibitions at the British Museum in 1976, and at the Courtauld Institute Galleries in 1978. A group of drawings that had passed from Stirling into the Witt collection were displayed there, and some were shown again in a small exhibition at Nottingham University in 1980 on the theme of 17th-century Spanish art.

One modern British painter who – like Reynolds

51. Study after Velasquez's portrait of Pope Innocent X (1953) by Francis Bacon (born 1909) (Des Moines Arts Center, Iowa). See fig.12.

52. Juan de Pareja, by Velasquez (Metropolitan Museum, New York) (before cleaning). Imported to this country before 1801, and sold in 1970 for £2,310,000.

before him – has studied Velasquez's portrait of Innocent X (fig.12) is Francis Bacon. Responding more directly than Reynolds to the sense of loneliness that is conferred by Velasquez on his sitters, Bacon adapted the portrait for a series of paintings dating from the 1950s and 60s (fig.51). The sense of suffering in Spanish painting is also conveyed by Stevie Smith, in her short poem 'Spanish School': 'The painters of Spain / Dipped their brushes in pain . . . Dr Péral / In a coat of grey / Has a way / With his mouth which seems to say / A lot / But nothing very good to hear' (fig.122).

Suffering and loneliness it may indeed affirm and assuage, for one of the great strengths of Spanish painting – conceived as it mainly was in relative freedom from preconception and academic restraint – is its power to speak directly from artist to spectator, and the infinity of feelings it can in consequence inspire. This is above all true of Velasquez, whose present position is well symbolized in the sale of his portrait of Juan de Pareja (fig.52), which fetched at auction in 1970 no less than £2,310,000, a price as surprising in its day as that realised by Murillo's 'Immaculate Conception' at the sale of the Soult collection in Paris in 1852.

44

Catalogue

Note Measurements are given in centimetres, height preceding width. Some have been translated from inches and are only approximate. In many cases inscriptions and signatures are not given in full, though all dates are noted.

The principal catalogues of artists' works are included under *References* together with important articles, but the bibliographies are intended as a guide, not a complete survey of the literature.

In the lists of exhibitions those devoted to Spanish art are preceded by their date, and appear in the survey of Spanish exhibitions that follows the bibliography at the end of the catalogue.

El Greco, Morales and Tristán

The genius of El Greco was not fully recognised until the start of the present century, and his work is in consequence not fully represented in Britain, where there are, for example, no large-scale altarpieces by the painter. Yet some pictures of his were in British collections from the middle years of the 19th century, and one is recorded here in the 17th century (collection of the 2nd Duke of Buckingham).

The paintings of El Greco's early years, reflecting his training in Venice and stylistically akin to the late work of Titian, were those which early critics preferred: 'He imitated Titian and Tintoretto, but was very unequal; thus what he did *well* was excellent, while what he did ill was worse than anybody else' (Richard Ford, 1845). The spiritual expressiveness of El Greco's later work was understandably unacceptable to those brought up to venerate Titian. Indeed it was probably the secular atmosphere of Renaissance Italy that induced El Greco to settle in Spain, in the city of Toledo.

The overwhelmingly devotional character of 16th-century Spanish painting is familar from the work of Luis Morales, 'the Divine Morales' (died 1586), almost the only early Spanish artist whose paintings, usually on a small scale, circulated widely and were much coveted. During Morales' lifetime, however, painters like Sánchez Coello, working for Philip II (1556–98), distinguished themselves in portraiture, while religious painting for the king was largely entrusted to Italians.

El Greco found no real favour at the Court, but he established a short-lived school at Toledo, where Luis Tristán (1586?–1624) produced curiously 'realistic' variants of several of El Greco's famous compositions until well into the 17th century. The striking piety of El Greco's work was echoed in the later 17th century, though with a far more human emphasis, by Murillo.

Luis de MORALES (died 1586)

Born probably about 1520 in Badajoz, Estremadura, and largely active in that area of Spain. The earliest known work is of 1546. Morales specialized in the repetition of small devotional compositions, influenced (somewhat erratically) by both Northern and Italian painting. According to Ford, Morales was known as the 'Parmigianino of Spain'.

1. *The Virgin and Child*

The Ashmolean Museum, Oxford
Panel, 43 × 29cm

In the collection of Sir Augustus Daniel (1866–1950), a Trustee and later Director of the National Gallery (1929–33).

An example of one of the most attractive of Morales' compositions, apparently influenced by Dürer, but unusual in the introduction of the hat, one of several apparently contemporary features of the Virgin's dress, which is not unlike a halo in its effect.

Several related compositions by Morales are known, including ones known as the 'Virgen del Sombrero' or 'del Sombrerete', the presence of the hat conveying an added meaning in allusion to the journey of the Holy Family to Egypt. A painting in the National Gallery (no.1229), of which variants are in the Prado, Madrid (nos.944 and 2686), is alike in the treatment of the Child. The Ashmolean painting is probably a relatively late work, and is dated by Bäcksbacka to the early 1570s.

PROVENANCE: Garriga collection (?), 1890; Sir

53 (No.1). The Virgin and Child, by Luis de Morales (died 1586) (Ashmolean Museum, Oxford). Morales was one of the few early Spanish painters whose works were much collected.

Augustus M. Daniel; acquired by the Ashmolean Museum from Messrs. Colnaghi, 1954.
EXHIBITED: 1913–14, Grafton Galleries, no.22A (not included in the catalogue); *Paintings by Old Masters*, Colnaghi, London, 1954, no.5.
REFERENCES: Colnaghi exhibition catalogue, 1954; J. A. Gaya Nuño, *Luis de Morales*, 1961, nos. 3,6,7 and 9 (related compositions); Ashmolean catalogue, 1961, p.102; I. Bäcksbacka, *Luis de Morales*, 1962, no.77.

Figure 53

Luis de MORALES (died 1586)

2. *The Virgin mourning over the dead Christ*
Lt. Col. William Stirling of Keir
Panel, 43.5 × 31cm

Bought for William Stirling at the Standish sale, 1853, and finest of three paintings of the *Pietà* ascribed to Morales that he apparently owned.

The ascetic side of Morales' work, which looks forward to the spiritual austerity in El Greco, expressed itself in such subjects as Christ bearing the Cross, Christ as Man of Sorrows, and the Virgin mourning the dead Christ, of all of which many variations and versions have survived. Morales' treatments of the first subject are amongst those most indebted to Italian art, while the second two derive from Netherlandish painting.

Related paintings to No.2, which is not apparently featured in the literature on Morales, are in the Episcopal Palace, Madrid, and the Church of

54 (No.2). The Virgin mourning over the dead Christ, by Morales (Stirling collection, Keir). Showing the more typical, ascetic character of Morales art, which anticipates El Greco.

Las Teresas, Seville. The composition is also related to paintings by Morales which show a three-quarter length Christ (Academy of San Fernando, Madrid), and the 'Lamentation beneath the Cross' (Museo Provincial, Salamanca). A variant of a similar composition, but with the figure of Christ in reverse and including the heads of the Magdalen and S. John (Hastings Wheler collection) was apparently one of the three pictures in the Stirling collection. The third is the picture forming part of the Pollok House collection, which is also closely related to No.2 in composition.

PROVENANCE: Frank Hall Standish; King Louis-Philippe; Standish sale, 27 May 1853, lot 65.

EXHIBITED: Spanish Gallery, Standish collection, Louvre 1841–48, no.108 (the size given there, 44 × 32 cm. is that of the present painting); apparently not exhibited since then.

REFERENCES: D. Angulo Iñíguez in *Archivo español de Arte*, 1950, p.255 (the Hastings Wheler picture, which is close in size to no.145 in the Spanish Gallery of Louis-Philippe); J.A. Gaya Nuño, *Luis de Morales*, 1961, pls.26 and 38 (related paintings in Madrid and Seville); I. Bäcksbacka, *Luis de Morales*, 1962, nos.61 and A36 (Hastings Weler and Pollok pictures).

Figure 54

El GRECO (1541–1614)

Domenikos Theotokopoulos, known as Domenico Greco, and in Spain as *el Griego* ('the Greek'). Born in Crete and trained in Venice, he was in Rome from 1570 and in Toledo from 1577, where he died. A peculiarity of El Greco's work is the extent to which he produced repetitions and variations of many of his compositions.

3. *'The Adoration of the Name of Jesus'*

The National Gallery
Panel, 57.8 × 34.2cm
Signed in Greek capitals, bottom left.

Bought at the sale of King Louis-Philippe's Spanish Gallery in London (1853) for William Stirling.

Probably a repetition of, rather than a sketch for, the larger canvas painting in the Escorial of the later 1570s, known as 'The Dream of Philip II'. King Philip is shown kneeling in the foreground, with the Pope and the Doge of Venice, and to the right is the artist's haunting representation of Hell. His signature appears, as though attached to the drapery of a cloak, in the opposite corner. The composition probably refers to the Holy League of

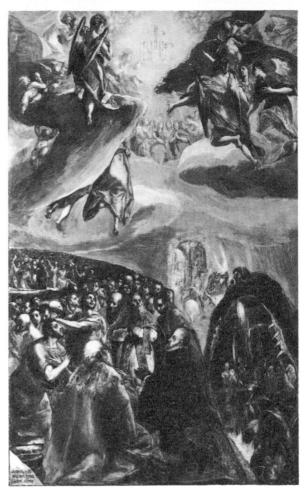

55 (No.3). 'The Adoration of the Name of Jesus', by El Greco (National Gallery). Corresponding with the larger painting in the Escorial, and probably an allegory of the victory of Lepanto (1571).

Spain, Rome and Venice which defeated the Turks at Lepanto (1571).

The Escorial picture was possibly commissioned by the king in 1578 on the death of his illegitimate brother, Don Juan, the victor of Lepanto, who may be represented in the figure with raised arms on the left of the Pope. Except for the 'Martyrdom of S. Maurice' (of the early 1580s) no other works are known to have been painted by El Greco for the king.

The composition was formerly known as the 'Gloria' of El Greco, alluding to the famous 'Gloria', now in the Prado, that Titian had painted for King Philip's father, Charles V. The theme of the adoration of the Holy Name is based on Philippians, ii, 9–10, while the tradition of representing Hell as a sea inhabited by Leviathan derives from

medieval art, lingering, especially in northern Europe, until the 16th century. Leviathan is placed in dramatic proximity to the figure of the king, but the sense of the picture would appear to be that those who participated in the Holy League would thus escape damnation.

In format the National Gallery picture is narrower than that of the Escorial, and some of the figures in the larger composition are omitted. It is close in size to the following picture (No.4), which corresponds with another of El Greco's major early paintings in Spain, the 'Espolio'. An old inventory number, *76*, in white paint is present in the bottom right corner; the black dress of King Philip II is considerably repainted.

PROVENANCE: probably in the collection of Don Luis Méndez de Haro y Guzmán, second Conde-Duque de Olivares (died 1661) passing by inheritance to the Dukes of Alba; in that collection probably at least until the time of the Napoleonic Wars; Louis-Philippe sale, Christie's, 7 May 1853, lot 112 (£31); bought from Lt. Col. W.J. Stirling of Keir, for the National Gallery in 1955.

EXHIBITED: Spanish Gallery, Louvre, 1838–48, no.256; 1895–96, New Gallery, no.173; 1928, Burlington Fine Arts Club; 1938, Spanish Art Gallery, no.1; 1947, Arts Council, no.13; 1951, Edinburgh, no.18.

REFERENCES: Cossío, 1908, no.337 (dating the picture, 1594–1604); Mayer, 1926, no.123a (dating: 1580–82); A. Blunt in *The Journal of the Warburg and Courtauld Institutes*, 1939–40, III, nos.1–2, p.58 (identification of the subject matter); Camón Aznar, 1950, no.261 (dating: 1576–77); Wethey, 1962, no.116 (as a finished study for the Escorial picture, datable about 1578); *National Gallery Catalogues, Acquisitions* 1953–62, p.53; MacLaren and Braham, 1970, p.27.

Figure 55

El GRECO (1541–1614)

4. *The Disrobing of Christ ('El Espolio')*

The National Trust
(Bearsted collection, Upton House)
Panel, 55.3 × 31.6cm (excluding later strips at top and sides)
Traces of signature on the paper, bottom right, in Greek cursive letters.

In Paris in the early 19th century, where it belonged to Delacroix, and to Baron Schwiter, the subject of Delacroix's full-length portrait in the National Gallery (no.3286).

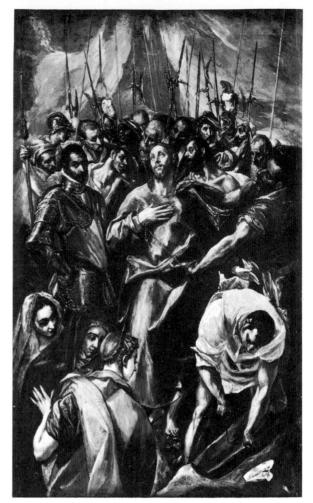

56 (No.4). The Disrobing of Christ (before cleaning), by El Greco (National Trust, Bearsted collection, Upton House). A small version of the famous painting 'El Espolio' in Toledo Cathedral.

The most brilliant of several surviving small versions of the picture in the Sacristy of Toledo cathedral, which El Greco painted shortly after his arrival in Spain (1577–78). The subject is inherently suited to the decoration of a sacristy and the artist, apparently on his own initiative, added to its pathos by introducing the figures of the three Maries (bottom left), to which the cathedral authorities objected on the grounds that the Maries were not present at the event. They also complained that the heads of the tormentors were shown at a higher level than the head of Christ. The soldier to the left of Christ, who plays no active part in the mocking, may represent S. Longinus.

This present version of the 'Espolio' is unlikely to have been a sketch, at least in the sense of being produced for the guidance of El Greco's patrons, as

it corresponds closely with the larger painting and includes the details which were considered objectionable. If not a sketch, then the painting is presumably an autograph record of the Cathedral painting, matching No.3 above in size and in technique.

Though the picture shows evidence of Byzantine and Venetian inspiration in composition and in style, the subject of the mocking of Christ, lending itself to exaggeration and caricature, was more popular in northern Europe than in the south, and the strikingly expressive group of the tormentors seems northern in character. The man preparing the Cross (lower left) recalls figures by Michelangelo and Tintoretto ('Marriage at Cana', in the Salute, Venice). A personal identification with the subject may be present, as is often the case in El Greco's work, in the prominent and unusual presentation of the signature, in this case upon a crumpled sheet of paper placed beside the Cross.

Cleaned in 1981.

PROVENANCE: Don Gaspar Méndez de Haro y Guzmán (died 1687), whose initials are inscribed on the back of the panel and who probably inherited the picture, together with the preceding, from his father; thence to the Alba collection, and there probably at least until the time of the Napoleonic Wars; Eugène Delacroix, Paris; Baron Schwiter sale, Paris, 3 May 1886, lot 10; Chéramy sale, Paris, 5 May 1908, lot 77; Ducrey, Paris; Messrs. Wildenstein, Paris, 1938; Bearsted collection.

EXHIBITED: *Greek Art*, Royal Academy, London, 1946, no.351; Bearsted and Cook collections exhibition, Whitechapel Art Gallery, London, 1948, no.19; *The Bearsted Collection*, Whitechapel Art Gallery, 1955, no.38; 1980, Nottingham University, no.6.

REFERENCES: Cossío, 1908, no.294; Mayer, 1926, no.73 (dating the picture to 1581–82); Camón Aznar, 1950, no.150 (dating: 1580); J.M. de Azcárate, *Archivo español de Arte*, 1955, p.189 (the subject-matter and the authority of S. Bonaventure for the inclusion of the three Maries); Wethey, 1962, no.80 (dating: about 1577–80, and, 2, pp.51–54, on the commission and the subject); Harris Frankfort and Troutman in Nottingham 1980 exhibition catalogue, p.11 (possibly painted before the completion of the Cathedral picture).

Figure 56

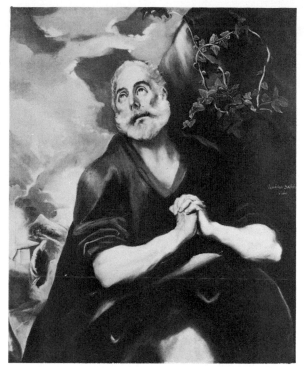

57 (No.5). 'The Tears of S. Peter', by El Greco (Bowes Museum). One of several famous compositions by El Greco of saints in penitence.

El GRECO (1541–1614)

5. *'The Tears of S. Peter'*

The Bowes Museum, Barnard Castle
Canvas, 108 × 89.6cm
Signed in cursive Greek letters, centre right.

Purchased by John Bowes from the Conde del Quinto collection in Paris in 1869.

Several versions by El Greco of this composition have survived, and of these the present example is the earliest in date, probably of the later 1580s, and perhaps El Greco's first essay in the subject. The theme itself, reflecting the importance of repentance and confession in the programme of the Counter-Reformation, became very popular in the early part of the 17th century, as Ribera's very different interpretation of the subject in the present exhibition (No.18) may serve to show.

With characteristic theological and visual acumen, El Greco appears to have combined two episodes of Holy Week in the picture, the image of the repentant S. Peter and, in the background, Christ's Resurrection. The angel of the Lord rolling back the stone of the Sepulchre is described in Matthew, xxviii, 3 ('His countenance was like

lightning, and his raiment white as snow'), while the particular involvement of Peter in this phase of the story, with the Magdalen running to tell him the news, is recounted in John, xx, 1–10.

The miracle of the Resurrection is suggested in the treatment of the sky and in its relation to the figure of S. Peter, as he kneels (?) with clasped hands and eyes upturned. The rock, where the artist's signature appears, probably refers symbolically to S. Peter, and the ivy (which is more prominent in the later versions of the composition), must also have a special significance in the context of the picture, probably its traditional association with eternity (being evergreen), and endurance or affection.

PROVENANCE: Conde del Quinto sale catalogue, Paris, 1862, no.62; purchased by Bowes from Gogué for 200 francs, 16 April 1869.

EXHIBITED: 1913–14, Grafton Galleries, no.117; on loan to the National Gallery, 1920–27; *North East Coast Exhibition*, Newcastle, 1929, no.309; *Masterpieces from the Collections of Yorkshire and Durham*, Leeds, 1936, no.8; 1947, Arts Council, no.14; *Pictures from the Bowes Museum*, Agnew's, London, 1952, no.26; *The Triumph of Mannerism*, Amsterdam, 1955, no.59; Bowes Museum exhibitions, Arts Council, 1959, no.38, and 1962, no.76; *Between Renaissance and Baroque*, Manchester, 1965, no.130; 1967, Bowes Museum, no.24.

REFERENCES: Mayer, 1926, no.202 (dating the picture to 1583–86); J. López-Rey in *Art in America*, 35, 1947, pp.313–18 (the general character of the subject); Camón Aznar, 1950, 1, p.602; Wethey, 1962, no.269 (dating the picture to about 1585–90); Young, 1970, pp.38–40 (with full bibliography, and notes on the subject and on the signature).

Figure 57

El GRECO (1541–1614)

6. *Christ driving the Traders from the Temple*

The National Gallery
Canvas, 106.3 × 129.7cm

First recorded in this country in 1877, the picture was presented by Sir J.C. Robinson, former Superintendent of the Victoria and Albert Museum, in 1895, and was the first El Greco to enter the National collection.

The figures to the right of Christ probably represent a group of the Apostles, including S. Peter in blue and yellow in the foreground; the reliefs between the columns show the Expulsion from Paradise (left), and the Sacrifice of Isaac (right). Several versions of the composition exist of which the National Gallery picture and a closely related painting in the Frick collection, New York, are probably of about 1600. Though the subject, taken

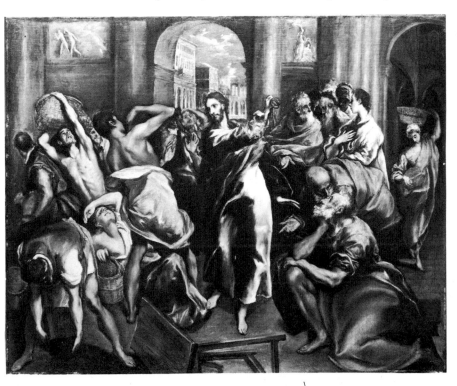

58 (No.6). Christ driving the Traders from the Temple, by El Greco (National Gallery). The first El Greco in the National Gallery collection (1895).

from Matthew, xxi, 12–13, was not uncommon in the 16th century, it may well have symbolized the purification of the Church during the period of the Counter-Reformation, and as such would have been likely to appeal especially to El Greco.

The subject was one that preoccupied the artist throughout his career. The latest version of the theme is the picture in the church of S. Ginés, Madrid, painted at the very end of his life, while the two earliest, at Washington and Minneapolis (the picture belonging in the 17th century to the Duke of Buckingham, fig.10) probably both date from the period before El Greco's arrival in Spain. The architectural background, which is alike in all but the S. Ginés version of the picture, combines a vista of apparently Venetian inspiration with a more Roman structure that is not unlike a triumphal arch in its effect. Of the two reliefs between the columns, the Sacrifice of Isaac is often depicted as the Old Testament prototype of the Crucifixion, and it probably stands here for Redemption; the Expulsion from Paradise is presumably related to the 'unredeemed' traders on the left of the composition.

The poses of the traders and of the other figures in the composition are mainly adapted from the works of famous Italian masters of the 16th century, as is particularly clear from the early version of the composition in Washington. Christ himself recalls, in reverse, the central figure of Titian's 'Transfiguration' in San Salvatore, Venice, and the trader beside him, with upraised arm, is taken from Michelangelo's 'Conversion of S. Paul' in the Vatican (Cappella Paolina). Other traders resemble figures in Michelangelo's 'Last Judgement', and in his series of drawings showing the Purification of the Temple. The stooping trader in the left foreground is close to the figure, also derived from Michelangelo, in the foreground of the 'Espolio' (see No.4 above). Portraits of Michelangelo, Titian, Raphael and Giulio Clovio occur in the right foreground of the early version of the composition now at Minneapolis, painters to whom El Greco was artistically indebted, but whose presence in the context of this particular subject, reflecting El Greco's own professional self-consciousness, may not be wholly flattering.

PROVENANCE: possibly identifiable with one of the paintings of the same subject in the inventories of El Greco and his son, 1614 and 1621; anonymous sale, Christie's, 30 June 1877, lot 63 (£25. 4s. 0d.), bought by Sir J.C. Robinson, by whom presented, 1895.

EXHIBITED: 1947, Arts Council, no.11; Cleaned pictures exhibition, National Gallery, 1947, no.46.

REFERENCES: Cossío, 1908, no.342 (dating the picture 1584–94); Mayer, 1926, no.53 (dating: after 1604); Camón Aznar 1950, no.86; Wethey, 1962, no.108 (dating: about 1600–05); MacLaren and Braham, 1970, pp.24–27.

Figure 58

El GRECO (1541–1614)

7. *Portrait of a Man*

Glasgow Museums and Art Galleries,
Stirling Maxwell collection, Pollok House.
Canvas, 74.6 × 47.3cm
Signed, upper right, in cursive Greek letters; the signature abbreviated or partly cut away.

One of two portraits by El Greco bought for Wil-

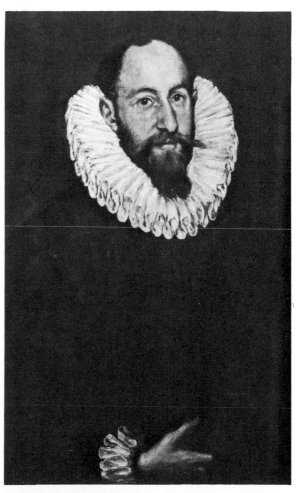

59 (No. 7). Portrait of a Man, by El Greco (Glasgow Museums, Pollok House). One of two famous El Greco portraits in the collection of William Stirling.

liam Stirling at the sale of the Louis-Philippe collection, 1853.

The second of the two Pollok House portraits, 'A Lady in a Fur Wrap', is an attractive but earlier and less typical example of El Greco's perhaps rather unexpected genius as a portrait painter, which appears to advantage in his narrative masterpiece, 'The Burial of the Conde de Orgaz' (1586–88, Santo Tomé, Toledo). The present portrait is relatively late in date, probably of the 1590s.

Though striking in design, and in the relation of head to hand, the composition is unusual in its narrow format and has probably been somewhat cut down at the top and sides, as the truncation of the signature in any case suggests. The lower part of the picture including the hand is painted on a different and apparently later strip of canvas (about 17.2cm. high).

Cleaned and restored in 1970. An old inventory number apparently '*10*', appears in the bottom left corner.

PROVENANCE: bought for William Stirling at the Louis-Philippe sale, Christie's, 6 May 1853, lot 22; by descent Mrs Anne Maxwell Macdonald, by whom presented, 1966 (the Pollok Gift).

EXHIBITED: Spanish Gallery, Louvre, 1838–48, no.267; 1913–14, Grafton Galleries, no.126; National Gallery of Scotland, 1922; 1928, Burlington Fine Arts Club; 1938, Spanish Art Gallery, no.4; 1947, Arts Council, no.15; 1951, Edinburgh, no.19; *Art Treasures Centenary*, Manchester, 1957, no.150; *Paintings from Pollok House*, Glasgow,

1960–61; Glasgow Art Gallery 1977, no.46; *Paintings from Glasgow Art Gallery*, Wildenstein, London, 1980, no.15.

REFERENCES: Cossío, 1908, no.347 (dating the picture, 1594–1604); Mayer, 1926, no.347b (dating: 1592–97); Caw, 1936, no.13; Camón Aznar, 1950, no.747 (dating: 1590); MacLaren in Arts Council Spanish Paintings exhibition catalogue, 1947, p.12 (addition of strip at base; dating: about 1590–1600); Wethey, 1962, no.141 (picture slightly cut on all sides; dating: about 1595–1600); Auld, no.17; Macartney, forthcoming Stirling collection catalogue.

Figure 59

El GRECO (1541–1614)

8. *Allegorical Night Scene*

The Earl of Harewood
Canvas, 71 × 92cm
Signed in cursive Greek letters, centre right.

Said to have been brought from Spain by a British soldier in the early nineteenth century.

Two versions of this unusual and obscure composition by El Greco survive in the British Isles (see No.9 below). A related design by El Greco, also known in more than one version, shows only the boy lighting a candle, the central figure of the present painting. The Harewood picture is probably a work of the later 1570s, produced shortly after El Greco's arrival in Spain. In these night scenes the

60 (No.8). Allegorical Night Scene, by El Greco (Earl of Harewood). Probably a moral or religious allegory, which has not so far been fully explained.

influence of Venetian painting, and more especially the work of the Bassano family, is apparent.

It is generally believed that the scene illustrates a saying or a proverb, probably one with a distinct moral significance, connected with conflagration, discord, and perhaps metaphorically with evil, as a consequence of blowing on fire (not unrelated to the English expression 'fanning the flames'). The unlikely figures beside the boy lighting the candle presumably represent an elaboration, perhaps El Greco's own, of this theme – a chained monkey, perhaps standing for evil, or at least mischief, and a grinning, apparently foolish, youth. The theme of a boy blowing on fire was known to have been painted in ancient Greece.

The two compositions may be connected with items listed in El Greco's inventory as 'El Soplon' and 'Fabula'. Pictures of a very similar subject – tending to confirm their moral significance – are recorded in the 1611 inventory of Beato Juan Ribera, Archbishop of Valencia.

Restored in 1957, when additions to the canvas were removed.

PROVENANCE: possibly taken from Spain to Britain in the early 19th century; S.E. Bensusan, Essex (by whom, alternatively, acquired in Spain); acquired from the Carfax Galleries by the 5th Earl of Harewood (1846–1929).
EXHIBITED: 1951, Edinburgh, no.22.
REFERENCES: Cossío, 1908, no.343; Mayer, 1926, no.304 (dating: 1576–77); T. Borenius, *Catalogue of the Pictures and Drawings at Harewood House . . .* ,

1936, pp.47–48; E. Harris, *The Burlington Magazine*, 1951, p.313 (the subject matter); Robres Lluch, *Archivo español de Arte*, 1954, p.254 (Archbishop Ribera's inventory); Wethey, 1962, no.125 (2, pp.78 and 81, the subject matter); J. Bialostocki in *Arte in Europa* (essays in honour of Edoardo Arslan), 1966, pp.591–95 (antique precedents).

Figure 60

El GRECO (1541–1614)

9. *Allegorical Night Scene*

Private collection, on loan to the National Gallery of Scotland.
Canvas, 66 × 88cm

Imported to England in the present century; formerly in Paris and Berlin.
The picture is close in composition to the preceding, so that differences in technique are clearly defined. A period of several years must divide the two pictures, of which the second is probably of the earlier 1580s.

PROVENANCE: Féret, Paris; C. Cherfils, Paris; James Simon, Berlin (no.49 in the 1927 catalogue of the collection).
EXHIBITED: 1931, Tomás Harris, p.10; 1938, Spanish Art Gallery, no.3.
REFERENCES: Cossío, 1908, no.296 (dating: 1571–76); Mayer, 1926, no.305 (dating: 1576–78; and with confused provenance, corrected by Mayer in

61 (No.9). Allegorical Night Scene, by El Greco (Private collection, on loan to the National Gallery of Scotland). A later variant by El Greco of No.8 (fig.60).

62 (No.10). The Adoration of the Shepherds, by Luis Tristán (1586?–1624) (Fitzwilliam Museum, Cambridge). An altarpiece of 1620 by the most famous follower of El Greco.

Pantheon, 1930, p.182); Camón Aznar, 1950, no.689 (dating: 1580; and with confused provenance); Wethey, 1962, no.126 (dating: about 1585–90); see also references for No.8.

Figure 61

Luis TRISTAN (1586?–1624)

A native of Toledo, where he was chiefly active, Tristán is reasonably considered to have been a pupil of El Greco, probably in the early 1600s. In their greater 'realism' his paintings occasionally recall early works by Velasquez, whom he has been said to have influenced. Tristán was commended by Stirling (1848) for avoiding 'the hard unblending streaks of colour, the narrow gleams of light and the blue unhealthy flesh tints' of El Greco.

10. *The Adoration of the Shepherds*

The Fitzwilliam Museum, Cambridge
Canvas, 231 × 113cm
Signed in capitals, lower right, and dated 1620.

One of several paintings by Tristán in the collection of King Louis-Philippe, sold in London in 1853.

The picture recalls El Greco in its tall and narrow shape and in the general character of the design, which resembles in particular the 'Adoration of the Shepherds' now in Bucharest, which El Greco painted in 1596–1600. Like other artists of the early 17th century, Tristán emphasizes the rustic character of this particular subject. He includes many details (animals, etc.) that El Greco had excluded, and, less mystical in his approach than El Greco, he allows the angels to appear only in the air.

A companion painting, 'The Adoration of the Kings', also signed and dated 1620 and corresponding in size, is in the Museum at Budapest (no.6373). This was also in the collection of Louis-Philippe, together with a series of four slightly smaller paintings, a Pentecost, a Crucifixion, a Resurrection and another Adoration of the Kings, which is now at Pollok House (bought for William Stirling at the Louis-Philippe sale). One of the paintings by Tristán over the high altar of the church at Yepes, near Toledo is closely related in composition to the Fitzwilliam picture.

The site for which the Fitzwilliam and the Budapest canvases were painted is unclear. The Louis-Philippe sale catalogue describes two of the Tristáns, the Fitzwilliam picture and the one now at Pollok House, as having come in each case from

a convent at Toledo. It has been suggested that the convent may have been that of the Hieronymite nuns, known as La Reina, where the high altar, recorded in the 18th century, was decorated with paintings by Tristán of the four main church festivals: Christmas, Epiphany, Easter and Pentecost. The Christmas and Epiphany scenes may be identical with the Fitzwilliam and Budapest picture though the remaining two have since disappeared; alternatively the four smaller pictures in the Louis-Philippe collection may be those from the altarpiece, if the subjects were incorrectly recorded in the early sources.

The scroll inscribed: GLO[RI]A IN EXCELSIS DEO ET IN TE[RR]A PAX.

PROVENANCE: see above; Louis-Philippe sale, London, 6 May 1853, lot 27, bought Haines; bequeathed by Charles Brinsley Marley, 1912.

EXHIBITED: Spanish Gallery, Louvre, 1838–48, no.272.

REFERENCES: W.G. Constable, *The Burlington Magazine*, 1925 2, p.291; Andor Pigler in Budapest Museum Catalogue, 1954, p.579, and 1967, p.709 (with further bibliography); Gaya Nuño, 1958, no.2734; J.W. Goodison and Denys Sutton in the Fitzwilliam Museum Catalogue, 1, 1960, p.217; Auld, no.64 (Pollok painting).

Figure 62

Early Velasquez, Ribalta and Ribera

The earliest works of Velasquez, painted before he left Seville to reside permanently in Madrid in 1623, at the age of twenty-four, form a unique series in the history of European painting, and many of the best of them are now in collections in Britain and Ireland. Eclipsed in fame by his later paintings and by works of Murillo, they were not amongst the most coveted Spanish pictures until the period of the Peninsular War, and several were acquired at this time by British diplomats and soldiers serving in Spain. The most celebrated of the series, 'The Water-seller of Seville', was one of the paintings captured by the Duke of Wellington from Joseph Bonaparte after the Battle of Vitoria (1813).

Though related to the revolutionary art of Caravaggio (1573–1610), and to scenes of everyday life by recent Italian painters like Annibale Carracci (1560–1609), Velasquez's genre scenes (called in Spain *bodegones*) show so intense a response to the world seen by the artist as to make them a group unrivalled of their kind in 17th-century art. Following much the same approach to religious subjects in these years, Velasquez created images of unusually moving directness, as in the National Gallery's 'S. John', or 'The Adoration of the Kings' of 1619 (Prado, Madrid), which is the largest and most ambitious of his earliest paintings.

A more conventional Spanish artist, also indebted at this time to new developments in Italian painting, was Francisco Ribalta. Many years older than Velasquez, he became increasingly receptive to the work of Caravaggio, who was a decisive influence on the more famous painter, who was probably his pupil, Jusepe de Ribera.

An artist whose career was passed in Italy, mainly in Naples, where he had settled by 1616, Ribera was internationally more famous than his Spanish contemporaries. Paintings by him and those marked by his distinctive style (including early works by Luca Giordano) circulated widely in Europe. Appreciation of his great professional ability was often clouded by repugnance for his subject matter, and especially for his scenes of martyrdom, which survive mainly in Naples and Madrid. Overlooking the more attractive of his works, Richard Ford (1845) warned visitors to the Prado against Ribera: 'this cruel forcible imitator of ordinary ill-selected nature, riots in hard ascetic monks and blood-boltered subjects, in which this painter of the bigot, inquisitor and executioner delighted.'

Francisco RIBALTA (1565–1628)

Born at Solsona in Catalonia, Ribalta was active in Madrid after 1582 and from 1599 he worked in Valencia. His earlier pictures are influenced by Navarrete and other painters working at the Escorial in the later 16th century, but from the 1610s his style reflects knowledge of Caravaggio. He was probably the teacher of Ribera, who left Valencia at an early age and settled in Italy. According to Ford (1845), who owned a famous example of his work (No.11), Ribalta was regarded as the Annibale Carracci and the Sebastiano del Piombo of Spain.

11. *The Vision of Father Simón*

The National Gallery
Canvas, 211 × 110.5cm
Signed on the scroll, lower left, and dated 1612.

Bought in 1831 from the Pescuera collection at Valencia by Richard Ford, who described it in a letter as 'a stupendous picture, and of the very grandest finest class, and worth £500'.

Father Simón (1578–1612) was the priest of S. Andrés in Valencia, locally venerated for his piety and asceticism and for a vision that he frequently experienced of Christ carrying the Cross followed by the Virgin and S. John, accompanied by trumpeters. After his death application was made to Rome for his beatification, but without success. In his treatment of the subject, Ribalta had the guidance of paintings by Sebastiano del Piombo showing 'Christ descending to Limbo' (now Prado, Madrid) and 'Christ carrying the Cross', though his approach is more 'realistic' than Sebastiano's and particular in its detail.

Ribalta was an able portraitist, and in 1613 three pictures of Father Simón were commissioned from him (one each for King Philip III, for his first minister, the Duke of Lerma, and for the Pope). An engraving, by Michel Lasne after Ribalta, was also published of Simón, which shows in addition seventeen scenes of his life. The present painting is probably the one commissioned for the chapel in S. Andrés where Father Simón was buried, which was dedicated on 5 September 1612.

PROVENANCE: probably in S. Andrés, Valencia, in 1612 (see above); bought by Richard Ford from the Pescuera collection, Valencia, 1831; in Richard Ford's sale, London, 9 June 1836, lot 44, but bought in; by descent to Captain Richard Ford, from whom purchased, 1912.

EXHIBITED: British Institution, 1852, no.101; Royal Academy, 1873, no.104; 1895–96, New Gallery, no.50; National Loans Exhibition, Grafton Galleries, 1909–10, no.26; on loan to The National Gallery, 1910–13; Cleaned Pictures, The National Gallery, 1947, no.47; 1967, Bowes Museum, no.33; 1980, Nottingham University, no.22.

REFERENCES: Ford, 1905, p.58 (acquisition of picture); D. Fitz Darby, *Ribalta and his School*, 1938, pp.54–55; Gaya Nuño, 1958, no.2255; MacLaren and Braham, 1970, pp.87–91 (with further bibliography).

Figure 63

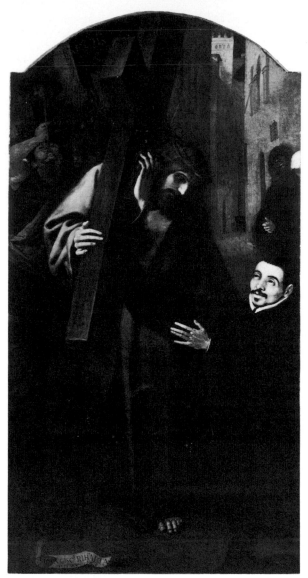

63 (No.11). The Vision of Father Simón, by Francisco Ribalta (1565–1628) (National Gallery). Dated 1612, and probably painted for Father Simón's funeral chapel.

56

Diego VELASQUEZ (1599–1660)

Diego Rodríguez de Silva Velázquez, born in Seville, and trained by Franciso Pacheco, whose daughter he married in 1618. He visited Madrid in 1622 and resided there from 1623, working for King Philip IV, and securing a series of court appointments. In 1629–31 he visited Italy, and again in 1649–51. He was made a Knight of Santiago in 1659, and died in Madrid in the following year (6 August).

12. *Kitchen Scene with Christ in the House of Martha and Mary*

The National Gallery
Canvas, 60 × 103.5cm

The remains of a date, 1618, discovered during cleaning in 1965, are present near the right edge.

From the Packe collection, and possibly acquired in Spain during the Peninsular War by Lt. Col. Henry Packe.

One of a group of *bodegones* with prominent still-life and half-length figures, all of Velasquez's Sevillian period, and all of an unusual horizontal format, more commonly associated with engravings or with canvases over door cases. The scene in the background illustrates the story of Martha and Mary (Luke, x, 38–42), and is related thematically to the preparation of food shown in the foreground kitchen where garlic, red peppers, fish and eggs, executed with conspicuous virtuosity, are laid out.

The idea for the composition probably derived from a Netherlandish 16th-century engraving; kitchen scenes frequently occur in pictures by Joachim Beuckelaer and Pieter Aertsen (by whom a related painting of Martha and Mary of 1552 is in Vienna). An engraving resembling Velasquez's composition, after Aertsen, shows a woman cleaning fish in a kitchen with the Supper at Emmaus in the background.

Another of Velasquez's horizontal *bodegones*, 'The Kitchen Maid' in the Beit collection, shows the Supper at Emmaus in the background, visible through a hatch. This and the National Gallery painting may be the earliest of the *bodegones*, the artist later omitting the biblical scenes that had served in the 16th century to justify the kitchen scene. The precise relation of the foreground and background figures in the National Gallery picture is unclear. It has been suggested that the old woman on the left, with head covered like Martha in the background, is also a representation of Martha. She closely resembles the woman cooking eggs in the following picture, where several of the same utensils also appear.

PROVENANCE: in the Lt. Col. Packe (deceased) sale, London, 18 June 1881, lot 18 (21 guineas); bought by Sir William H. Gregory by whom bequeathed, 1892.
EXHIBITED: 1947, Arts Council, no.28; *Velázquez y lo velazqueño*, Madrid, 1961, no.35.
REFERENCES: Mayer, 1936, no.9; López-Rey, 1963, no.8; MacLaren and Braham, 1970, pp.121–25.

Figure 64

64 (No.12). Kitchen Scene with Christ in the House of Martha and Mary, by Velasquez (National Gallery). Dated 1618, and one of the earliest works of the painter.

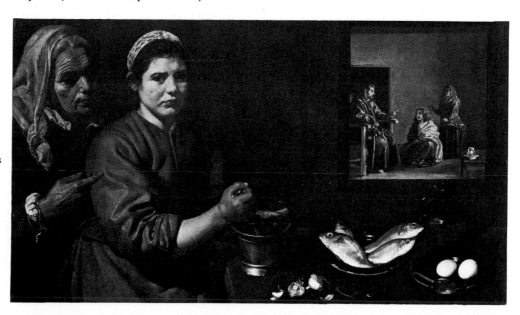

Diego VELASQUEZ (1599–1660)

13. *An Old Woman cooking Eggs*

The National Galleries of Scotland.
Canvas, 100.5 × 119.5cm
The remains of a date, 1618, discovered during cleaning in 1957, are present, bottom right.

Probably in London by 1813, in a sale where the picture was said to have been exported from Spain by the French dealer, Jean-Baptiste Le Brun.

Conspicuous amongst the early *bodegones* for the range of objects represented, the picture has also a suggestion of narrative, of direct communication between the figures, which Velasquez's style was never best adapted to convey. The old woman resembles the woman on the left in the previous painting, and several of the utensils are alike. The boy recalls the boy receiving water in the 'Waterseller' (No.15), and would appear to be of much the same age.

A detailed description of a woman frying eggs for a young boy occurs in Matheo Alemán's novel *Guzmán de Alfarache* (translated into English in 1623), and it may be that this and other such picaresque novels (which had originated with Lazarillo de Tormes), were not without their influence on Velasquez's *bodegones*.

PROVENANCE: most probably the picture of 'A woman poaching eggs' etc. in the Woollett sale, London, 8 May 1813, lot 45, bought Peach; later with a London dealer and in a Bradford collection from which the picture was acquired in 1863 by (Sir) J.C. Robinson, passing shortly thereafter to (Sir) Francis Cook; by descent in the Cook collection; purchased from Sir Francis Cook and the Trustees of the Cook collection, 1955.

EXHIBITED: Royal Academy, London, 1873, no.93; 1895–96, New Gallery, no.135; 1901, Guildhall, no.102; Loans exhibition, Grafton Galleries, 1909–10, no.32; 1913–14, Grafton Galleries, no.47; Burlington Fine Arts Club, 1936–37, no.22; on loan to the Toledo Museum of Art, Ohio, 1944–45; 1947, Arts Council, no.38; on loan to the Fitzwilliam Museum, Cambridge, 1947–55.

REFERENCES: J.C. Robinson, *The Burlington Magazine*, 1906, p.178; Mayer, 1936, no.111; D. Baxandall, *The Burlington Magazine*, 1951, pp.156–57 (discovery of the date); López-Rey, 1963, no.108; Brigstocke, 1978, pp.176–79 (with translation from *Gúzman de Alfarache*).

Figure 65

65 (No.13). An old woman cooking eggs, by Velasquez (National Galleries of Scotland). Also dated 1618, and one of the most elaborate of the early kitchen scenes of Velasquez.

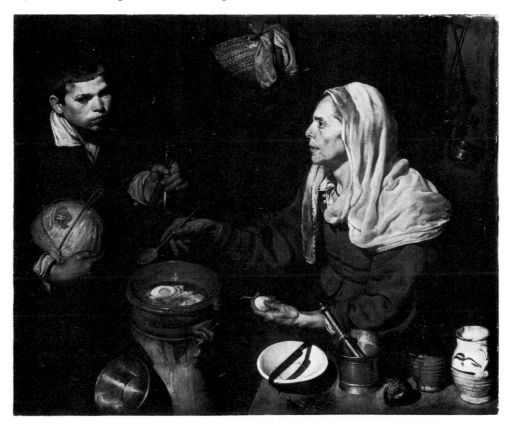

Diego VELASQUEZ (1599–1660)

14. *Two young men eating at a Humble Table*

The Wellington Museum (Apsley House)
Canvas, 65.3 × 101cm

One of the pictures from the Spanish royal collection captured by the Duke of Wellington from Joseph Bonaparte at the Battle of Vitoria, 1813.

The most discreet of the surviving *bodegones* in subject matter, the picture appears less thickly painted in consequence of the disposition of the figures. The canvas is more finely woven than that used for the majority of Velasquez's early works. As in the 'Water-seller' (No.15) the grouping, especially of the kitchen utensils, is denser than in Nos.12 and 13, though the figures are not in direct communication with each other. The table is placed to the left, as in the 'Water-seller', and the perspective is lower.

The picture is one of the *bodegones* of Velasquez mentioned by Antonio Palomino in his *Museo Pictórico* (vol.3, 1724), where the naturalism of the work is praised: 'He painted another picture of two poor men eating at a humble table where there are different earthenware vessels, oranges, bread and other things, everything observed with rare thoroughness.'
Cleaned in 1958.

PROVENANCE: one of 29 paintings bought from the Marquis of Ensenada by King Charles III of Spain in 1769; in the King's retiring room in the Royal Palace of Madrid (1772); captured by Wellington at Vitoria, 1813, and presented by Ferdinand VII; Duke of Wellington Bequest, 1947.

EXHIBITED: Royal Academy, London, 1888, no.125; 1895–96, New Gallery, no.73; 1901, Guildhall, no.103; 1913–14, Grafton Galleries, no.45; 1947, Arts Council, no.39.
REFERENCES: Palomino, 1724, 3, p.480; Ponz, 1776, 6, p.34; Ceán Bermúdez, 1800, 5, p.178; Curtis, 1883, no.85; Mayer, 1936, no.109 (dating: about 1619–20); López-Rey, 1963, no.105; Kauffmann, forthcoming Apsley House catalogue (with full bibliography).

Figure 66

Diego VELASQUEZ (1599–1660)

15. *The Water-seller of Seville*

The Wellington Museum (Apsley House)
Canvas, 106.7 × 81cm

From the Spanish royal collection; captured from Joseph Bonaparte by the Duke of Wellington at the Battle of Vitoria, 1813.

The most famous, and visually the most coherent, of the early *bodegones* of Velasquez. The composition, as in other masterpieces of early 17th-century art, is subordinated to one dominant feature – the water-seller and his great jar, which forms the main theme of the picture. The care taken in the design of the principal figure is indicated by many changes now visible through the paint (in his collar, sleeves and both hands). Like the old woman cooking eggs (No.13), the water-seller is shown in strict profile, but both he and the boy to whom he passes the glass here look downwards, giving the picture a reflective, almost sacramental, mood.

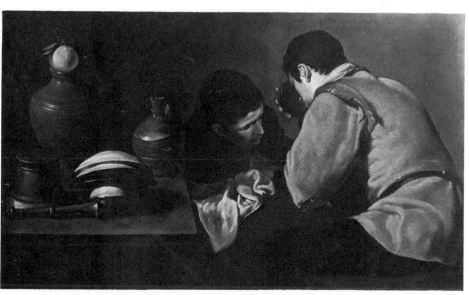

66 (No.14). Two young men eating at a Humble Table, by Velasquez (Wellington Museum, Apsley House). One of the paintings captured by the Duke of Wellington after the Battle of Vitoria (1813).

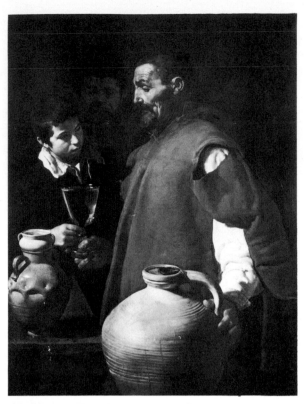

67 (No.15). The Water-seller of Seville, by Velasquez (Wellington Museum, Apsley House). The most famous of the early *bodegones* of Velasquez, also captured by the Duke of Wellington in 1813.

King Philip IV; Buen Retiro Palace, Madrid; Royal Palace, Madrid (1772 inventory, no.497, hanging in the passage to the king's pew; and 1794 inventory, in the king's dining room); captured by the Duke of Wellington at Vitoria, 1813; Duke of Wellington bequest 1947.

EXHIBITED: British Institution, 1828, no.46, and 1847, no.121; Royal Manchester Institution, 1834, no.121; Royal Academy, London, 1886, no.119; 1895–96, New Gallery, no.134; 1901, Guildhall, no.100; National loan exhibition, Grafton Galleries, 1909–10, no.31; 1913–14, Grafton Galleries, no.49; 1928, Burlington Fine Arts Club; *17th century art in Europe*, Royal Academy, 1938, no.219; 1947, Arts Council, no.37; *Velázquez y lo velazqueño*, Madrid, 1960 no.40; *Man and his world*, Montreal, 1967, no.35.

REFERENCES: Palomino, 1724, 3, pp.892–93; Cumberland, 1782, 2, p.6; Ceán Bermúdez, 1800, 5, pp.158, 178; Waagen, 1854, 2, p.276; Stirling, 1848, 2, p.580; Curtis, 1883, no.486 (dating: about 1620); Mayer, 1936, no.118 (dating: about 1618); J. López Navio, *Archivo español de Arte*, 1961, p.64 (Fonseca collection); López-Rey, 1963, no.124 (dating: about 1619–20; p.30, use of figs in water); J. Gallego, *Velázquez en Sevilla* 1974, pp.99–100, and J.F. Moffitt in *Traza y Baza. Cuadernos hispanos de simbología, arte y literatura*, 1978, pp.5–23 (interpretations of the subject matter); Kauffmann, forthcoming Apsley House catalogue (with full bibliography; dating: about 1620)

Figure 67

The fig is present in the glass to freshen the water.

The 'Water-seller' was acquired by Velasquez's early admirer in Madrid, Don Juan Fonseca y Figueroa, who was chaplain to King Philip IV. When Fonseca died in 1627, Velasquez made the appraisal of his collection and valued the 'Water-seller' (at 400 *reales)* higher than any other work that he owned. In early inventories of the royal collection, the 'Water-seller' is named as El Corzo, the Corsican. The picture was already famous in the early 18th century and 'so talked of' according to Palomino (1724), 'that it has been kept to this day in the Buen Retiro palace'.

According to a recent interpretation, the painting has been said to represent an allegory of providence, illustrated by the Three Ages of Man.

Cleaned in 1959; an old inventory number, lower left, apparently corresponding with the 1772 Madrid Palace inventory.

PROVENANCE: Juan Fonseca y Figueroa, Madrid (died 1627); Gaspar de Bracamonte; said to have passed into the Spanish royal collection through the Infante Don Fernando (died 1641) brother of

Diego VELASQUEZ (1599–1660)

16. *S. John the Evangelist on the Island of Patmos*

The National Gallery
Canvas, 135.5 × 102.2cm

Acquired in Seville by Bartholomew Frere, British Minister there in 1809–10, and imported before 1813.

S. John is shown on the island of Patmos, engaged in writing the Book of Revelation. His eagle sits to the left and in the sky is the vision of the Woman of the Apocalypse with the dragon. The painting was possibly commissioned, together with 'The Immaculate Conception' (No.39), for the convent of the Shod Carmelites in Seville, where it is first recorded in 1800. Though normally shown as an old man at the time of writing Revelation, Velasquez chose a young model to pose for the saint, similar to those represented is some of the *bodegones*.

68 (No.16). S. John the Evangelist on the Island of Patmos, by Velasquez (National Gallery). Companion painting to No.39 (fig.91) and one of the earliest of Velasquez's relatively few religious compositions.

The artist's habit of wiping his brush clean on the primed surface of the canvas is clearly visible in the S. John in the marks in the sky to the right and on the rock where the eagle is poised.

The picture is closely related in theme to 'The Immaculate Conception' (see under No.39 below) since S. John's vision of the Woman of the Apocalypse was regarded as one of the indications of the Virgin's unstained birth. Velasquez's representation of the Woman, a type of subject foreign to his work, is painted on a small scale and almost diagrammatically: 'a woman clothed with the sun, and the moon under her feet, and upon her head a crown of twelve stars: And she being with child cried, travailing in birth, and pained to be delivered. And there appeared another wonder in heaven; and behold a great red dragon, having seven heads and ten horns, and seven crowns upon his heads. And his tail drew the third part of the stars of heaven . . . And to the woman were given two wings of a great eagle, that she might fly into the wilderness' S. John's vision was of particular relevance to the Carmelites as a proof of the

Immaculate Conception because of its analogies with Elijah's visions on Mount Carmel.

The 'S. John' and 'The Immaculate Conception' probably date from late in Velasquez's Sevillian period, from the period after 'The Adoration of the Magi' of 1619.

Cleaned and restored in 1946.

PROVENANCE: recorded, together with 'The Immaculate Conception' in the Chapter House of the Convent of the Shod Carmelites in Seville, 1800; acquired by Don Manuel López Cepero, Dean of Seville Cathedral, and sold to Bartholomew Frere, Minister Plenipotentiary *ad interim* at Seville, November 1809 to January 1810; imported by 1813 and by descent to Mrs Woodall and the Misses Frere, from whom purchased with the aid of a Special Grant and contributions from the Pilgrim Trust and the National Art-Collections Fund, 1956.

EXHIBITED: Royal Academy, 1910, no.47; 1947, Arts Council, no.26; *Velázquez y lo velazqueño*, Madrid, 1961, no.31.

REFERENCES: Curtis, 1883, no.19; Mayer, 1936, no.35; *National Gallery Catalogues, Acquisitions 1953–1962*, p.82; López-Rey, 1963, no.29; MacLaren and Braham, 1970, p.129 (with further references); see also under No.39, below.

Figure 68

Jusepe de RIBERA (1591?–1652)

Born at Játiva near Valencia, and probably trained by Ribalta, Ribera had moved to Italy by 1610–15, when he is recorded in Rome. By 1616 he had settled in Naples, where he worked for the Spanish Viceroys and many of the religious foundations of the city. Known in Italy as 'Lo Spagnoletto', Ribera became a major and influential figure in his adopted country, noted for the unsqueamish character of his art, which slowly evolved away from the sombre idiom of Ribalta.

17. *S. Paul with a Sword and a Book*

The Trustees of the Chatsworth Settlement
Canvas, 74.3 × 61cm

Presumably acquired, like most of the foreign paintings at Chatsworth, in the earlier 18th century.

An early work, probably of the later 1610s, notable for the density of the design, and the psychological concentration of the figure, holding his sword in his right hand, and reading from a scroll.

A group of paintings of saints, showing heads

69 (No.17). S. Paul with a Sword and a Book, by Jusepe de Ribera (1591?–1652) (Trustees of the Chatsworth Settlement). An early work by Ribalta's main pupil, who passed his working life in Naples.

and shoulders, are known from the period of Ribera's early years in Italy. A related figure of S. Paul, though looking out from the canvas, occurs in a picture of SS. Peter and Paul at Strasbourg (Musée des Beaux-Arts), of which the authorship has, in the past, been questioned.

PROVENANCE: possibly acquired by the 2nd Duke of Devonshire (1673–1729), or from Lord Burlington through the marriage of the 4th Duke to Burlington's daughter in 1748 (see No.27).

EXHIBITED: Chatsworth Exhibition, The Graves Art Gallery, Sheffield, 1948–49, no.14 (as possibly school of Ribera).

REFERENCES: apparently not recorded in the literature on Ribera; Spinosa, 1978, nos.13 (painting at Strasbourg), and 8–12 (comparable compositions).

Figure 69

Jusepe de RIBERA (1591?–1652)

18. S. Peter

Glasgow Museum and Art Gallery
Canvas, 124.2 × 97.8cm
Signed and dated, 1628

In a collection in Perth in 1904; previous history so far unknown.

S. Peter in penitence became a popular theme for painting in the early years of the 17th century (see El Greco, No.5). Ribera's interpretation, which possibly shows S. Peter's denial of Christ, is notably forceful, the saint far from idealized in feature and with wide-open mouth. His key is prominently displayed, but held away from his body and, like a possession of disputed ownership, not firmly grasped.

The comparatively elaborate form of the signature ('Jusepe de Ribera, Spaniard, of Valencia. Painted at Naples, 1628'), apparently differing in some details from Ribera's usual spelling, suggests that the client was an important one, or the picture one to which the artist himself attached particular significance. Other versions of the composition are

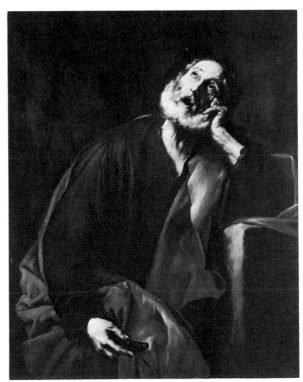

70 (No.18). S. Peter, by Ribera (Glasgow Museum and Art Gallery). Dated 1628, and showing the 'realism' for which Ribera was famous.

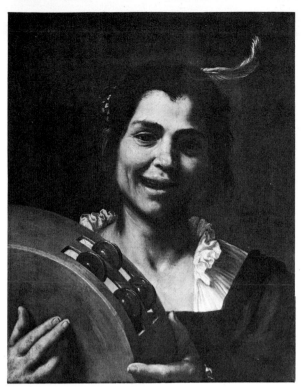

71 (No.19). A Girl with a Tambourine, by Ribera (Mr and Mrs R.E.A. Drey). Dated 1637, and one of several 'low-life' paintings by Ribera.

known and a related design in reverse is recorded in two variants.

PROVENANCE: bought from A.G. Preston, Perth, in 1904.

EXHIBITED: *Primitives to Picasso*, Royal Academy, 1962, no.95.

REFERENCES: Glasgow Art Galleries and Museums catalogue, ed. 1935, p.272; Gaya Nuño, 1958, no.2274; Spinosa, 1978, no.341, and nos.339–40, 342–43 (related compositions).

Figure 70

Jusepe de RIBERA (1591?–1652)

19. *A Girl with a Tambourine*

Mr and Mrs R.E.A. Drey
Canvas, 59.1 × 45.1cm.
Signed on the right, and dated, 1637

Imported to this country before 1938.

Related to other portrayals of musicians in early 17th-century art, like those of Terbrugghen and Honthorst, the picture also has an element of the grotesque in the facial distortion of the singer, which contributes to the vivacity of the image. Characteristic of the later work of Ribera is the less sombre colouring. Such images by Ribera recall, in their 'picaresque' character, the low-life paintings produced by Murillo in the later 17th century, and they are not unrelated to Velasquez's unsmiling, more objective, representations of court dwarfs.

PROVENANCE: Private collection, Paris; Spanish Art Gallery London; Drey collection.

EXHIBITED: 1938, Spanish Art Gallery, no.9; 1947, Arts Council, no.24; 1951, Edinburgh, no.33; *Stora Spanska Mästare*, Stockholm, 1959–60, no.82; *Neapolitan Baroque and Rococo Painting*, Bowes Museum, 1962, no.7; 1967, Bowes Museum, no.35; *Painting in Focus: Velázquez, The Rokeby Venus*, The National Gallery, 1976.

REFERENCES: Gaya Nuño, 1958, no.2318; Spinosa, 1978, no.114.

Figure 71

Painting at Court

An unusually large proportion of Spanish paintings were created to meet the needs of the Court, mainly portraits of the – sometimes bizarre – Spanish kings, members of their families, and prominent courtiers. Though eclipsed in fame by Velasquez, many other distinguished Spanish painters were employed in what was almost an industry of royal portrait manufacture, beginning with Sánchez Coello in the later 16th century, and continuing until the French domination of the Court in the early 18th century. A surprising number of such portraits survive in Britain, though many show themselves to be mainly the work of studio assistants.

The Court itself was radically changed in 1548, when the Emperor Charles V, the first Hapsburg king of Spain, introduced there the elaborate ceremony of the court of Burgundy. The stifling formality of court manners, a source of wonder to later visitors to the Peninsula, was alleviated by such official pastimes as hunting, and at times by frivolity and immorality of which the public – and the Inquisition – remained in ignorance.

Madrid, lying in the centre of the Peninsula, was chosen as the capital city by Charles' son, King Philip II, in 1561, and the castle there, the old Alcázar, was adapted as the principal seat of the Court. It was here that Velasquez had his studio and where, towards the end of his life, he painted 'Las Meninas' (1656). Showing the painter himself and his sitters in one of the larger rooms of the palace, the picture hauntingly conveys the atmosphere of court life in the middle years of the 17th century.

After the War of the Spanish Succession (1700–12), the Bourbon dynasty replaced the Hapsburgs in the person of Philip V and the Alcázar was not long after destroyed by fire (1734). Many paintings, including court portraits, perished in the fire, but furnishings that had been saved were evacuated to other royal residences in and near Madrid until the new Madrid palace, designed by Italians, was completed (1764).

Alonso SANCHEZ COELLO (1531–88)

Born in Benifayó, Valencia, but trained in Lisbon and Brussels, where he was a pupil of Sir Anthony Mor, the Netherlandish painter in the service of King Philip II. Sánchez Coello returned to Spain by 1555, and served Philip II mainly as a portraitist, following in his own distinctive manner the

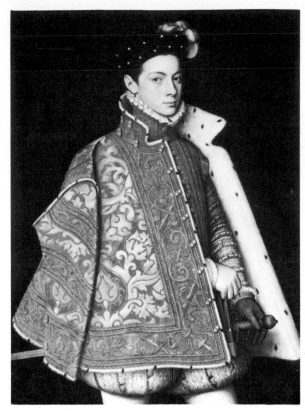

72 (No.20). Alessandro Farnese, Duke of Parma, by Alonso Sánchez Coello (1531–88) (National Gallery of Ireland). An early picture by the chief portrait painter of King Philip II of Spain (1556–98).

examples of Titian and Mor. A favourite of the King, Sánchez Coello was known in the 19th century as 'the Velasquez of the court of Philip II'.

20. *Alessandro Farnese, Duke of Parma*

The National Gallery of Ireland
Canvas, 108.5 × 80.5cm.

Acquired for Dublin in Rome, 1864.

Alessandro Farnese (1545–92), the famous general and statesman in the service of Philip II, was a great-grandson of Pope Paul III. Born in Rome and brought up in Spain and the Netherlands, he is the subject of portraits by Tintoretto and Mor, as well as by Sánchez Coello. The portrait at Dublin, one of the artist's masterpieces, dates from the earlier part of the sitter's residence at Madrid in 1559–65. It resembles a full-length portrait of the same sitter by Mor, dating from 1557 (Parma Gallery), while being far more static and ornamental in character.

The portrait may have been taken to Italy

(Opposite) Velasquez, *Philip IV of Spain in brown and silver* (detail), No.23

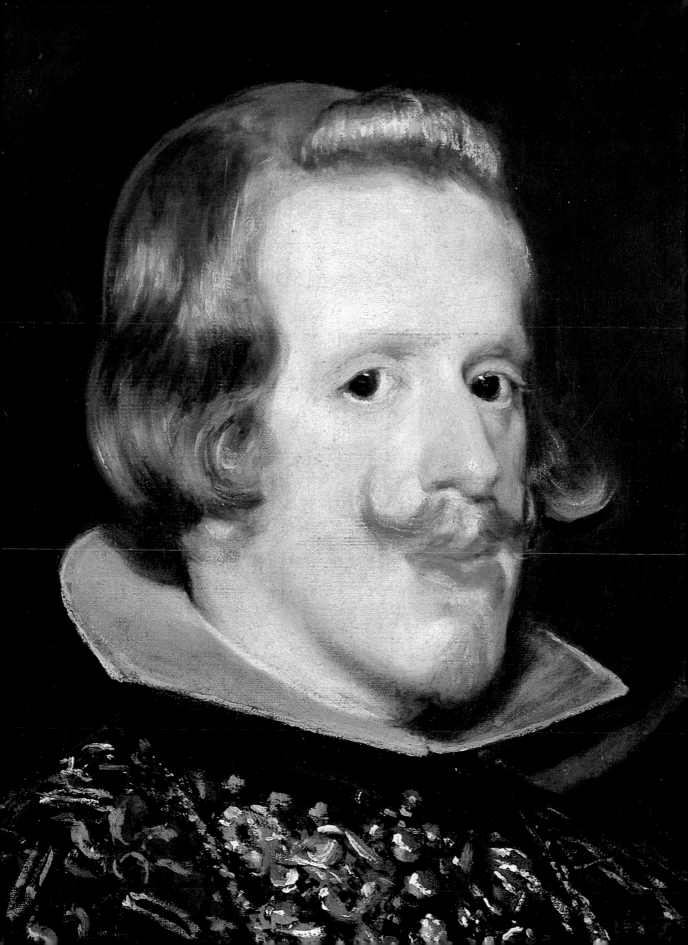

shortly after its completion, for the design was adapted by Federico Zuccaro for a portrait of Alessandro Farnese which he introduced in one of the frescoes, painted in 1562–63, in the 'Sala dei fasti farnesiani' in the Farnese palace at Caprarola near Rome. The fresco shows Pope Julius III creating Ottavio Farnese, Alessandro's father, Lord of Parma, an event dating from 1550, when Alessandro was some ten years younger than the age at which he is shown in Sánchez Coello's portrait and in the fresco.

Cleaned in 1967.

PROVENANCE: unknown before 1864, when bought in Rome.
EXHIBITED: 1913–14, Grafton Galleries, no.109; *Flandres, Espagne, Portugal du XVe au XVIIe siècle*, Bordeaux, 1954, no.101; *Centenary Exhibition*, National Gallery of Ireland, Dublin, 1964, no.56.
REFERENCES: 1928 Dublin catalogue, p.24; F.M. Kelly, in *The Burlington Magazine*, June 1934, p.278 and *Apollo*, August 1937, p.74; Gaya Nuño, 1958, no. 2588; Michael Wynne, in *Aurea Parma*, 1960, 3, and 1968, 1–2 (for full discussion of the portrait, and further references).

Figure 72

Alonso SANCHEZ COELLO (1531–88)

21. *The Infante Don Diego, son of King Philip II*

Private collection
Canvas, 111 × 91cm.
Inscribed at the top with the sitter's name; signed on the door jamb, left, and dated, 1577.

Bought at the Louis-Philippe sale in London, 1853, for Thomas Baring.

Don Diego was born on 12 July 1575 and can be no more than 2 years old in the portrait; in accordance with the fashion of the time, he is dressed in skirts. Until 1570 when he married Queen Maria of Austria as his fourth wife, Philip II had no surviving male heir. Don Diego, the fourth son of this marriage, was to die in 1582, and the throne was inherited by his younger brother, Philip (born 1578). The toys carried by Don Diego, unusual in a child portrait of the time and contrasting with his female dress, presumably refer, in hope, to his future as warrior and king.

The mastery of the horse as an analogy with kingship was a familiar idea in the 16th century, and one which persisted in equestrian portraits of the 17th century (see No.24). Hopes for the survival of Don Diego and his future welfare appear to

73 (No.21). The Infante Don Diego, son of Philip II, by Alonso Sánchez Coello (Private collection). Dated 1577 and showing the prince at the age of two, dressed in skirts.

be reflected in the presentation of the sitter, who wears around his neck two gold chains with a medallion of the Virgin and Child, a crucifix, a heart and other ornaments.

Noting that works by Sánchez Coello were seldom seen outside Spain, Waagen said of this picture in 1857: 'The truth . . . of every portion, and the care of the execution, are worthy of the high reputation as a portrait-painter which Coello bore at the Court of Philip II.'

PROVENANCE: Louis-Philippe sale, London, 7 May 1853, lot 146 (as the Infanta Fernando, daughter of Philip II); bought by Graves (64 guineas) for Thomas Baring; bequeathed (1873) to his nephew, Lord Northbrook.
EXHIBITED: Spanish Gallery, Louvre, 1838–48, no.73 (as the Infante Fernando); 1913–14, Grafton Galleries, no.139.
REFERENCES: Waagen, 1857, p.96; Northbrook collection catalogues, by Lord Ronald Gower, 1885, pp.9–10, and by Jean Paul Richter, 1889, pp.180–81; Gaya Nuño, 1958, no.2586.

Figure 73

(Opposite) Zurbarán, *S. Francis in Meditation* (detail), No.33

74 (No.22). Doña Juana de Salinas (before cleaning), ascribed to Juan Pantoga de la Cruz (about 1553–1608) (National Gallery of Ireland). Probably of about 1600 and attributed to the main pupil of Sánchez Coello.

Ascribed to Juan PANTOJA DE LA CRUZ (about 1553–1608)

Born in Valladolid, and trained by Sánchez Coello, Pantoja became court painter to Philip II in 1596 and then to Philip III (1598–1621), specializing in portraits but also executing some religious works. He died in Madrid. 'His style', according to Stirling (1848), 'much resembles that of his master, Sanchez Coello, and is more remarkable for care and finish than for force and freedom'.

22. *Doña Juana de Salinas*

The National Gallery of Ireland
Canvas, 105 × 82cm

In Ireland (Powerscourt collection) in the later 19th century.

The elaborate ruff and dress suggest a date around 1600. Far from overwhelmed by her costume, the sitter is shown discreetly smiling, unlike the sitters in contemporary royal portraits. Her right hand is emphasized in the design, the sitter probably showing off the ring on her finger rather than pointing to

the floor. Her identification is based upon an inscription on the reverse of the canvas.

This was apparently written in the early 19th century, when the picture was in the Carderera collection, but it may well record a traditional identification: 'DOÑA JUANA DE SALINAS/Señora de la Revilla/Coll de D Vⁿ Carderera'. The attribution of the portrait is questioned by Kusche, who relates it to a painting in the Prado (no.1037), possibly of Isabella of Bourbon. In quality it seems to exceed the more routine work of Pantoja.

Cleaned in 1981.

PROVENANCE: Carderera collection; Viscount Powerscourt; bought in Dublin, 1920.
EXHIBITED: 1967, Bowes Museum, no.23.
REFERENCES: 1928 Dublin catalogue, p.100; Gaya Nuño, 1958 no.2135; Kusche, 1964, p.209.

Figure 74

Diego VELASQUEZ (1599–1660)

23. *Philip IV of Spain in brown and silver*

The National Gallery
Canvas, 199.5 × 113cm
Signed on the paper in the sitter's hand.

Probably the picture removed from the Library at the Escorial for Joseph Bonaparte, which came into the possession of William Beckford, who had admired the paintings of Velasquez at the Escorial in 1787.

Philip IV, son of Philip III, was born in 1605 and ascended the throne in 1621. His reign witnessed the gradual decline of Spain as a European power. He wears in Velasquez's portrait, painted in the early 1630s and showing signs of many alterations, the simple collar (*golilla*) that had replaced the ruff in Spain, but the costume is otherwise unusually elaborate, the king normally preferring to wear black. Few of Velasquez's paintings are signed and this is the only portrait of the king bearing his signature, which is included 'naturalistically' in the form of a petition. The king is apparently standing in the pose he usually adopted for receiving petitions.

A portrait of the king painted by Rubens on his visit to Spain in 1628–29 and now in Genoa (Durazzo Giustiniani collection) shows the king in almost exactly the same pose. Velasquez's portrait, which must have been begun shortly after returning from his first visit to Italy (1629–31), seems to have been followed for the majority of other portraits of the king produced in Velasquez's studio during the 1630s, including one at Vienna (sent

there in September 1632), the portrait of the king as a huntsman of about 1635 (Prado, Madrid), and the much weaker portrait at Hampton Court (probably the one sent to England in 1639, fig.6). The many changes visible in the picture include the lowering of the cloak, altered positions of the right leg and the left foot, and a different angle for the point of the sword.

The picture was probably installed in the Library of the Escorial in the later 17th century, as part of a series showing four kings of Spain, of which Charles V and Philip III by Pantoja de la Cruz, and Philip II in the style of Pantoja are still *in situ*. One of the few English visitors to comment on the picture in the Escorial was Lady Holland

who, in 1803 before the nature of Velasquez's style was well understood, doubted the attribution, commenting that the picture was 'out of all drawing especially the right leg'.

PROVENANCE: almost certainly identifiable with the picture removed from the Library of the Escorial in November 1809 for Joseph Bonaparte and given by him to General Dessolle in January 1812; sold by Dessolle's daughter to Woodburn, presumably after her father's death in 1828, and acquired by William Beckford, passing by inheritance to the 10th Duke of Hamilton; bought for the National Gallery at the Hamilton sale, 17 June *sqq.*, 1882, lot 1142, at 6000 guineas.

EXHIBITED: 1947, Arts Council, no.31; Cleaned Pictures Exhibition, The National Gallery, 1947, no.62.

REFERENCES: Lady Holland, p.141; Curtis, 1883, no.117; Mayer, 1936, no.216; López-Rey, 1963, no.245; G. de Andrés, *Archivo español de Arte*, 1967, pp.360ff. (early history of the picture); MacLaren and Braham, 1970, pp.114–19; Mary Crawford Volk (forthcoming publication with reference to the significance of the king's pose).

Figure 75

Diego VELASQUEZ (1599–1660)

24. *Prince Baltasar Carlos ('The Riding School')*

The Duke of Westminster
Canvas, 144 × 91cm.

First recorded in this country in the sale catalogue of the collection of Welbore Ellis Agar in 1806: 'he [the prince] is in a proud attitude, suitable to his rank. The horse especially is painted with spirit and force. It is a masterpiece of the painter.'

The son of Philip IV, Baltasar Carlos (1629–46) is shown outside the Buen Retiro palace, built for the king by his first Minister, the Duke of Olivares. Olivares, who was also Master of the Horse at Court, stands on the right, about to grasp the lance being offered him, while the king and queen (Isabella of Bourbon) appear on the balcony immediately beyond his head. The theme underlying the picture is the analogy of kingship and equestrian mastery, popular in the early 17th century, though well-known from an earlier age (see No.21), and related here to the role of Olivares in the guidance of Spanish affairs.

The picture, painted about 1635–36, probably belonged to Olivares himself, and its quality, as

75 (No.23). Philip IV of Spain in brown and silver, by Velasquez (National Gallery). Dating from the early 1630s and showing the king in unusually colourful attire.

67

well as the alterations made by the artist in the course of creating it – visible especially along the roof of the palace and through the figure of Olivares, and remarkable in number even for Velasquez – became clearly apparent after cleaning in the early 1970s.

The secondary figures in the composition are probably Alonso Martínez de Espinar, the Keeper of Arms, who holds out the lance to Olivares and Juan Mateos, the Master of the Hunt, the figure behind Espinar, while the figures with the king and queen on the balcony possibly include the Countess of Olivares and the Infanta Maria Antonia, born in January 1635 (died December 1636). In a variant of the painting, probably by Mazo, in the Wallace collection, many details of the composition are omitted and shadowy and anonymous figures are substituted for the secondary portraits here.

Baltasar Carlos on horseback was also the subject of one of the equestrian portraits painted by

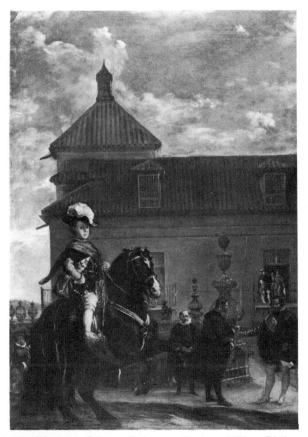

76 (No.24). Prince Baltasar Carlos ('The Riding School'), by Velasquez (Duke of Westminster). The prince is shown near the Buen Retiro Palace, with the Duke of Olivares to the right and the king and queen on the balcony behind him.

Velasquez for the Hall of the Realms in the Buen Retiro palace (1634–35, now Prado). The prince appears to be a little younger in this portrait, though the position of the horse (performing a 'levade') is the same, but in the reverse direction. Olivares also commissioned the equestrian portrait (fig.21), which was regarded in the later 18th century as one of Velasquez's greatest masterpieces.

PROVENANCE: In the collection of Luis de Haro, nephew of Olivares, and of his son (see El Greco, Nos.3,4); sold in 1690 but returned to the collection; by descent to the Alba collection; Cardinal Silvio Valenti Gonzaga (1690–1756), Papal Nuncio in Spain (1736–39); Welborne Ellis Agar collection (sale catalogue 2 May 1806, lot 22) purchased by Lord Grosvenor, later Marquess of Westminster.

EXHIBITED: British Institution, 1819, no.8; Royal Academy, 1870, no.2.

REFERENCES: Palomino, 1724, 3, p.332; Curtis, 1883, no.134 (suggesting age of prince as 12); Mayer, 1936, no.267 (as by Mazo); López-Rey, 1963, no.206 (workshop of Velasquez, possibly with Velasquez's participation); Michael Levey, *Painting at Court*, 1971, pp.142–44 (identification of setting and elucidation of subject); Enriquetta Harris, *The Burlington Magazine*, 1976, pp.266–75 (publication of picture after cleaning, with full discussion of provenance, subject-matter and relation to Wallace collection picture); Brown and Elliott, 1980 (the Buen Retiro Palace).

Figure 76

Studio of Diego VELASQUEZ (1599–1660)

25. *Prince Baltasar Carlos as a Hunter*

The National Trust and H.M. Treasury (Bristol collection, Ickworth)
Canvas, 154.9 × 90.2cm.

Possibly acquired in Spain by a son of Lord Bristol, on diplomatic service in Madrid, 1830–40.

A variant of the composition now in the Prado Museum, which Velasquez painted in 1635–36 as one of a series of portraits showing Philip IV and members of his family as huntsmen. The portraits were installed in the royal hunting lodge near Madrid, the 'Torre de la Parada'. The quality of the picture emerged in 1962 after cleaning and it was greeted then as a possible original by Velasquez. It differs from the Prado portrait in several important details most conspicuously in the omission of the large tree that covers most of the top and right side of the canvas in Madrid.

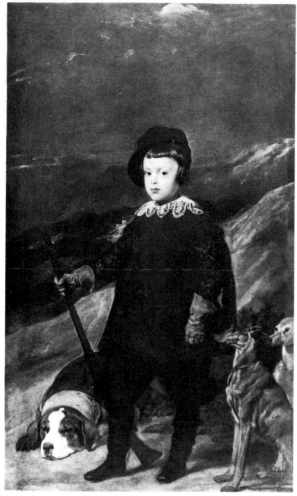

himself, although it is not comparable, for example in the treatment of the prince's face, with the Prado picture.

For Velasquez the hunting portraits provided his first real opportunity for the portrayal of dogs as well as humans. The painting of animals was well suited to his descriptive style and to the discretion of his colour schemes, and it had flourished before Velasquez's time particularly in the work of Titian, where a dog in a portrait, traditionally illustrating the concept of 'fidelity', could also be used to show the character and circumstances of the sitter. Very much the same psychological resonance is created by the dogs which appear in Velasquez's portraits, no less than three of them, in two different attitudes, being present in this portrait of the young prince.

PROVENANCE: possibly acquired in Spain by Lord William Hervey, son of Lord Bristol, when Secretary to the Legation at Madrid, 1830–40 (though an earlier Lord Bristol was Ambassador to Madrid in the 1760s); at Ickworth and by descent (a similar portrait, probably not the same one, was in the Campbell sale, 9 July 1814).

EXHIBITED: at the Courtauld Institute Galleries after cleaning in 1962.

REFERENCES: Mayer, 1936, no.272 (as a studio replica); López-Rey 1963, no.306 (as lacking the brilliancy of Mazo); *Apollo*, 1962, pp.331 and 492 (letters about authenticity of picture); St. John Gore, *Country Life*, 10 December 1964, p.1656 (history of the picture and Ickworth collection).

Figure 77

77 (No.25). Prince Baltasar Carlos as a Hunter, studio of Velasquez (National Trust and H.M. Treasury, Bristol collection, Ickworth). A variant of the painting in the Prado Museum, Madrid.

The sleeping dog is much further from the prince's legs in the Prado painting, and only the front part of the dog to the right, which is also at a greater distance from the prince, is shown, most probably because the Madrid canvas has been cut at the right edge (and possibly also at the left). The hunting portraits in the Prado (particularly that of the king himself, which has been recently cleaned) are conspicuous for the many alterations made by the artist during the course of creating the pictures, and the Ickworth picture was possibly painted when the Prado portrait was at an early stage in its evolution, before the details of the composition had been finally established. A painting that notably differs from Velasquez's original, the portrait may have been created with the assistance of the artist

Diego VELASQUEZ (1599–1660)

26. *The Toilet of Venus ('The Rokeby Venus')*

The National Gallery
Canvas, 122.7 × 177cm

Brought to England in 1813 and acquired in the following year by John Bacon Sawrey Morritt of Rokeby Hall, Yorkshire, the painting remained little known until the mid-19th century.

Velasquez's only surviving painting of a female nude, the picture was probably painted for Don Gaspar Méndez de Haro, Marqués del Carpio, the son of Olivares' nephew, who had succeeded as first minister to the King after Olivares' disgrace in 1643. The picture is recorded in an inventory of Carpio's possessions in 1651, and it must have been painted during Velasquez's second visit to Italy in 1649–51, or shortly before his departure. Paintings of such subjects were rare in Spain,

where they courted the disapproval of the Inquisition, though they were not discordant with the unofficial pleasures of the court. The subject is treated by Velasquez with few concessions to the conventions, derived from classical sculpture, usually adopted in Italy for the painting of the nude.

The subject of Venus at her mirror attended by Cupid was popularised by Titian, as was also the theme of Venus lying full-length on her bed. A seated Venus with a mirror, based on this Venetian tradition, was also painted by Rubens. The pose of Velasquez's Venus may also have been influenced by classical statues (the Sleeping Hermaphrodite and a draped Ariadne) of which the painter ordered casts for Philip IV during his second journey to Italy. The picture is unusual in the prominence given to the mirror reflecting the face of the goddess, and in this it is related to the mirror in Velasquez's 'Las Meninas', which is used to reflect the likenesses of the king and queen. Considerable artistic licence was employed for the misty reflection in the mirror; for just the head to appear would, in theory, involve a view-point at an unusual distance.

The picture may have been smaller at first and shown Venus alone, the figure of Cupid and the strip of canvas across the top being added during the course of its creation. The head of Venus was at first apparently in profile, and many other changes are also visible, in the contour of the arm, in the frame of the mirror, and in the figure of the Cupid.

An early English visitor to Spain (1775–76),

Henry Swinburne, described the picture as 'a charming Venus, by Velasquez, lying half-reclined with her back to the spectator'.

PROVENANCE: Don Gaspar Méndez de Haro, 1651 (see above); by descent to the Alba collection; acquired in 1802 by Manuel Godoy, Prince of the Peace; bought at some time after 1808 by G.A. Wallis for Buchanan and imported to England in September 1813; in the Yeates collection in January 1814, and sold shortly afterwards to Morritt; at Rokeby Hall until 1905; purchased from Agnew's by the National Art-Collections Fund, by whom presented, 1906.

EXHIBITED: Art Treasures Exhibition, Manchester, 1857, no.787; Royal Academy, 1890, no.135; National Art-Collections Fund exhibition, National Gallery, 1945–46, no.6; 1947, Arts Council, no.30; *Velázquez y lo velazqueño*, Madrid, 1961, no.76; *Painting in Focus*, The National Gallery, 1976.

REFERENCES: Swinburne, p.167; Curtis, 1883, no.34; Mayer, 1936, no.58; López-Rey, 1963, no.64; MacLaren and Braham, 1970, pp.125–29;

Figure 78

78 (No.26). The Toilet of Venus ('The Rokeby Venus'), by Velasquez (National Gallery). The only surviving painting of a female nude by Velasquez; probably painted for the great-nephew of the Duke of Olivares.

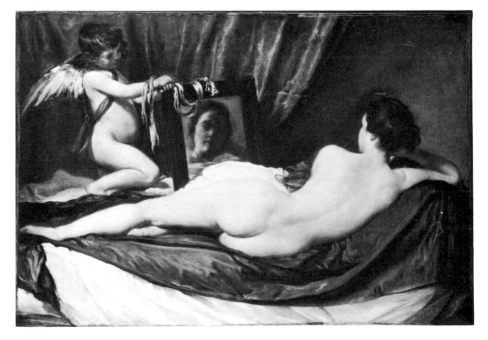

Circle of Diego VELASQUEZ
(1599–1660)

27. *A Lady in a Mantilla*

The Trustees of the Chatsworth Settlement
Canvas, 98 × 48cm

In the collection of the 3rd Earl of Burlington and recorded at Chiswick Villa in 1761.

A variation of Velasquez's 'Lady with a Fan' in the Wallace Collection, the picture has probably been cut at the sides, creating an unusual and striking design. The 'Lady with a Fan' is probably a painting of the later 1630s, while the present picture appears some years later in date. The face, though similar in both pictures, seems not exactly the same, perhaps indicating different sitters of the same family, the younger emulating the older woman.

Though the traditional attribution to Velasquez of the 'Lady in a Mantilla' has recently been revived, the picture differs in style and in its more intimate idiom from the 'Lady with a Fan' and approximates to the work of Mazo (see No.28). A drawing at Chatsworth in an album containing sketches by Lady Burlington and her daughters, shows the painting in the form of a full-length portrait in a landscape with a view of a town. Such a setting would be unusual for a portrait painted in the orbit of Velasquez, and was perhaps a fancy of the draughtsman.

PROVENANCE: 3rd Earl of Burlington (1695–1753); recorded at Chiswick Villa in 1761; by descent to the Devonshire collection.

EXHIBITED: The British Institution, 1852, no.17; Royal Academy, 1876, no.117, and 1890, no.141; 1913–14, Grafton Galleries, no.53; 1928, Burlington Fine Arts Club; 1967, Bowes Museum, no.38; Chatsworth Exhibitions: Agnew's, London, 1948, no.29, Leeds City Art Gallery, 1954–55, no.45, Graves Art Gallery, Sheffield, 1955, no.45, Royal Academy, London, 1980–81 (and previously in the U.S.A.), no.35.

REFERENCES: Curtis, 1883, no.266; Mayer, 1936, no.561; López-Rey, 1963, no.600 (as by Velasquez, and suggesting possible family relationship between the sitter and the 'Lady with a Fan'); Enriqueta Harris, *The Burlington Magazine*, 1975, pp.316–19 (discussion of the 'Lady with a Fan', after cleaning, attributing the Chatsworth picture to Mazo); Peter Day in Royal Academy 1980–81 exhibition catalogue (related drawing at Chatsworth).

Figure 79

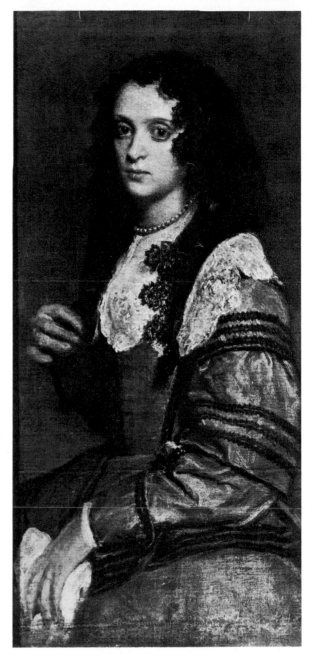

79 (No.27). A Lady in a Mantilla, circle of Velasquez (Trustees of the Chatsworth Settlement). A variant (cut at the sides) of Velasquez's 'Lady with a Fan' in the Wallace collection.

Juan Bautista del MAZO
(about 1612/16–1667)

Born at Cuenca, Mazo entered the studio of Velasquez, whose daughter he married in 1633. He succeeded in 1661 to the post of court painter that Velasquez had occupied. Though overshadowed by the fame of Velasquez, by whose style his own more conventional approach to portraiture was deeply marked, Mazo is in his own right a major figure in the context of 17th-century portraiture.

28. *A Knight of Santiago*

York City Art Gallery
Canvas, 102.8 × 80.2cm

Acquired by Lord Mahon in Italy in 1845.

Like the 'Lady in a Mantilla' (No.27) the sitter draws attention to his costume by the gesture of his hand, fingering the chain on which the enamelled shell, insignia of the Order of Santiago, is suspended round his neck; a sword is indicated on the right. Like many other works by Mazo, the picture was formerly attributed to Velasquez, the sitter being identified as Olivares.

The sitter may be a member of the Leyva family, as a variant of the composition in New York (Hispanic Society) bears the Leyva coat-of-arms.

PROVENANCE: Purchased by Lord Mahon in 1845 from Count Lecchi, Brescia; Earl Stanhope; Horace Buttery, 1947; purchased by F.D. Lycett Green by whom presented through the National Art-Collections Fund, 1955.

EXHIBITED: Art Treasures, Manchester, 1857, no.1063; British Institution, 1861, no.36; Leeds, 1868, no.326; Royal Academy, 1912, no.24; *The Lycett Green Collection*, York, 1955, no.120; 1967, Bowes Museum, no.39.

REFERENCES: Waagen, 1857, p.181; Curtis, 1883, no.204; Mayer, 1936, no.376; Gaya Nuño, 1958, no.1712; York City Art Gallery catalogue, 1, 1961, pp.95–96; López-Rey, 1963, no.452.

Figure 80

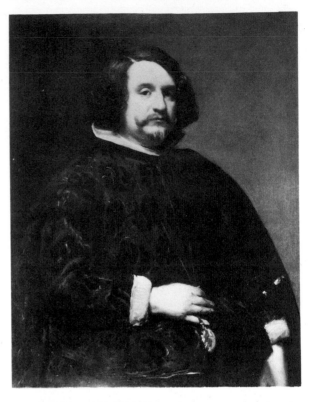

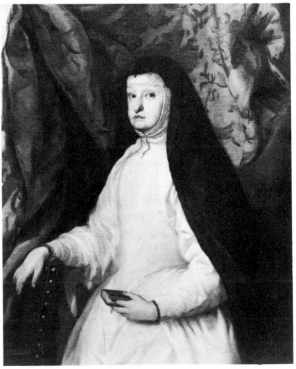

80 (No.28). A Knight of Santiago, by Juan Bautista del Mazo (died 1667) (York City Art Gallery). The son-in-law of Velasquez, Mazo became painter to the Court in 1661.

81 (No.29). Queen Mariana of Spain, by Juan Carreño de Miranda (1614–85) (Bowes Museum). The sitter was the niece and second wife of King Philip IV.

Juan CARREÑO de Miranda (1614–85)

Born in Gijón and trained in Madrid, Carreño succeeded as court painter during the Regency of Queen Mariana, and was active in the production of portraits, in which the influence of Velasquez is apparent, and history paintings (including frescoes).

29. *Queen Mariana of Spain*

The Bowes Museum, Barnard Castle
Canvas, 104.7 × 84.1cm

Acquired by John Bowes from the Conde del Quinto in the 1860s.

Mariana of Spain (1634–96), the daughter of the Emperor Ferdinand III and the Infanta María (Philip IV's sister), had been betrothed to Prince Baltasar Carlos. Though she was his niece, Philip IV married her in 1649, and their son, the physically and mentally handicapped Charles II, the last of the Hapsburg kings of Spain, ascended the throne in 1665. In Carreño's striking portrait, probably of the early 1680s, the dowager queen wears, in accordance with Spanish etiquette, the habit of a nun.

Many more elaborate portraits of the queen and of Charles II were produced by Carreño and his assistants, some of them showing rooms in the Madrid palace. Several of these compositions derive from prototypes by Mazo, including his 'Queen Mariana of Spain in mourning' of 1666 in the National Gallery (no.2926)

Restored in 1967; worn in the background and the costume.

PROVENANCE: Conde del Quinto collection (no.35 in the sale catalogue of 1862).
EXHIBITED: 1913–14, Grafton Galleries, no.165; Bowes Museum exhibition, Agnew's, London, no.42; 1967, Bowes Museum, no.52.
REFERENCES: Gaya Nuño, 1958, no.529; Young, 1970, pp.24–25 (with full references); J. Barettini Fernández, *Juan Carreño*, 1972.

Figure 81

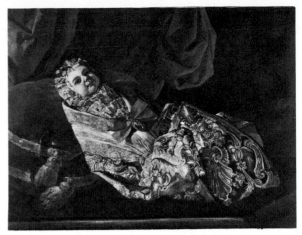

82 (No.30). A Royal Infant, ascribed to Claudio Coello (1642–93) (Glasgow Museums, Pollok House). Possibly a portrait of Philip IV's son, later King Charles II (1661–1700), the last of the Hapsburg kings of Spain.

Ascribed to Claudio COELLO (1642–93)

Carreño's successor as court painter in 1685, Coello was born in Madrid and may have visited Italy in his youth. Like Carreño he was a gifted creator of portraits and equally at ease as a religious and narrative painter, working frequently in fresco. He was familiar to early travellers in Spain as the author of 'The Mass of Charles II' in the sacristy of the Escorial: 'a work of great power and splendour, and one of the most interesting pictures which has been spared to the desolate Escorial' (Stirling, 1848).

30. *A Royal Infant*

Glasgow Museums and Art Galleries,
Stirling Maxwell Collection, Pollok House
Canvas, 76.8 × 100cm

Bought by William Stirling in 1859.

The elaborate swaddling, the cushion, and the crown above the medallion suggest that the baby is indeed a 'royal infant', cossetted as formally as other royal Spanish babies (see No.21).

In handling the picture appears to be of the later 17th century, though not close to Coello (see No.38). The last royal infant born at this time in Spain was apparently King Charles II (1661–1700), which would indicate an earlier court painter than Coello as the author of the portrait.

PROVENANCE: in the John Auldjo sale, 14 July 1859, lot 628; bought for William Stirling; left to Glasgow by Mrs Anne Maxwell Macdonald (the Pollok Gift), 1966.

EXHIBITED: 1895–96, New Gallery, no.164 (as by Sánchez Coello); 1901, Guildhall, no.92; 1913–14, Grafton Galleries, no.137; *17th century Art in Europe*, Royal Academy, 1938, no.233; 1951, Edinburgh, no.5; Anniversary Exhibition, Glasgow Art Galleries, 1977, no.60.
REFERENCES: A. de Beruete, *Gazette des Beaux-Arts*, 1901, p.258; Caw, 1936, no.9; Gaya Nuño, 1958, no.616; Auld, p.14; Hilary Macartney, forthcoming Stirling collection catalogue.

Figure 82

Ascribed to Francisco Antonio MELENDEZ (1682–1752)

Born at Oviedo, and trained by his elder brother, Miguel Jacinto, Francisco Meléndez spent many years in Italy, where his son Luis, the still-life painter (see Nos.60 and 61), was born in 1716. The work of the brothers (Francisco being especially a painter of miniatures) represents the last, not uncharming, echo of the great tradition of Spanish court portraiture, before it was transformed by French painters arriving in the Peninsula.

31. *Queen Marie Louise Gabrielle of Savoy*

Her Majesty the Queen
Canvas, 81.3 × 57.2cm

Bought for Queen Victoria at the Louis-Philippe sale in 1853.

Marie Louise of Savoy was the first wife of Philip V (1700–46), the first Bourbon king of Spain. The marriage took place in 1702, and the queen died in 1714, when Philip married the yet more dominating Isabella Farnese.

The picture, influenced by Italian and Spanish portraiture, may have been a marriage portrait, as the flowers held by the sitter could indicate, and painted in Savoy. Unless sent from Savoy, it is more likely to be by Miguel Meléndez than Francisco, who was in Italy during the queen's reign.

Cleaned in 1981.

PROVENANCE: Louis-Philippe sale, Christie's, 7 May 1853, lot 139, bought for Queen Victoria.
EXHIBITED: Spanish Gallery, Louvre, 1838–48, no.139 (together with other portraits by Miguel and Francisco Meléndez); 1913–14, Grafton Galleries, no.86; 1920–21, Royal Academy, no.104.
REFERENCES: Thieme-Becker, *Allgemeines Lexikon*, vol.24 (1930), pp.360–61; E. Santiago Páez in *Revista de Archivos, Bibliotecas y Museos*, 1966 (Miguel Meléndez).

Figure 83

83 (No.31). Queen Marie Louise Gabrielle of Savoy (before cleaning), ascribed to Francisco Antonio Meléndez (1682–1752) (Royal Collection). The sitter was the first wife of King Philip V (1700–46), the first of the Bourbon kings of Spain.

Zurbarán and Religious Painting

Appreciation of religious painting in Spain was largely centred, until the late 19th century, upon the work of Murillo. Zurbarán, who worked in Seville from after the time of Velasquez's departure to Madrid until the early years of Murillo's career, was elevated to fame in France in the 1840s as the true interpreter of the Spanish monastic ideal. His work, like that of other 17th-century painters who combined an individual or 'primitive' manner with apparent response to the work of Caravaggio (Georges de la Tour, Hendrick Terbrugghen, etc.), has also attracted much recent interest. 'Zurbarán is called the Spanish Caravaggio;' in the words of Richard Ford (1845) 'but is much more Titianesque, more elevated in mind and manner.'

Zurbarán's style, like Ribera's, altered in his later years, and – probably under Murillo's influence – his works became more graceful and sophisticated. But as with other Spanish painters of the later 17th century, many of whom are comparable in the quality of their work with the best of their Italian contemporaries, they retained a distinctly personal, and national inflection. Only a few of the major Spanish artists of the 17th century (Carducho, Coello, Valdés Leal, Antolínez) are adequately represented by paintings and sculpture in this country; rare outside Spain is the work of Alonso Cano of Granada, who was active as a painter, sculptor and architect, of Francisco Herrera the younger of Seville, Cerezo and Escalante of Madrid, or the two Espinosas of Valencia.

As the 17th century advanced the devotion to the Virgin, distinctive as a feature of Spanish culture, became increasingly apparent in painting, and above all in the countless representations of The Immaculate Conception, a speciality not confined to Murillo alone. Under pressure, particularly from Spain, the dogma of the Immaculate Conception, though not officially proclaimed by the Pope until 1854, became increasingly favoured in Rome, and was underlined by decrees of 1617, 1622, and in the Bull *Sollicitudo* of 1661 promulgated by Pope Alexander VII following the initiative of Philip IV.

Francisco de ZURBARAN (1598–1664)

Born at Fuente de Cantos, in the province of Badajoz, Zurbarán was trained in Seville in the same years as Velasquez, and first worked at Llerena (1617–28). In 1629 he settled in Seville, visiting Madrid in 1634 when he painted the series showing the Labours of Hercules for the Buen Retiro palace. Apparently resident from 1658 in Madrid where he died (27 August), Zurbarán shared with Velasquez, by whom he was influenced, the designation of 'the Caravaggio of Spain.'

32. *The Surrender of Seville*

The Duke of Westminster
Canvas, 160 × 205.7 cm
Signed, lower right, and dated 1634.

Possibly in the Grosvenor collection in the early 19th century, but not recorded in early catalogues.

As well as his celebrated images of saints and biblical figures, often forming series (Nos.33-35), Zurbarán also painted several famous cycles of narrative pictures, apparently represented in this country only by this painting of 1634, which remained unknown until comparatively recently. It is one of a series showing scenes from the life of S. Peter Nolasco, begun by Zurbarán in 1629 for the Shod Mercedarians of Seville. This order had been formed by S. Peter Nolasco in 1218 for the redemption and ransoming of Christians captured by the Moors, and in Zurbarán's painting, which records an event of 1248, the saint stands behind King Ferdinand III of Castille and León, who receives from the Moorish governor, Achacaf, the key of the city of Seville.

S. Peter Nolasco had been canonized in August 1628, and Zurbarán received in the following year a commission to supply within a year twenty-two large canvases of scenes from the saint's life for the small cloister of the convent of Shod Mercedarians. Only fifteen paintings were recorded in the cloister in the later 18th century, and these were dispersed in 1810. Of the pictures from the series which are now traceable, not all are by Zurbarán himself, though the whole series was no doubt produced under his direct supervision. Apart from the present painting, three others in the series are signed by Zurbarán, and two are dated: 'The Vision of the Heavenly Jerusalem' and 'The Vision of S. Peter on his Cross' of 1629 (both Prado, Madrid), and 'The Recovery of the Image of the Virgin of Puig', of 1630 (Cincinnati, Art Museum).

The figure beside S. Peter Nolasco in No.32 is probably the Dominican, S. Raymond of Penyafort, who participated in the foundation of the Mercedarian order. The badge of the order, a cross and five gold bars on a red ground, is worn by S. Peter Nolasco and by the central figure of the group of three soldiers to the left of the king, who may well represent contemporaries of the artist. The tower of Seville cathedral, 'La Giralda'

(fig.38), is visible in the left background and the flag in the middle distance, over the head of the kneeling Arab governor, shows the arms of Castille and León – castles and lions in yellow on white.

Completed presumably before Zurbarán left Seville for Madrid in the spring of 1634, the picture is only slightly earlier in date than Velasquez's very different representation of the surrender of a town to a Catholic victor, 'The Surrender of Breda' (fig.37), which was painted, like Zurbarán's Labours of Hercules, as one of the series of canvases for the Hall of Realms in the Buen Retiro palace.

PROVENANCE: In the small cloister of the convent of the Shod Mercedarians in Seville, probably until 1810 (see above); subsequent history unknown.
EXHIBITED: apparently not exhibited hitherto.
REFERENCES: Soria, 1953, nos.30-33, and Guinard, 1960, p.187 (other paintings in the Shod Mercedarians' series); López-Rey in *Apollo*, 1965, 2, pp.23-25 (publication and analysis of the picture); J. Gállego and J. Gudiol, *Zurbarán*, 1977, no.15.

Figure 84

Francisco de ZURBARAN (1598–1664)

33. *S. Francis in Meditation*

The National Gallery
Canvas, 152 × 99cm

The most famous of the Zurbaráns in the Louis-Philippe collection; bought for the National Gallery at its sale in 1853.

Meditation upon death, with the aid of a skull, was greatly favoured as a religious exercise, especially by the Jesuits. S. Francis with a skull was a subject frequently treated by Zurbarán, though rarely with the degree of mystical intensity achieved here through shadowing the face with the cowl and highlighting the clenched hands embracing the upturned skull. The picture, which is probably of the later 1630s, was one of the works chiefly instrumental in arousing admiration for Zurbarán in Paris in the 1840s, when it inspired a famous poem by Théophile Gautier.

Until cleaning in 1980 the picture was much discoloured, but its condition is far better than had been suspected. A curious feature revealed by cleaning is the dark band to each side of the upper part of the picture, of which the edges coincide with tears running down the canvas. The whole upper part of the background may have been dark, and then the lighter, grey paint, which clearly appears

84 (No.32). The Surrender of Seville, by Zurbarán (Duke of Westminster). Dated 1634, and showing the surrender of the Keys of Seville in 1248 to King Ferdinand III of Castille and León, who is accompanied by S. Peter Nolasco.

85 (No.33). S. Francis in Meditation, by Zurbarán (National Gallery). One of the famous Zurbaráns in the Louis-Philippe collection which led to the 'discovery' of the painter in Paris in the 1840s.

PROVENANCE: acquired in Spain for King Louis-Philippe and exhibited at the Louvre (see below); Louis-Philippe sale, 6 May 1853, lot 50, acquired for the National Gallery.
EXHIBITED: Spanish Gallery, Louvre, 1838–48, probably no.346 (the measurements given as 156 × 116cm, but it seems unlikely that the picture has been cut down substantially).
REFERENCES: Waagen, 1854, 3, p.67 (Zurbarán's monks); Soria, 1953, no.166 (dating: about 1639); Guinard, 1960, no.354; MacLaren and Braham, 1970, pp.137–38.

Figure 85

Francisco de ZURBARAN (1596–1664)

34. *S. Rufina*

The National Gallery of Ireland
Canvas, 174 × 104cm
The remains of an inscribed panel, lower left, giving the name of the saint, were recovered by cleaning in 1967.

Formerly believed to represent S. Justa and one of a series of full-length female saints by Zurbarán in the Louis-Philippe collection.

Saints Justa and Rufina, legendary martyrs and the patrons of Seville, were the daughters of a poor potter of the city. They refused to allow their father's wares to be used in the temple of Venus, and destroyed the image of the goddess, for which they were put to death by the Roman governor. Despite the damage recently revealed by cleaning, this representation of S. Rufina retains much of its quality as one of the most endearing of Zurbarán's naive and colourful images of female martyrs, distinguished by the still-life of pottery, referring to the faith of S. Rufina.

Several of the series of female saints in the Louis-Philippe collection were wrongly identified in its catalogue, and the pictures were not ordered in a coherent sequence. Others in the series which can now be traced include a pair of paintings at Strasbourg (Musée des Beaux-Arts), a 'S. Lucy' (New York, Hispanic Society), and a 'S. Marina' (Gothenburg). The pictures are related to the series of female saints which Zurbarán painted, probably in the 1640s, for the Hospital of La Sangre in Seville, and they may be of approximately the same date.

PROVENANCE: Louis-Philippe sale, Christie's, 22 May 1853, lot 297; Denyson collection, Newcastle; Lady Eleanor Denyson sale, Christie's, 23 June 1933, lot 61, bought by Dublin.

to be original, added by the artist after the picture had been equipped with its frame, one that was narrower than the painting and from which the canvas in time began to tear.

The habit worn by the saint, with the same tear on the sleeve, corresponds with those in other compositions by Zurbarán of S. Francis, including the one signed and dated 1639, showing the saint in a landscape pointing to a skull, which is also in the National Gallery collection. This was probably acquired in Spain by Sir Arthur Aston, British envoy in Madrid in 1840–43.

Of another Zubarán painting, Waagen noted that 'no painter has portrayed the Spanish monk, both in his quiet and in his passionate devotion, and also in his fearful fanaticism, with such truth and power as Zurbaran'.

86 (No.34). S. Rufina, by Zurbarán (National Gallery of Ireland). The patrons of Seville, SS. Justa and Rufina, were the daughters of a poor potter of the city.

EXHIBITED: Spanish Gallery, Louvre, 1838–48, no.393; Manchester, 1857, no.1004; Leeds, 1868, no.356.
REFERENCES: Guinard, 1960, no.266 (and p.206, series of female saints).

Figure 86

Ascribed to Francisco de ZURBARAN (1598–1664)

35. *Joseph*

The Bishop of Durham
and Church Commissioners
Canvas, 198 × 102cm

One of a series of thirteen canvases showing Joseph and his brethren, first recorded in England in the early 18th century and the earliest pictures of their kind in this country.

With the exception of one canvas, the series was acquired in 1756 by Richard Trevor, Bishop of Durham. The high quality of the picture is now apparent after the recent cleaning of the series. Related sequences of paintings, issuing from the studio of Zurbarán, probably in the 1640s, survive in Puebla in Mexico and at Lima, and it is believed (not, perhaps, unreasonably) that the Durham series may have been captured from a Spanish ship bound for the New World. Despite the portrait-like character of Joseph and some of his brethren, and

87 (No.35). Joseph, by Zurbarán (Bishop of Durham and Church Commissioners). One of a series of thirteen canvases possibly captured from a Spanish ship bound for the New World.

the colourful oriental elaboration of their costumes, Zurbarán probably used Netherlandish engravings to guide him in designing the series.

The thirteenth picture in the sequence, showing Benjamin, was acquired in 1756 by Lord Willoughby of Eresby, and is now in the Earl of Ancaster collection, a copy by Arthur Pond, made in 1756, completes the series at Auckland Palace.

PROVENANCE: Sir William Chapman (1677–1748) – undated sale, lots 41–53; James Mendez of Mitcham, posthumous sale by Langford, 25–26 February 1756, lots 21–33; twelve bought by Richard Trevor, Bishop of Durham, and by descent at Auckland Palace.

EXHIBITED: 1967, Bowes Museum, no.66; 1980, Nottingham University, no.37.

REFERENCES: C. Peman, *Archivo español de Arte*, 1948, pp.158–66, and 1949, pp.209–13; Guinard, 1960, pp.274–76 and nos.546,555,556 and 557; A. Bonnet Correa, *Archivo español de Arte*, 1964, pp.164–67 (series in South America); Eric Young in 1967 Bowes Museum exhibition catalogue, pp.50–52 (with further bibliography), and in *The Connoisseur*, October, 1978, p.104.

Figure 87

Vicente CARDUCHO (1576–1638)

Born in Florence, Carducho accompanied his elder brother Bartolommeo, to Spain in 1585. He was appointed Court painter in 1609 and was chiefly active at the Escorial. Famous as the writer of a *Diálogos de la Pintura* (1633), Carducho shows himself as author and painter in a portrait in the Stirling collection (Pollok House). He and Eugenio Cajés were the leading painters of Madrid until the advent of Velasquez in 1623.

36. *Dream of S. Hugh, Bishop of Grenoble*

The National Galleries of Scotland
Canvas, 57 × 45.5cm

First recorded, as a painting by Velasquez, at a sale at Christie's in June 1859.

The picture is a sketch, or *modello*, for one of an important series of fifty-four canvases, illustrating the life of S. Bruno, which Carducho painted in 1626–32 for the cloister of the Carthusian monastery of El Paular, near Madrid. The foundation of the Grande Chartreuse by S. Bruno had followed a dream of S. Hugh, in which the bishop saw heavenly spirits erecting a temple and houses on the site to which stars had guided them. The sketch-like character of the painting may have sug-

88 (No.36). The Dream of S. Hugh, Bishop of Grenoble, by Vicente Carducho (1576–1638) (National Galleries of Scotland). One of the two leading painters of Madrid before Velasquez's arrival in 1623.

gested the early attribution to Velasquez, though the similarity with his work is not obvious.

The series of paintings from El Paular was removed in 1836 and dispersed in 1896; the painting corresponding with the present *modello* survives in the School of Fine Art at La Coruña. Twenty-five other *modelli* from the series are known.

PROVENANCE: Sir John Pringle sale, Christie's, 18 June 1859, lot 82 (as Velasquez); presented by Andrew Coventry of Edinburgh, 1863.

EXHIBITED: 1951, Edinburgh, no.1; 1967, Bowes Museum, no.37; 1980, Nottingham, no.12.

REFERENCES: R. Longhi, '*Me Pinxit*' e quesiti caravaggeschi, 1968, p.156 (identification of painting in 1930); B. Cuartero y Huerta in *Boletin de la Real Academia de la Historia*, 1950, pp.362–63 (identification of subject); Gaya Nuño, 1958, no.510; Angulo Iñíguez and Pérez Sánchez, 1969, pp.122ff. (other paintings in the series); Mary Crawford Volk, *Vicencio Carducho and seventeenth-century Castilian painting*, 1977 (no.29, finished painting); Brigstocke, 1978, pp.30–31 (further discussion and references).

Figure 88

89 (No.37). 'A Jesuit Conversion', by Juan de Valdés Leal (1622–90) (York City Art Gallery). After Murillo, the leading painter of late 17th-century Seville.

Juan de VALDES LEAL (1622–90)

Born in Seville and probably trained in Cordova, where his earliest works were produced. By 1656 he had returned to Seville, where he was instrumental in founding the Seville Academy of which he was president, 1664–66. A more fantastic and exuberant painter than Murillo, Valdés Leal was known to English visitors in Spain from the later 18th century, especially for the two large allegories, *In Ictu Oculi* and *Finis Gloriae Mundi* that complemented the great cycle of paintings by Murillo (see no.51) in the church of the Caridad.

37. 'A Jesuit Conversion'

York City Art Gallery

Canvas, 127 × 95.2cm

First recorded in this country in 1938.

An illustration of the paths of Christian repentance, the picture conveys the temper of religious fervour in Seville in the later years of the 17th century. Crowded as it is with well-rendered detail, it expresses an almost frenetic urgency, not to be found in Murillo but characteristic of the work of Valdés Leal. A companion painting (in the Wadsworth Athenaeum, Hartford, Connecticut), representing the 'Vanities of the World', is dated 1660.

The figure reading was formerly thought to be a portrait of the Sevillian nobleman, who was head of the Hospital of the Caridad, Don Miguel Mañara (1627–79), and the picture itself was thought possibly to have been painted for the Hospital. More recently it has been suggested that the picture is an illustration of the second stage of Jesuit conversion, according to the *Spiritual Exercises* of S. Ignatius Loyola. An image of the Crucifixion in an elaborate frame hangs above the table where a lily emerges in the centre of a still-life of opened and unopened religious books, most of which have been identified. The 'convert', holding to his head a rosary, is accompanied by an unseen angel, bearing a curious triple hour-glass, and pointing to the shining crown that awaits the virtuous.

PROVENANCE: Tomás Harris, London; bought in 1938 by F.D. Lycett Green, by whom presented to York through the National Art-Collections Fund, 1955.

EXHIBITED: 1938, Spanish Art Gallery, no.20; *The Lycett Green Collection*, York, 1955, no.93; 1967, Barnard Castle, no.77; 1980, Nottingham University, no.63.

REFERENCES: T. Borenius, *The Burlington Magazine*, 1938, pp.146–47 (proposing identification of sitter as Mañara); Gaya Nuño, 1958, no.2753; F. Nordström, *Figura Nova*, series I, 1959, pp.127–37 (suggesting relation of picture to the *Spiritual Exercises* of Loyola); E. du Gue Trapier, *Valdés Leal*, 1960, pp.32–34; York City Art Gallery catalogue, 1961, p.98; D. Kinkead, *Juan de Valdés Leal*, 1978, no.81 (as 'Allegory of the Crown of Life', and with further bibliography).

Figure 89

(*Opposite*) Murillo, *Self-portrait* (detail), No.43

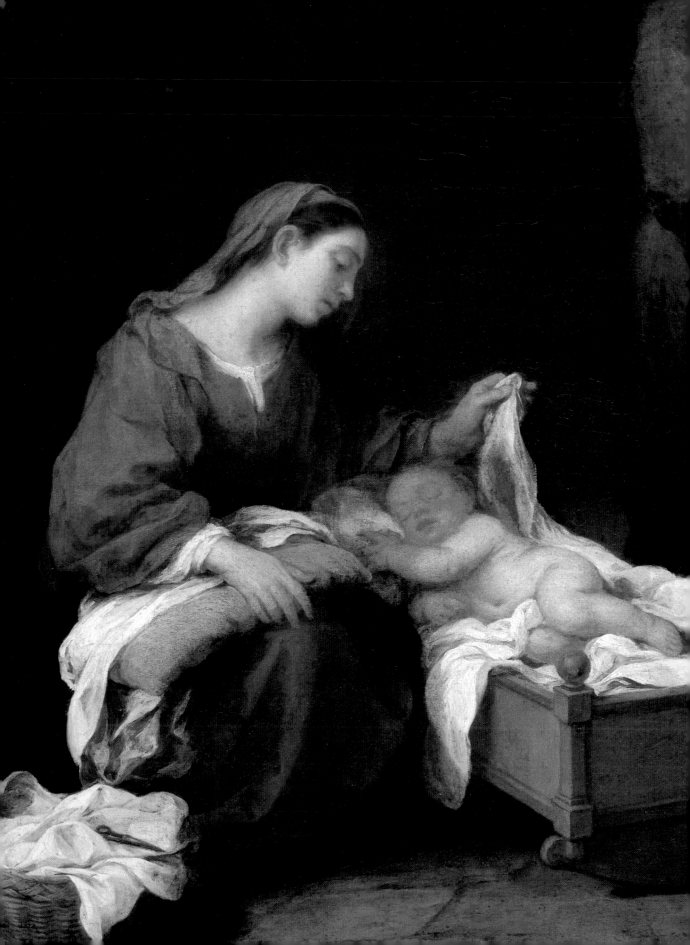

Claudio COELLO (1642–93)
(see No.30)

38. *S. Catherine of Alexandria*
The Wellington Museum (Apsley House)
Canvas, 112 × 94.6cm
Signed on the wheel, lower right, and dated 1683 (last number indistinct).

Captured by the Duke of Wellington from Joseph Bonaparte after the Battle of Vitoria (1813).

The painting was taken from the chapel of San Domingo in the church of El Rosario, Madrid, where it is recorded in the 18th century, together with a now-lost companion picture of S. Hyacinth. One of the most famous images of saints in later 17th-century Spanish art, the picture is clearly marked in handling and composition by the influence of Van Dyck, while also rivalling Italian religious art of the period, though in a quite different way from Murillo's. As well as the spiked wheel and the palm of martyrdom, the sword with which S. Catherine was finally slain is indicated at her right hand.
 Cleaned in 1950.

90 (No.38). S. Catherine of Alexandria, by Claudio Coello (Wellington Museum, Apsley House). A dated work of 1683 by the leading Madrid painter of the later 17th century.

PROVENANCE: From the church of El Rosario, Madrid, and captured at Vitoria (see above).
EXHIBITED: 1913–14, Grafton Galleries, no.158; 1920, Royal Academy, no.12.
REFERENCES: Palomino, 3, 1724, p.655 (as 'S. Catalina [sic] de Sena'); Ponz, 5, 1776, p.187; J.A. Gaya Nuño, *Claudio Coello*, 1957, pl.19 and 1958, no.611; Michael Kauffmann, forthcoming Apsley House catalogue (with full bibliography).
Figure 90

Diego VELASQUEZ (1599–1660)
39. *The Immaculate Conception*
The National Gallery
Canvas, 135 × 101.6cm

Acquired in Seville, together with No.16, by Bartholomew Frere, British Minister there in 1809–10.

Painted during the artist's early years in Seville, possibly about 1620, the picture is one of the earliest, and most moving, of the many representations of the subject in 17th-century Spain. Velasquez followed the recommendations of Francisco Pacheco, his father-in-law, in showing the Virgin as a young girl and in most of the details in the picture. These include the emblems derived from the litanies of the Virgin, which are shown 'naturalistically' as part of the landscape: the garden ('hortus conclusus'), the fountain ('fons signatus'), the temple ('domus sapientiae'), the ship ('navis institoris'), and probably also the hills ('desiderium aeternorum collium'), the dawn ('aurora consurgens') and the city ('urbs fortitudinis'). Also conceived 'naturalistically' are the banks of cloud, which spread out from a golden centre like a mandorla to enclose the middle of the Virgin's body.
 The Carmelites, for whom the picture was most likely painted, were particularly committed to belief in the Immaculate Conception of the Virgin, and the vision of S. John the Evangelist of the Woman of the Apocalypse, related to Elijah's visions on Mount Carmel, was of importance to their belief in the dogma (see entry for No.16). Though visionary scenes were not those best suited to the art of Velasquez, here and in his comparable 'Coronation of the Virgin' of the 1640s (Prado, Madrid) a solemn human dignity supplies the place of any supernatural abandonment. A significant change in the design of the picture, shown in x-rays, lies in the treatment of the drapery at the Virgin's feet, which originally swirled outwards to the left.

91 (No.39). The Immaculate Conception, by Velasquez (National Gallery). Companion to No.16 (fig.68), an early work of Velasquez, and one of the most moving of the many paintings of the subject in 17th-century Spain.

PROVENANCE: see No.16; purchased from the Woodall Trustees, 1974.
EXHIBITED: Royal Academy, 1910, no.45; 1947, Arts Council, no.25; *The Working of the National Gallery*, 1974 (as a recent acquisition).
REFERENCES: Curtis, 1883, no.4; Mayer, 1936, no.5 (dating: about 1618); López-Rey, 1963, no.21 (dating: about 1619).

Figure 91

Francisco de ZURBARAN (1598–1664)

40. *The Immaculate Conception*

The National Gallery of Ireland
Canvas, 168 × 108.5cm

First recorded in England in 1872, and believed in the 19th century to be a work by Valdés Leal.

Not widely known or accepted as an undoubted Zurbarán, the picture, probably dating from the 1650s, has emerged as a work of obvious merit following its recent cleaning. It resembles Murillo's treatments of the subject (see No.41) in the presence of the cherubim at the feet of the Virgin and in the sky, but the Virgin herself is a young girl, as in Velasquez's early picture (No.39), and her symbols (cypress, temple, city, ship) appear in a landscape setting. The allegorical figures in the bottom corners, Hope on the right with an anchor, are

92 (No.40). The Immaculate Conception (before cleaning), by Zurbarán (National Gallery of Ireland). Probably of the 1650s and clearly influenced by Murillo, but still showing the Virgin as a young girl.

uncommon (perhaps unique) in a painting of the subject and presumably included to express the special views of the patron on the dogma. Hope itself is another of the Virgin's symbols.

Zurbarán painted the subject on a number of occasions throughout his career, the Virgins always being recognizably akin, and a large painting in the National Gallery of Scotland (from the Louis-Philippe collection) includes figures of the parents of the Virgin, S. Joachim and S. Anne, in the lower corners. The significance of the figure on the left in the Dublin picture, complementary or contrasting with Hope, is not clear. With hand on breast and eyes shrouded by the Virgin's cloak, the figure may represent Faith, though Ignorance is the most usual connotation of being blindfold. The allegory is presumably designed as a modest contribution to the development of the debate about the Immaculate Conception.

During cleaning in 1981 the remains of a signature or inscription were discovered on a paper, lower left, resembling those in other works by Zurbarán

PROVENANCE: possibly from Valladolid; Captain Larkyns collection, 1872; W. Graham sale, 10 April 1886, lot 408 (as Valdés Leal); purchased by Dublin.

EXHIBITED: apparently not included in any exhibitions.

REFERENCES: 1932 Dublin catalogue, p.159; Guinard, 1960, no.17 (as a late work, if by Zurbarán, and giving details of early provenance).

Figure 92

Ascribed to Bartolomé Esteban MURILLO (1617–82)

41. *The Immaculate Conception*

The National Gallery
Canvas, 211 × 126cm

One of two 'Conceptions' by Murillo in the Louis-Philippe collection, where the picture was engraved and enjoyed some fame.

After cleaning and restoration in 1980–81, the picture appears far better in quality than was hitherto assumed. Though the paint has been much flattened by past lining, the extensive participation of Murillo himself in its creation seems likely. In the Immaculate Conceptions of Murillo, the subject is more confidently treated than in the earlier part of the 17th century, the Virgin borne heavenwards – as at her Assumption – through the urgency of the painter's technique, and her sym-

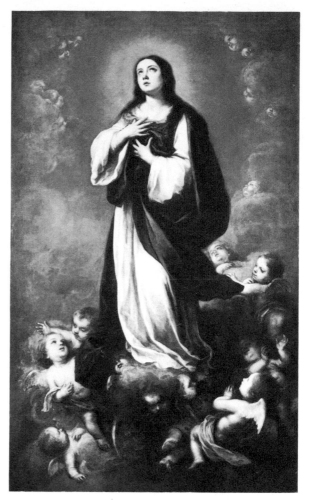

93 (No.41). The Immaculate Conception, ascribed to Murillo (National Gallery). A picture from the Louis-Philippe collection, which has recently been cleaned and restored.

bols – the arguments for the miracle – are treated with well-understood playfulness or even omitted.

The present picture, dating probably from the 1670s, is distinguished from an Assumption only in the presence of the crescent moon at the Virgin's feet, and the moon is unusual for Murillo in pointing downwards. A weaker variant of the picture is in the church of Santa Catalina (Capuchin convent) at Cadiz. Details in the picture resemble those in several other paintings by Murillo: the figure of the Virgin is similar in the 'Immaculate Conception' now at Detroit (Institute of Arts); the cherub in the left bottom corner resembles one in the 'Assumption' in the Hermitage (fig.13).

The left sleeve of the Virgin's dress seems originally to have covered more of her wrist.

PROVENANCE: from a convent at Cordova, according to the sale catalogue of the Louis-Philippe collection, Christie's, 7 May 1853, lot 163; bought for Cave for £810; William Cave sale, London, 29 June 1854, lot 78, bought by C. Levy (£747. 10s. 0d.); by 1883 in the collection of Joseph Trueman Mills, Rugby, by whom bequeathed, 1924.

EXHIBITED: Spanish Gallery, Louvre, 1838–48, no.152.

REFERENCES: Palomino, 3, 1724, p.422 (references to an 'Immaculate Conception' in the Convent of La Victoria at Cordova, but rejecting its attribution to Murillo); Curtis, 1883, nos.50(?),50h(?) and 54a; MacLaren and Braham, 1970, pp.78–80 as 'Follower of Murillo' (until the first edition of this catalogue, 1952, the picture had been accepted as a work by Murillo); Gaya Nuño, 1978, no.327; Angulo Iñíguez, 1981, no.737.

Figure 93

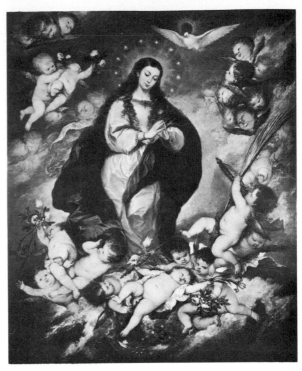

94 (No.42). The Immaculate Conception, by José Antolínez (1635–75) (the Ashmolean Museum, Oxford). A version of the theme by a younger contemporary of Murillo who worked in Madrid.

José ANTOLINEZ (1635–75)

With Coello, his slightly younger contemporary, Antolínez was the leading religious painter in Madrid, where he was born and died, in the later 17th century. He was well known for his arrogant temper, and, though dying young, he was a prolific painter, renowned for his many renderings of the Immaculate Conception, fiery and individual in their colouring, of which two survive in this country (No.42, and a painting of 1668 in the Bowes Museum).

42. *The Immaculate Conception*

The Ashmolean Museum, Oxford
Canvas, 213 × 170cm

In the Lansdowne collection (as a work by Alonso Cano), probably in the early 19th century.

As in Murillo's Immaculate Conceptions, the colourful cherubim play an active part in Antolínez's treatments of the theme, though many of them pay little attention to the figure of the Virgin, playfully holding her emblems (roses and other flowers, a palm and a sceptre) but not assisting to bear her higher into the sky. The Virgin herself looks downwards, hands clasped actively in prayer rather than folded in passive submission.

Several variants of the composition are known (Bilbao Museum, Caraman collection, and in another private collection).

PROVENANCE: in the Lansdowne collection as a work by Cano before 1897 (see References); Lansdowne sale, 7 March 1930, lot 36; bought for the Ashmolean Museum.

EXHIBITED: apparently not included in any exhibition.

REFERENCES: G. E. Ambrose, Lansdowne collection catalogue, 1897, p.12, no.252; *Archivo español de Arte*, 1954, pp.214–27 (D. Angulo Iñíiguez on Antolínez's Immaculate Conceptions), and 1956, p.4 (M. Soria); D. Angulo Iñíguez, *José Antolínez*, 1957, no.14; Gaya Nuño, 1958, no.248.

Figure 94

Bartolomé Esteban Murillo (1617–82)

Murillo was born and trained in Seville, and influenced in his earliest work by the paintings that Velasquez had produced there before his departure for Madrid in 1623. Known as 'the Spanish Van Dyck' and 'the Spanish Veronese', Murillo indeed quickly showed appreciation for the work of Van Dyck and Rubens, for the great Venetian painters, and for the later achievements of Velasquez. One journey to Madrid is recorded, in 1658, but there were probably others.

He became famous in Seville after the completion of a series of canvases in the cloister of S. Francisco el Grande (1645–46), and with two large paintings of saints (Isidoro and Leandro) for the Cathedral in 1656. In 1660 he was one of the founders and the first president of the Seville Academy. Amongst his most famous paintings were later series of canvases carried out for churches in Seville, especially the cycle in the church of the Caridad, a foundation of which Murillo was a member. Murillo's humanity expressed itself most clearly in his near-domestic paintings of the life of the Holy Family and in the closely related rustic scenes with beggar children. His style, as it matured, enabled him to master like no other painter the realm of heavenly visions, and above all the theme of the Immaculate Conception.

First mentioned in England in 1693 (by John Evelyn), his popularity grew throughout the 18th century, when several major works were in this country, their colour and technique appealing to painters of that time. In the earlier part of the 19th century, what was later to be considered the 'sentimental' character of his art, guaranteed him a position above almost all other artists. The 'Immaculate Conception' which Maréchal Soult had taken from the Hospital of the Venerables in Seville in 1810 fetched an unheard of price at auction in 1852. Gradually his popularity declined, and Velasquez, Goya, El Greco and even Zurbarán have taken the place of Murillo in the popular imagination.

Bartolomé Esteban MURILLO (1617–82)

43. *Self-portrait*

The National Gallery
Canvas, 122 × 107cm
Signed and inscribed on the tablet.

Imported to this country before 1729, the portrait belonged briefly to Frederick, Prince of Wales, and must have been known to Hogarth.

According to the inscription the portrait was made by Murillo at the request of his children. Despite the unlined appearance of the face it probably dates from the early 1670s, when the painter would have been in his fifties. In design it resembles an engraved frontispiece; and it was used for an engraving produced in Brussels in 1682.

In 1724 Palomino mentioned two self-portraits by Murillo, one that was sent to Flanders to be engraved, and one belonging to Murillo's son, Gaspar, in which the artist wore a stiff collar, a *golilla*. The second portrait is known in several versions and in engravings and it appears to show the artist some years younger than No.43.

PROVENANCE: Probably acquired in Spain by Sir Daniel Arthur passing by 1729 to a Mr 'Bagnall' who had married Arthur's widow; sold in about 1740 to Frederick, Prince of Wales, and still recorded in his possession in 1750; Sir Lawrence Dundas sale, 31 May 1794, lot 25, bought by Lord Ashburnham; Earl of Ashburnham sale, 20 July 1850, lot 50; Earl Spencer, Althorp House; bought from the Spencer collection, 1953.

Bart. Murillo seipsum depin
gens pro filiorum votis acprae
bus explendis

95 (No.43). Self-portrait, by Murillo (National Gallery). Painted, according to the inscription, at the request of Murillo's children, probably in the early 1670's, and perhaps designed to be used for an engraving.

EXHIBITED: British Institution, 1855, no.53; Manchester, 1857, no.640; Leeds, 1868, no.342; South Kensington Museum, 1876–80, no.77; 1895–96, New Gallery, no.103; 1913–14, Grafton Galleries, no.99; 1920–21, Royal Academy, no.83, Birmingham, *Art Treasures*, 1934, no.7; *Pictures from Althorp*, Agnew's, London, 1947, no.22; 1951, Edinburgh, no.28.

REFERENCES: Curtis, 1883, no.462; *National Gallery Catalogues, Acquisitions 1953–62*, pp.65ff.; MacLaren and Braham, 1970, pp.71–74; Young, 1980, no.264; Angulo Iñíguez, 1981, no.414 (dating: about 1670).

Figure 95

Bartolomé Esteban MURILLO (1617–82)

44. *Don Justino de Neve*

The National Gallery

Canvas, 206 × 129.5cm

Inscribed and dated on the panel beneath the coat of arms: 1665.

Looted by the French in Seville in 1810 and imported to this country before 1818.

Don Justino de Neve, a Canon of Seville Cathedral, was a close friend and patron of Murillo, and one of the executors of his will. Murillo's painting was always regarded as the masterpiece amongst his portraits, being singled out even in the early 18th century, when the little dog, directing affectionate attention to the sitter, excited special admiration. For a European portrait of its date the picture is austerely designed, attention being focused on the head of the sitter, his hands, the dog and the few objects on the table. The purple curtain and the green tablecloth were enlarged by the artist in the course of painting the portrait.

Don Justino had been instrumental in commissioning the famous series of paintings by Murillo in the church of Sta. María la Blanca (No.50), which he produced in 1662–65 and the pictures of the late 1670s in the Hospital of the Venerables Sacerdotes, including the Soult 'Immaculate Conception' (fig.42), and he bequeathed this portrait to that institution on his death in 1685. It was seen there in the ante-refectory by early writers on Spanish art, Palomino, Ponz and Ceán Bermúdez, and was found there by the French when they invaded Seville. They included it amongst the 999 paintings assembled in the Seville Alcázar from which a museum of Spanish art was to be founded. In England in the 19th century Waagen was greatly impressed by the portrait: 'In point of elevation of conception, admirable keeping in silvery tones, extending equally to the accessories, among which is a clock, this is one of the finest pictures I know by the master.'

The coat-of-arms and the inscription panel are probably an early addition to the picture, but the date given there, 1665, seems reliable. The wording, in not very intelligible Latin, describes the origin of the picture as a work painted by Murillo at the request of the sitter and while working for him. This probably refers to the cycle of canvases in Sta. Maria la Blanca, painted for Don Justino and completed in 1665.

The painting, which is well preserved, was cleaned and restored shortly before acquisition by the National Gallery in 1979. X-ray photographs of the head, the hands and the dog show no traces of alterations in these areas made by the artist.

96 (No.44). Don Justino de Neve, by Murillo (National Gallery). A portrait of 1665 of a friend and patron of the artist, a Canon of Seville Cathedral.

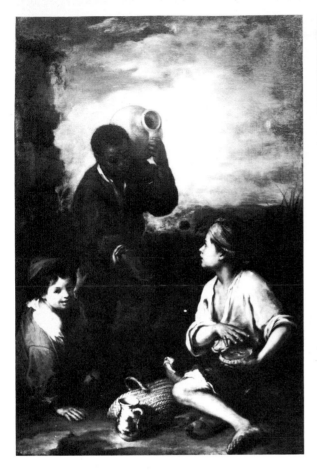

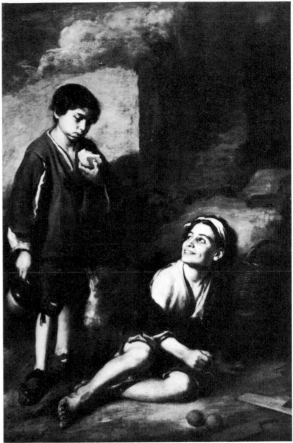

PROVENANCE: in the Hospital of the Venerables Sacerdotes, Seville, from 1685 (see above); confiscated during the French occupation of Seville, reaching England before 1818 (see exhibitions), possibly through the dealer Delahante; its first recorded owner was George Watson Taylor, M.P.; Taylor sales, 14 June 1823, lot 5 (withdrawn), and 24 July 1832 (at Erlestoke Park), lot 77; acquired by Lord Lansdowne, and by descent; bought from the Trustees of the Bowood collection through Messrs Agnew, 1979.

EXHIBITED: British Institution, 1818, no.36; Lansdowne collection exhibition, Agnew's, London, 1954–55, no.35.

REFERENCES: Palomino, 3, p.432; Ponz, 9 (1780), p.123; Ceán Bermúdez, 1800, 4, p.60, and 1806, pp.93–94; Curtis, 1883, no.470; George E. Ambrose, Lansdowne collection catalogue, 1897, p.66; Mayer, 1923, pl.229; Braham in *The Burlington Magazine*, 1980, pp.192–94; Young, 1980, no.91; Angulo Iñiguez, 1981, no.415.

Figure 96

97,98 (Nos.45 and 46). Two Peasant Boys and a Negro Boy, and Two Peasant Boys, by Murillo (Dulwich Gallery). Probably of the 1660s and two of the most famous Murillos in Britain in the 19th century.

Bartolomé Esteban MURILLO (1617–82)

45. *Two Peasant Boys and a Negro Boy*

The Governors of Dulwich Picture Gallery
Canvas, 168.3 × 109.8cm

In the Dulwich collection, together with its companion (No.46), before 1804, and possibly acquired in 1786.

The two Dulwich pictures of peasant boys were the most famous Murillos in the country in the early 19th century, and they exerted a considerable influence on British taste and art which continued after the denunciation of the pictures by Ruskin in 1853 ('mere delight in foulness'). Such peasant scenes, of which a later group are at Munich, though indebted to painters of the earlier 17th century, especially Ribera, are a phenomenon that

remained more or less unique to Murillo until the more condescending paintings of the poor in 18th century art.

The earliest of Murillo's peasant boy paintings, a solemn and introspective picture in the Louvre, is probably of the early 1650s and shows a considerable debt to Velasquez. The Dulwich pictures, freer in handling and more self-conscious in the teasing behaviour of the boys, may be of the later 1660s, while the series in Munich ('Dice-players', 'Pie-eaters', 'The Fruit-seller' and 'The Lice-searcher') appear to show greater confidence in their design and contain more 'picturesque' detail, especially still-lives and dogs.

PROVENANCE: EXHIBITED: REFERENCES: see following entry.

Figure 97

Bartolomé Esteban MURILLO (1617–82)

46. *Two Peasant Boys*

The Governors of Dulwich Picture Gallery
Canvas, 164.9 × 110.5cm

Companion to No.45.

PROVENANCE: probably in the Noel Desenfans sale, 8 *sqq.* April 1786, lots 177 and 178; listed with the Dulwich pictures, 1804, nos.8 and 9; Bourgeois bequest to Dulwich, 1811.
EXHIBITED: British Institution, 1828, nos.66 and 69.
REFERENCES: Curtis, 1883, nos.435 (No.46), and 452 (No.45); Mayer, 1923, pls.212,213; J. Montana, *Archivo español de Arte*, 1962, pp.271–73 (variant of No.46 in Paris collection); Gaya Nuño, 1978, no.167 (No.46), and 168 (No.45); Young, 1980, nos.185,186; Peter Murray, Dulwich catalogue, 1980, p.85 (nos.222 and 224); Angulo Iñíguez, 1981, no.382 (No.46), and 383 (No.45) (dating: about 1670).

Figure 98

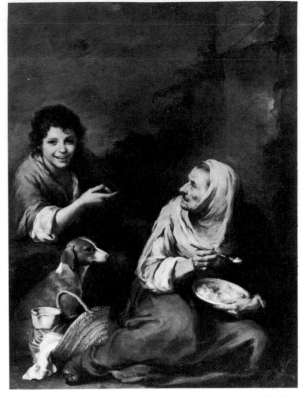

99 (No.47). A Peasant Woman and a Boy, by Murillo (National Trust, Blathwayt collection, Dyrham Park). Probably of about 1670, and related in conception to the early Velasquez at Edinburgh (fig.65).

Bartolomé Esteban MURILLO (1617–82)

47. *A Peasant Woman and a Boy*

The National Trust
(Blathwayt collection, Dyrham Park)
Canvas, 143 × 103.5cm

In the Blathwayt collection at Dyrham since the later 18th century, where exhibited with a copy, probably by Gainsborough.

Richer in colour and more fluent in handling than the Dulwich paintings (Nos.45 and 46), the picture has the same element of conscious humour, the boy apparently inviting mockery of the old woman, a distant descendant of the much sterner woman frying eggs in the presence of a more solemn boy in Velasquez's early painting (No.13). In the presence of the dog and the grouping and prominence of the still-life, the painting resembles the peasant scenes at Munich, and it probably dates from about 1670.

Other versions of the composition are known,

including one purchased by the Duke of Wellington in 1847, which is in the Duke of Wellington collection.

PROVENANCE: William Blathwayt III (died 1787), Dyrham Park, and previously belonging to his uncle; by descent at Dyrham.

EXHIBITED: Royal Academy, 1882, no.158; 1980 Nottingham University, no.53.

REFERENCES: Curtis, 1883, no.450B; Mayer, 1923, pl.208; J. Kenworthy Brown, *Dyrham Park*, 1967, p.12; Angulo Iñíguez, 1981, no.400 (dating: about 1670).

Figure 99

Bartolomé Esteban MURILLO (1617–82)

48. *The Prodigal Son feasting*

Beit Collection, Blessington
Canvas, 104.8 × 135.9cm

One of a series of six canvases illustrating the parable of the Prodigal Son, bought in Paris in 1867 by the Earl of Dudley.

The patron who commissioned the series, probably in the 1660s, and the reason for its being ordered are unknown. Murillo apparently used a series of engravings by Jacques Callot for guidance, and sketches by him of four of the compositions (including No.48) with slight variations, exist in the Prado Museum. As a banquet scene, the painting recalls in design the compositions used for various New Testament subjects, including the Marriage at Cana of which Murillo painted a famous canvas (Barber Institute, Birmingham).

PROVENANCE: together with four others in the series apparently in the Marqués de Narros collection, Zaráuz, Guipúzcoa, in the mid-19th century; acquired through José de Madrazo by the Marqués de Salamanca, and bought as the Salamanca sale, Paris, 3–6 June 1867, by the Earl of Dudley; purchased by Sir Alfred Beit between 1896 and 1901. The sixth painting in the series ('The Return of the Prodigal Son'), for sale in Madrid in the mid-19th century, was presented by Queen Isabella to Pope Pius IX, who exchanged it with Lord Dudley between 1868 and 1871.

EXHIBITED: Leeds, 1868, nos.2917–21 (the series); Royal Academy, 1871, no.412; 1895–96, New Gallery, no.126; 1901, Guildhall, no.95; 1913–14, Grafton Galleries, no.80; 1947, Arts Council, no.19.

REFERENCES: Curtis, 1883, no.187; Mayer, 1923, pl.117; Gaya Nuño, 1978, no.264 (as the last in date of Murillo's narrative cycles, about 1675); Young, 1980, no.251; Angulo Iñíguez, 1981, no.20 (dating: possibly before 1660).

Figure 100

100 (No.48). The Prodigal Son feasting, by Murillo (Beit collection). One of a series of six paintings of the parable of the Prodigal Son, possibly of the 1660s.

Ascribed to Bartolomé Esteban MURILLO (1617–82)

49. *S. John the Baptist in the Wilderness*

The National Gallery
Canvas, 120 × 105.5cm

Probably brought from Spain by Richard Cumberland in 1781; acquired by Gainsborough in 1787, the year before his death.

Though famous in the 18th century as a devotional composition by Murillo and accepted as an original when acquired by the National Gallery, the picture has been regarded recently as the work of a follower of Murillo. After cleaning in 1980–81, the picture (like No.41) has emerged as a work of higher quality than previously supposed, though hastily painted and worn in appearance.

The composition is unusual in the scale of the figure in relation to the landscape, but the design appears to be complete, rather than being the upper half of a full-length composition, since stretch-marks are present at the edges of the canvas on all sides. The style is that of Murillo in the 1660s.

PROVENANCE: believed to have been acquired for King Charles II of Spain from Don Juan del Castillo, about 1670; most probably acquired in Spain by Cumberland, passing to Noel Desenfans and in 1787 to Gainsborough; Gainsborough sale, 30 *sqq.* March 1789, lot 34; sold to Sir Peter Burrell (Lord Gwydyr); Gwydyr sale, 9 May 1829, lot 84; Maxwell sale, 1 March 1873, lot 107, bought by Rutley; Cavendish Bentinck sale, 8 *sqq.* July 1891, lot 558; bought for Dr Ludwig Mond; Mond bequest, 1924.
EXHIBITED: Royal Academy, 1877, no.238.
REFERENCES: Curtis, 1883, no.336,336f,336g and 336k; MacLaren and Braham, 1970, p.80 (Follower of Murillo); Gaya Nuño, 1978, no.328; Angulo Iñíguez, 1981, no.2158.

Figure 101

Bartolomé Esteban MURILLO (1617–82)

50. *'The Triumph of the Eucharist'*

The Trustees of the Faringdon collection, Buscot Park
Canvas, 196 × 250cm

Imported after being sold in Paris in 1865.

One of four large arched canvases painted by Murillo at the instigation of Justino de Neve (No.44) for the church of Sta. Maria la Blanca (S. Mary of the Snows) in Seville about 1665. Two illustrate the story of the foundation of Sta. Maria Maggiore, the mother church in Rome (Prado Museum, Madrid), and a smaller canvas, companion to the present picture, shows The Immaculate Conception with a group of worshippers in the left corner (Louvre, Paris). The Virgin (as Christ's first 'tabernacle') was closely associated with the Eucharist, and the figure who carries it on high in the picture, bearing keys and a book in her left hand, probably represents the Church.

Celebrated publicly in Seville in 1661, the glorification of the Virgin, with particular reference to the Immaculate Conception, is one of the principal themes of the four canvases. She appears with the Christ-child in a vision in the first of the Prado paintings, pointing to the spot where a miraculous fall of snow is to determine the site of the Basilica of Sta. Maria Maggiore. This vision is recounted in the second Prado canvas to Pope Liberius (352–66), who proceeds to the site for the ceremony of the founding of the basilica. The two smaller canvases are closely related in composition, and in the presence of contemporary figures (possibly including some portraits) to whom the visions of the Immaculate Conception (on the Gospel side of the church), and the Church with the Eucharist (on the Epistle side) are vouchsafed.

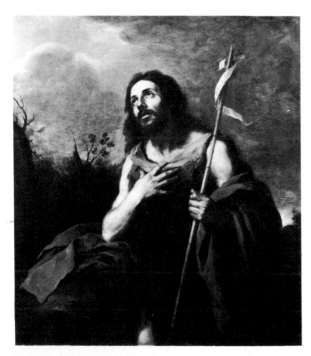

101 (No.49). S. John the Baptist in the Wilderness, by Murillo (National Gallery). Famous in the 18th century, when owned by Gainsborough, the picture has been recently cleaned.

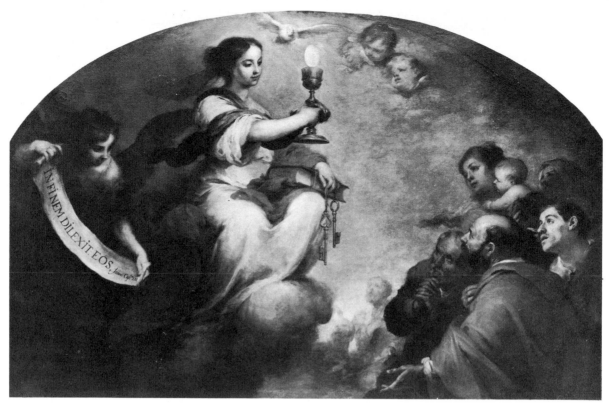

Cherubim bearing a scroll, prominently labelled in capitals 'In principio dilexit eam', accompany the Virgin in The Immaculate Conception, matching the angel who appears behind the figure with the Eucharist, whose scroll is labelled in capitals 'In finem dilexit eos' followed by a reference to its source 'Joanis Cap.e XIII': 'He loved them unto the end' (John, xiii, 1).

PROVENANCE: one of a group of four canvases from the church of Sta. Maria la Blanca, Seville (see above); removed by Maréchal Soult, who retained possession of three of the series for a few years; No.50 passed to General Faviers; in the Pourtalès sale, Paris, 27 March 1865, lot 199, probably acquired by Lyne Stevens; and in his sale, 10 May 1895, lot 324; Sir Alexander Henderson; Lord Faringdon.

EXHIBITED: Burlington Fine Arts Club, 1908, no.16; 1913–14, Grafton Galleries, no.79; 1920–21, Royal Academy, no.85.

REFERENCES: Curtis, 1883, no.231; D. Angulo Iñíguez in *Archivo Español de Arte*, 165, 1969, pp.13–42 (discussion of the series, and including illustrations of Sta. Maria la Blanca); Gaya Nuño, 1978, no.106; Young, 1980, no.110; Angulo Iñíguez, 1981, no.42.

Figure 102

102 (No.50). 'The Triumph of the Eucharist', by Murillo (Trustees of the Faringdon collection). One of a famous series of four canvases painted about 1665 at the instigation of Justino de Neve (fig.96) for Sta. Maria la Blanca in Seville.

Bartolomé Esteban MURILLO (1617–82)

51. *Christ healing the Paralytic at the Pool of Bethesda*

The National Gallery
Canvas, 237 × 261 cm

Purchased from Maréchal Soult for George Tomline and imported from Paris in 1847; considered by Waagen (1854) 'the finest Murillo in England'.

One of the series of canvases painted by Murillo for the church of the Caridad, the most famous works of art in Seville until their removal by the French in 1810. Murillo's paintings, of which two remain in the Caridad, were apparently installed in 1670 and they illustrated the Cardinal Acts of Charity, the story of Christ at the pool of Bethesda (from John, v, 2–8) representing Visiting the Sick. The theme, involving no violence and much appropriate 'picturesque' detail, was particularly well suited to Murillo, and the influence of Venetian painting

91

appears to advantage in the architecture of the pool, illuminated by the angel who 'went down at a certain season into the pool, and troubled the water.'

The confraternity of the Caridad had been founded in the 16th century for the succour of the poor and the burial of the dead. It was reformed about 1660 and through the efforts of its leader (1663–79), Don Miguel Mañara (see No.37) a hospital was built, and the church completed (1667–70). Murillo became a member of the confraternity in 1665 and his six canvases, though installed in 1670, were not all paid for until 1674, when the painter received 8000 *reales* for each of four of the canvases, including No.51. The two canvases still in the church illustrate 'Moses striking the Rock' and 'The Feeding of the Five Thousand', and the smaller canvases from the nave of the church comprise No.51 (the second canvas on the Epistle side), 'The Liberation of S. Peter' (now at Leningrad), 'The Return of the Prodigal Son' (Washington), and 'Abraham and the Three Angels' (Ottawa). The seventh Act of Charity was represented by the 'Entombment of Christ', the altarpiece sculpted by Bernardo Simón de Pineda.

PROVENANCE: removed from the church of the Caridad in 1810; appropriated by Maréchal Soult and taken to Paris before April, 1812; purchased for George Tomline of Orwell Park in 1846 or '47; by descent to E.G. Pretyman, and bought at his sale, 28 July 1933, lot 22, for Owen Hugh Smith; purchased from Agnew's by the executors of W. Graham Robertson and presented in his memory, through the National Art-Collections Fund, 1950.
EXHIBITED: Royal Academy, 1910, no.46.
REFERENCES: Waagen, 1854, 3, p.439; Curtis, 1883, no.182; Mayer, 1923, pl.131; MacLaren and Braham, 1970, pp. 67–70; Jonathan Brown in *The Art Bulletin*, 1970, pp.265–77 (detailed account of the Confraternity and church, and the dating and subject of the decorations); Gaya Nuño, 1978, no.252; Young, 1980, no.148; Angulo Iñíguez, 1981, no.82.

Figure 103

103 (No.51). Christ healing the Paralytic at the Pool of Bethesda, by Murillo (National Gallery). One of the celebrated series of six canvases, illustrating cardinal Acts of Charity, which Murillo painted for the church of the Caridad in Seville, probably in the later 1660s.

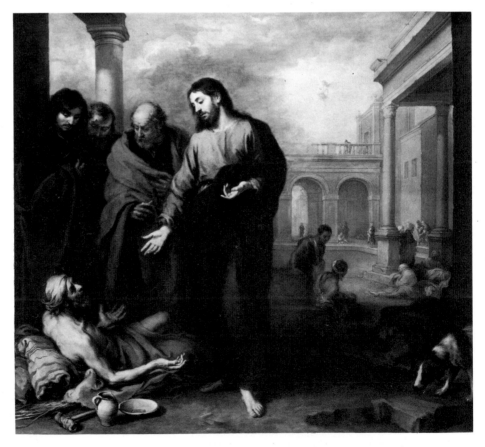

Bartolomé Esteban MURILLO (1617–82)

52. *The Virgin and Child in Glory ('La Vierge Coupée')*

The Walker Art Gallery, Liverpool
Canvas (arched top), 236 × 169cm

A large section of the upper part of the canvas, including half the figure of the Virgin with the Child, was cut out, apparently before 1800, and a copy substituted. This portion of the picture is first recorded in this country in 1824. The remainder was purchased from the heirs of Maréchal Soult in 1862, and the two sections were joined together again in London.

A late work of Murillo, the picture is probably the one ordered in 1673 by Archbishop Ambrosio Spinola for the altar of the lower oratory of the Archiepiscopal Palace in Seville. Painted as a devotional image rather than a religious narrative, the Virgin and Child – covetable as a separate painting – look directly at the spectator, supported in a static position by the cherubim who mainly look downwards.

The attractive idea that thieves cut out part of the upper section of the picture when Soult was on the point of seizing it gained currency in the 19th century, and likewise the idea that Soult himself was responsible for the mutilation, but Ceán Bermúdez claimed that the picture in the lower oratory of the Archiepiscopal Palace had already been cut before 1800, and the upper part made up. An engraving of the composition had been made in 1760. Soult had a copy made by Louis-François Lejeune which was inserted into the picture.

PROVENANCE: see above; the part with the Virgin and Child was in the collection of Edward Gray of Harringhay by 1824 and bought by Lord Overstone in 1838; the remainder was bought in at the Soult sale in Paris, 22 May 1852, lot 59, and purchased from Soult's heirs for Lord Overstone in 1862; the two pictures, then reunited, passed by descent to Lord Wantage and to the Loyd collection; presented to Liverpool by the National Art-Collections Fund, 1953.

EXHIBITED: British Institution, 1863, no.1; Royal Academy, 1885, no.164; Lockinge House exhibition, Birmingham City Art Gallery, 1945, no.24.

REFERENCES: Ceán Bermúdez, 1800, 2, p.62; Curtis, 1883, no.79; Mayer, 1923, pl.177; Walker Art Gallery catalogue, Foreign Schools 1977, pp.137–38; Gaya Nuño, 1978, no.166; Young, 1980, no.184; Angulo Iñíguez, 1981, no.151.

Figure 104

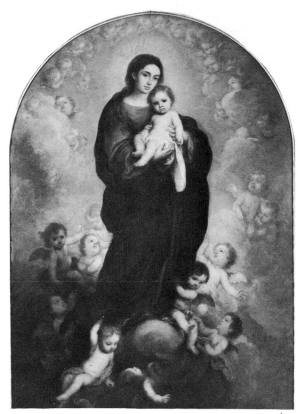

104 (No.52). The Virgin and Child in Glory ('La Vierge Coupée'), by Murillo (Walker Art Gallery, Liverpool). The upper part of the picture (the Virgin and Child) was cut out and stolen before 1800 and the remainder taken from Seville by Maréchal Soult, the two parts were reunited in London in 1862.

Bartolomé Esteban MURILLO (1617–82)

53. *The Holy Family in the Carpenter's Shop*

The Trustees of the Chatsworth Settlement
Canvas, 96.5 × 68.5cm

Possibly acquired, like most of the foreign paintings at Chatsworth, in the earlier 18th century.

A late representation on a relatively small scale of a theme frequently treated by Murillo. The general influence of Correggio is apparent in the picture, and Murillo may have known of Dutch cabinet pictures by Rembrandt and his circle of domestic scenes illustrating the New Testament. By tradition the wood being hewn by S. Joseph alludes in such compositions to the Cross, and the sleeping Child with his swaddling clothes to the dead Christ in his shroud, to which theme Murillo has added a group of cherubim hovering in the air.

93

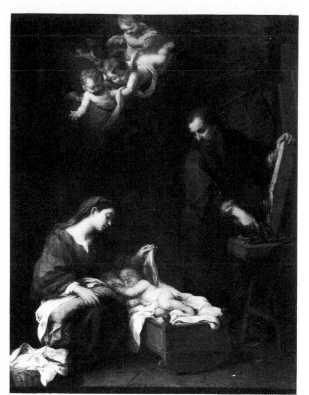

105 (No.53). The Holy Family in the Carpenter's Shop, by Murillo (Trustees of the Chatsworth Settlement). Unusual for Murillo in its scale, the picture may be influenced by Dutch as well as Italian paintings.

PROVENANCE: the majority of the foreign paintings now at Chatsworth were acquired by the second Duke of Devonshire (1673–1729), and by the fourth duke through marriage to the daughter of Lord Burlington (see Nos.17 & 28).
EXHIBITED: Chatsworth exhibitions: Derby, 1948, and Sheffield, 1948–49, no.9, Leeds City Art Gallery, 1954–5, no.20, Graves Art Gallery, Sheffield, 1955, no.20, Arts Council, 1955–56, no.19, Royal Academy, London, 1980–81 (and previously in America), no.36.
REFERENCES: Waagen, 1854, 3, p.351; Curtis, 1883, no.143; Mayer, 1923, pl.58; Gaya Nuño, 1978, no.174; Young, 1980, no.192; Angulo Iñíguez, 1981, no.187 (dating: about 1670–75).

Figure 105

Bartolomé Esteban MURILLO (1617–82)

54. *The Two Trinities ('The Pedroso Murillo')*
The National Gallery
Canvas, 293 × 207cm

Acquired in Seville and imported in or before January 1810.

A very late work of Murillo, the picture represents the comparatively rare theme of the Heavenly and Earthly Trinities, with Christ between his parents in a landscape and God the Father and the Holy Spirit above. The mystical character of the subject is emphasized by Murillo by placing the Child on a pedestal with the Virgin sitting and S. Joseph kneeling, and by the elaboration of the heavenly vision above, created with the buoyancy characteristic of his latest, 'vaporous', manner.

The picture was in the Pedroso collection in Cadiz in the 18th century, and may have been painted for the family about 1680. Murillo was

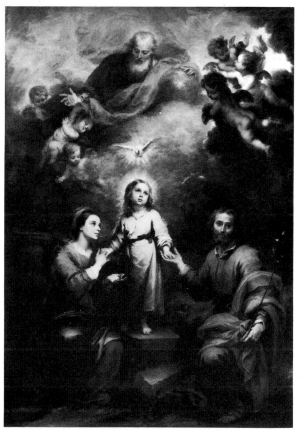

106 (No.54). The Two Trinities ('The Pedroso Murillo'), by Murillo (National Gallery). A late work which belonged to the Pedroso family in Cadiz.

94

engaged on a picture for the Capuchin church at Cadiz when, according to Palomino, he met with an accident that was to cause his death.

PROVENANCE: in the Pedroso collection, Cadiz, in 1708 (see above); brought in Seville by 1800 and acquired for Buchanan by January 1810; by 1824 in the collection of Thomas Bulkeley Owen and exhibited for sale at George Yeates' Gallery in London, May 1837; purchased for the National Gallery.

REFERENCES: Curtis, 1883, no.135: Mayer, 1923, pl.199; Buchanan, 2,202; MacLaren and Braham, 1970, pp.61–63; Gaya Nuño, 1978, no.304; Young, 1980, no.298; Angulo Iñíguez, 1981, no.129.

Figure 106

Still-Life and Landscape

'But in Spain, as among the classical ancients, landskip was only an accessory or conventional, and seldom really treated as a principal either in art or literature' (Richard Ford, 1845). The absence of a strong tradition of landscape painting is a distinctive feature of Spanish art, and paintings inspired by the Spanish landscape became common only when foreign artists began to visit the country in the early 19th century.

Velasquez and Murillo frequently introduced landscapes in portraits and narrative compositions, and Velasquez painted views of the Villa Medici when he was in Rome, but Spanish painters of the 17th century who specialized in landscape, including Francisco Collantes, Juan Fernández (mainly a painter of still-life), and Ignacio Iriarte, who collaborated with Murillo, are very few. The 18th century is distinguished by the work of Luis Paret, who represented particular sites and occasions in his canvases.

The relative dearth of landscape is compensated by an abundance of distinctive still-life, a speciality of many of the ablest Spanish painters. The history of still-life painting in Spain begins in the early years of the 17th century with the rare, almost sacramental, still-lives of Sánchez Cotán and Zurbarán, and with the work of Juan van der Hamen. More integrated still-life compositions made their appearance in these years in the work of Juan Fernández, developing into the agitated flower paintings of Juan de Arellano and Bartolomé Pérez. Velasquez in an occasional painting and Murillo in his peasant scenes are responsible for some of the most memorable of all passages of still-life in Spanish art.

The mid-18th century in Spain is celebrated in painting chiefly because of the still-lives of Luis Meléndez, 'superior to anything of that kind' in the opinion of Joseph Baretti, who discovered Meléndez living in poverty and obscurity in Madrid in 1760. Last of all occur the still-lives of Goya, as intense as any earlier still-life painting in Spain, but consecrated chiefly to the depiction of meat and dead flesh.

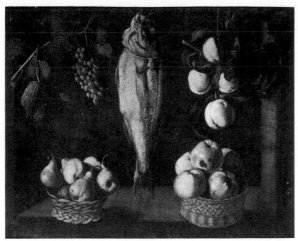

107 (No.55). Still-life with Fish, School of Seville (Stirling collection, Keir). Formerly attributed to Velasquez, and characteristic of early 17th-century still-life in its very formal arrangement.

108 (No.56). Still-life with Apples in a Dish, by Juan Fernández (died 1657) (Royal Collection). In the collection of King Charles I, and by an artist much patronized by British diplomats in Spain.

SCHOOL OF SEVILLE

55. *Still-life with Fish*

Lt. Col. William Stirling of Keir
Canvas, 66 × 83.8cm

Bought by William Stirling in Seville in 1845.

Characteristic of still-life painting in Spain in the early 17th century is the isolation of the components, the introduction of hanging objects filling the upper half of the canvas, and the incongruity (sometimes hinting at symbolic meaning) of the elements, here a large fish surrounded by fruit. Formerly attributed to Velasquez, the picture has also been ascribed to Alejandro de Loarte, a contemporary, active in Toledo, who specialized in *bodegones*.

PROVENANCE: see above.
EXHIBITED: *17th-century Art in Europe*, Royal Academy, 1938, no.214.
REFERENCES: Stirling, 1848, 3, p.1410; Curtis, 1883, Velasquez, no.90.

Figure 107

Juan FERNANDEZ ('El Labrador') (died 1657)

Landscape and still-life painter active in Madrid from the 1630s, 'El Labrador' ('the countryman') was much employed by Sir Arthur Hopton, who became British Ambassador in Madrid, and who apparently encouraged the painter in 1635 to depict flowers. Several of his still-lives were despatched to England and the painting here exhibited belonged to King Charles I.

56. *Still-life with Apples in a Dish*

Her Majesty the Queen
Canvas, 85.1 × 71.1cm

Presented to Charles I by Lord Cottington, Ambassador to Spain (1629–31).

In style, composition and subject matter the picture represents a considerable development of the 'additive' approach to still-life habitual in Spain in the early 17th century and characteristic of the work of van der Hamen. The picture must to this extent be influenced by Flemish and Italian still-lives, though it retains the sombre intensity of van der Hamen.

PROVENANCE: recorded in van der Doort's catalogue of Charles I's collection, 1639, as a present from Sir Francis Cottington; presumably in the

Commonwealth sale, 1651, but later history unknown.

EXHIBITED: 1967, Bowes Museum, no.26; 1981, Nottingham University, no.35.

REFERENCES: E. Young, *Apollo*, March, 1965, pp.214–15; exhibition catalogues, by Eric Young (1967) and by Enriqueta Harris Frankfort and Philip Troutman (1981) (with further references); Trapier, 1967; E. Harris in *Archivo español de Arte*, 1974, pp.162–64 (flower-pieces).

Figure 108

Juan de ARELLANO (1614–76)

Born at Santorcaz (Madrid), Arellano worked and died in Madrid. A prolific artist, he was, with Bartholomé Pérez (also active in Madrid), the leading flower painter of 17th-century Spain. His work is comparable to that of contemporary Italians, and the younger French still-life painter, Jean-Baptiste Monnoyer (1639–99).

57,58. *Flowers in a Glass Bowl, Flowers in a Gold-bordered vase*

Mrs E.P. Johnson-Taylor
Canvas, 80 × 58.4 and 82.5 × 61cm

109,110 (Nos.57,58). Flowers in a Glass Bowl, Flowers in a Gold-bordered Vase (1665), by Juan de Arellano (1614–76) (Mrs E.P. Johnson-Taylor). Arellano and Bartolomé Pérez were the two most prolific and accomplished flower painters of 17th-century Madrid.

Both signed and the second dated, lower right, 1665.

Recorded only recently in this country.

The flowers appear to be mainly the more exuberant species of the late spring and early summer, so much favoured by the painters of the later 17th century, peonies, tulips and lilies, with pinks and honeysuckle at the edges. The vases are not much ornamented, as the painter often preferred, but enlivened by the curved stems of the flowers seen through the water.

PROVENANCE: early history unknown.
EXHIBITED: 1967, Bowes Museum, nos.53 and 54.
REFERENCES: Eric Young in Bowes Museum exhibition catalogue (1967).

Figure 109,110

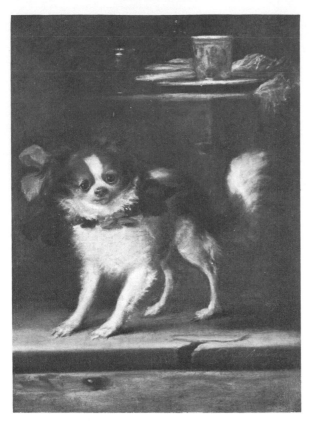

111 (No.59). A Pet Dog before a Table, by Antolínez (Stirling collection, Keir). Signed and dated 1670, and the work of an artist who normally painted religious subjects (fig.94).

José ANTOLINEZ
(see No.42)

59. *A Pet Dog before a Table*

Lt. Col. William Stirling of Keir
Canvas, 55.9 × 41.3cm.
Signed, lower right, and dated: 1670

Acquired for William Stirling at General Meade's sale in 1851.

A still-life with a beaker and a plate appears on a low ledge above the dog, which stands at the edge of a pavement. An unusual work for Antolínez, who is mainly known for his religious compositions. Portraits of dogs, though included by Velasquez and Murillo in larger compositions, are rare before the later years of the 18th century.

PROVENANCE: General the Hon. John Meade sale, 6–8 March, 1851, lot 250 (£8).

EXHIBITED: Manchester, 1857, no.747; *17th-Century Art in Europe*, Royal Academy, 1938, no.216.
REFERENCES: D. Angulo Iñiguez, *José Antolínez*, 1957, under no.48; Gaya Nuño, 1958, no.260.

Figure 111

Luis MELENDEZ (1716–80)

Born in Naples, the son of Francisco Antonio Meléndez (see No.31). Trained by his father and Louis-Michel van Loo, who was active in Spain from 1737. Apart from a later visit to Italy, Meléndez worked in Madrid and became a specialist in still-life. He was patronized by King Ferdinand VI (1713–59) and painted still-lives certainly in the period 1760–72 when those later in the palace of Aranjuez (now in the Prado) may have been produced. A self-portrait by Meléndez holding an 'academy' drawing (1746) is in the Louvre.

60. *Still-life with Bread and Strawberries*

Mrs G.B. Springell
Canvas, 35.6 × 48.2cm.
Signed with initials, lower right.

Recorded only recently in this country.

Meléndez was not attracted by the elaboration of late 17th-century still-life painting, and his work recalls, in the arrangement of the objects and in its high perspective, the earliest Spanish still-life. In their scale and intensity, though not in lighting or handling, his paintings approach the contemporary still-lives by Chardin (1699–1779).

PROVENANCE: early history unknown.
EXHIBITED: *European Masters of the Eighteenth Century*, Royal Academy, 1954–55, no.345.
REFERENCES: Gaya Nuño, 1958, no.1779; Eleanor M. Tufts in *The Art Bulletin*, 1972, pp.63–68 (life of Meléndez, and dating of his still-lives).

Figure 112

112 (No.60). Still-life with Bread and Strawberries, by Luis Meléndez (1716–80) (Mrs G.B. Springell). The most distinguished still-life painter of 18th-century Spain, the great majority of whose works are in the Prado Museum, Madrid.

113 (No.61). Still-life with Lemons and Nuts, by Meléndez (York City Art Gallery). Possibly part of the same series as No.60 (fig.112).

Luis MELENDEZ (1716–80)

61. *Still-life with Lemons and Nuts*

York City Art Gallery
Canvas, 37.1 × 50.1cm
Signed with initials, lower right.

Recorded in this country in 1943.

Possibly a companion piece or part of the same series as No.60, though less well preserved.

PROVENANCE: bought by F.D. Lycett Green from Matthiesen, 1943, and presented by him through the National Art-Collections Fund, 1955.

EXHIBITED: *Lycett Green Collection*, York, 1955, no.52; *Primitives to Picasso*, Royal Academy, 1962, no.172; 1967, Bowes Museum, no.83.

REFERENCES: Gaya Nuño, 1958, no.1780; York City Art Gallery catalogue, 1961, p.96.

Figure 113

Luis PARET (1746–99)

A Madrid painter, trained by Antonio González Velázquez and Charles de la Traverse, Paret is best known for his landscapes and scenes of social life, which recall similar works produced in the later 18th century in France and Italy, where Paret himself had travelled.

62. *The Port of Bilbao*

The National Trust
(Bearsted collection, Upton House)
Canvas, 67.3 × 94cm
Signed with initials

First recorded in this country in 1922.

One of the most famous of the works of Paret, the picture may be from the mid-1780s. The site has been identified as the Quay at Olaveaga, on the north side of Bilbao. In 1788 Alexander Jardine described the port as 'an agreeable place, a pretty little river, and a fine hilly country, – but the town again in the wrong place; on the wrong side of the river, and subject to be overflowed'.

114 (No.61). 'The Port of Bilbao', by Luis Paret (1746–99) (National Trust, Bearsted collection, Upton House). Paret is best known for his scenes of social life, often in landscape settings.

PROVENANCE: Christie's, 24 March 1922, no.111, bought by Sabin; Lord Bearsted.
EXHIBITED: 1963–64, Royal Academy, no.37; 1967, Bowes Museum, no.82.
REFERENCES: Jardine, 2, p.29; Gaya Nuño, 1958, no.2146; Bearsted collection catalogue, 1964, no.257; O. Delgado, *Paret y Alcázar*, 1957, no.55 (dating: about 1786 and noting – presumably in error – the presence of the picture in Spain in 1927).

Figure 114

Francisco de Goya
(1746–1828)

Francisco José de Goya y Lucientes, the last of the great Spanish painters before Picasso, was born in 1746 at Fuendetodos, near Saragossa. Moving to Madrid he became a pupil of Francisco Bayeu, whose daughter he married. He visited Italy in 1771, and began after his return the first of the long series of cartoons, now in the Prado, Madrid, for the Royal Tapestry Factory.

By the early 1780s Goya was much employed as a portraitist by a wide range of clients that included King Charles III (1759–88) and members of his family. He was appointed Painter to the King (Charles IV) in 1788, and 'Primer Pintor da Cámara' in 1799. In 1792 Goya became deaf following an illness, and from this time date the first of the famous series of the etchings (the 'Caprichos', the 'Disparates', the 'Disasters of War' and the 'Tauromaquia') that he continued to produce until the time of his death. Goya remained in Madrid during the French occupation of Spain (1808–13) and he was employed by Ferdinand VII after the restoration of the Spanish monarchy. He moved in 1824 to Bordeaux, where he died in 1828.

Goya knew something of English art, and was familiar with the engravings of John Flaxman, but he remained little known outside Spain until discovered by the French in the mid-19th century. Like El Greco, he is therefore not fully represented in British collections, where hardly any full-length portraits are to be found. The first English writer to mention his work was apparently Lady Holland, who referred to him as 'the celebrated Goya' in 1809.

He was for long known in England as 'the Hogarth of Spain', and his prints circulated in this country from the early years of the 19th century. A group was apparently burnt at the instigation of Ruskin in 1872. Some paintings were acquired by British collectors in Spain in the 1830s, but it was not until almost 1900, when the first book on Goya appeared in English (by William Rothenstein), that his work was represented in the National Gallery.

Francisco de GOYA (1746–1828)

63. *El Médico (The Doctor)*

The National Galleries of Scotland
Canvas, 95.8 × 120.2cm

Stolen from the Royal Palace in Madrid in 1869 and imported early in the present century.

The only certain tapestry cartoon by Goya not in the Prado, Madrid, the picture is one of the series

115 (No.63). 'El Médico' (The Doctor), by Goya (National Galleries of Scotland). One of a series of cartoons produced by Goya in 1776–80 for the Royal Tapestry Factory in Madrid.

of eleven painted by Goya in 1776–80 for tapestries for the 'Ante-Dormitorio' of the son of Charles III, the Prince of the Asturias, in the palace of El Pardo. Though the canvas is damaged and worn, the effect of the painting, designed for one of the over-doors of the room, can still be appreciated. The title derives from Goya's description of the composition: 'A doctor seated, warming himself by a brazier; some books on the ground by his side; behind him, two students.'

The cartoons, representing the costumes and diversions of the time, were delivered to the Royal Tapestry Factory on 24 January 1780, together with Prado, nos.786–92. No.63, forming a pendant to Prado, no.792 ('La Cita'), may have been amongst the latest to be completed. Many of the tapestries survive at the Pardo palace and the Escorial.

PROVENANCE: 1780, Royal Tapestry Factory, Madrid, and subsequently in the Royal Palace until stolen with six other cartoons in 1869 (three of the others were subsequently recovered, and are now in the Prado); acquired by Linker in Saragossa early in the present century; bought from Durlacher's, London, 1923.

EXHIBITED: 1963–64, Royal Academy, no.49.

REFERENCES: V. de Sambricio, *Tapices de Goya*, 1946, pp.245–46; P. Troutman in Royal Academy exhibition catalogue (1963–64), p.22; Gudiol, 1971, no.93; Gassier and Wilson, 1971, no.142; Brigstocke, 1978, pp.54–55; de Salas, 1979, no.89.

Figure 115

Francisco de GOYA (1746–1828)

64,65. *Boys playing at See-Saw, Boys playing at Soldiers*

Glasgow Museums and Art Galleries,
Stirling Maxwell collection, Pollok House
Canvas, 29.8 and 29.2 × 41.9cm

Two of a set of four paintings bought by William Stirling in Seville in 1842, and amongst the earliest Goyas imported to this country.

Stirling wrote of the pictures: 'I possess four of his hasty sketches of children at play, in which are introduced some small urchins, equipped as miniature friars and pummelling one another with all the ardour of Dominicans and Capuchins bickering about the doctrine of the Immaculate Conception.' The paintings, however, recall the tapestry cartoons of the late 1770s and early 80s, though the settings are more prominent, and seem not satirical in character.

The two others in the series ('Scrambling for Chestnuts' and 'Bird-nesting') passed to the collection at Keir, and are now in the Bührle collection, Zurich. Several versions or early copies of the pictures are known, including a series which shows two further subjects – 'Boys playing at Bull-fighting' and 'Leap-frogging'.

PROVENANCE: see above; presented by Mrs Anne Maxwell Macdonald to Glasgow, 1966 (the Pollok Gift).

EXHIBITED: Manchester, 1857, nos.869–72; 1895–96, New Gallery, nos.974–77; 1913–14, Grafton Galleries, nos.146 and 138; National Gallery of Scotland, 1922; 1928, Burlington Fine Arts Club; 1951, Edinburgh, nos.8 and 9; *European Old Masters*, Manchester, 1957, nos.166 and 167; Pollok exhibition, Glasgow, 1960–61; 1963–64, Royal Academy, nos.50 and 51; Centre Culturel du Marais, Paris, 1979, nos.3 and 2.

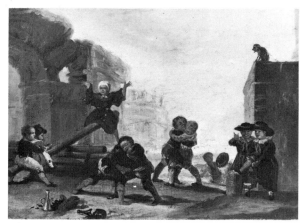

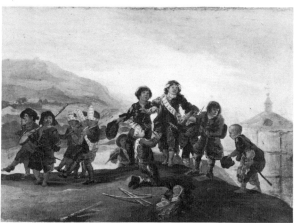

116,117 (No.64,65). Boys playing at See-Saw, and Boys playing at Soldiers, by Goya (Glasgow Museums, Pollok House). Two of a series of small paintings, related in character to Goya's tapestry cartoons, which William Stirling acquired in Seville.

REFERENCES: Stirling, 1848, 3, p.1265; Waagen, 1857, p.449; Loga, 1921, no.600; Mayer, 1924, no.724; P. Troutman in Royal Academy catalogue, 1963–64, pp.23–24 (copies of the series, dating, further references); Gudiol, 1971, nos.199 and 191; Gassier and Wilson, 1971, nos.155 and 154; de Salas, 1979, nos.96,95; Hilary Macartney, forthcoming Stirling collection catalogue.

Figures 116,117

Francisco de GOYA (1746–1828)

66. *A Picnic*

The National Gallery
Canvas, 41.3 × 25.8cm

Purchased for the National Gallery at the Osuna sale, in Madrid in 1896.

One of seven small Goyas bought from the artist by the Duke of Osuna in 1799, the painting was probably produced (like the six others) in the later 1780s as a sketch for a tapestry cartoon for the bedchamber of the princesses in the palace of El Pardo. The sketches were for some of the most famous of Goya's compositions (the four 'Seasons', the 'Meadow of S. Isidro' and 'Blind Man's Buff'), all pastoral themes in a well-established 18th-century tradition, but showing a new directness and pathos in the treatment of such subject matter.

Four cartoons corresponding to the sketches for the 'Seasons' were painted by Goya in 1786–87 (now in the Prado, together with the sketches), and a cartoon was made of 'Blind Man's Buff' (now in the Prado, with its sketch). Goya was working on the subject of 'The Meadow of S. Isidro' in 1788, but of this composition and of 'The Picnic', no cartoons are known to have been made, although stretchers were prepared for them. The death of Charles III in 1788 is the likely reason for the project having been halted.

PROVENANCE: in the Osuna collection, Palacio de la Alameda, near Madrid; bought at the Osuna sale, 18 May 1896, lot 78 (£190. 10s. 0d.).
EXHIBITED: 1947, Arts Council, no.8.
REFERENCES: Loga, 1921, no.451; Mayer, 1924, no.563; V. de Sambricio, *Tapices de Goya*, 1946, no.56; Desparmet-Fitzgerald, 1928–50, no.164; MacLaren and Braham, 1970, pp.9–11; Gudiol, 1971, no.359; Gassier and Wilson, 1971, no.663; de Salas, 1979, no.205.

Figure 118

118 (No.66). A Picnic, by Goya (National Gallery). One of the first Goyas acquired by the National Gallery (1896); a sketch for a tapestry cartoon, probably of 1788.

Francisco de GOYA (1746–1828)

67. *A Scene from 'El Hechizado por Fuerza'* *('The Forcibly Bewitched')*

The National Gallery
Canvas, 42.5 × 30.8cm

Purchased for the National Gallery at the Osuna sale in Madrid in 1896.

One of a series of six scenes of sorcery and witch-craft painted by Goya for the Duke of Osuna, for which he was paid in 1798. The subject is taken from a comedy by Antonio de Zamora, first performed in 1698. In order to frighten the timid Don Claudio into marriage with Doña Leonora, he has been led to believe that his life will last only as long as the lamp in the room of her servant remains alight. He goes to replenish the lamp with oil, pas-

sing a painting of donkeys that has been hung up to frighten him, and speaks to the lamp, 'lampara descomunal' ('monstrous lamp'). The first letters of these words appear in the lower right corner. Though playful in tone, the witchcraft series and the related etchings of the 'Caprichos', prefigure the more sombre fantasies of Goya's later years.

The other five paintings in the series, all of the same size, are 'Flying Witches' (private collection, Bilbao), 'Witches' Sabbath' and 'Conjuration' (both Museo Lázaro Galdiano, Madrid), 'The Witches' Cauldron' (private collection, Mexico), and 'Don Juan and the Commendatore' (whereabouts unknown). The pictures are probably identifiable with the six 'caprichos raros' exhibited at the Royal Academy in Madrid in 1799.

PROVENANCE: in the Osuna collection, Palacio de la Alameda, near Madrid and bought for the National Gallery at the Osuna sale, 18 May 1896, lot 88 (£55).

EXHIBITED: 1947, Arts Council, no.9; 1963–64, Royal Academy (but included after the start of the exhibition, and not in the catalogue).

REFERENCES: Loga, 1921, no.445; Mayer, 1924, no.557; Desparmet-Fitzgerald, 1928–50, no.174; MacLaren and Braham, 1970, pp.11–12 (with further references); Gudiol, 1971, no.254; Gassier and Wilson, 1971, no.274; de Salas, 1979, no.274.

Figure 119

Francisco de GOYA (1746–1828)

68. *Don Juan Antonio Meléndez Valdés*

The Bowes Museum, Barnard Castle
Canvas, 73.3 × 57.1cm
Signed, or inscribed, at base: 'A Melendez Valdes su amigo Goya'. ('To Melendez Valdes [by] his friend Goya), and dated, 1797.

Bought from the Conde del Quinto collection in the 1860s.

The sitter (1754–1817) was a lawyer and poet, a 'liberal' who later worked, like Goya himself, for Joseph Bonaparte after the French invasion of Spain, but who fled to France in 1813. In the year the portrait was painted, 1797, a collected edition

119 (No.67). A scene from 'El Hechizado por Fuerza', by Goya (National Gallery). One of a series of scenes of sorcery and witchcraft painted for the Duke of Osuna before 1798.

120 (No.68). Don Juan Antonio Meléndez Valdés (before cleaning), by Goya (Bowes Museum). A Madrid lawyer and poet, and a friend of Goya, painted in 1797.

of his poems appeared, and he was appointed Prosecutor for the Madrid municipality. The painting has been thought to show English influence, but in such essentials as the face and its expression the picture is more unguarded than any English portrait.

Two other versions of the painting are known (Banco Español de Crédito, Madrid, and in a private collection, Madrid), and a copy is in the Biblioteca Nacional, Madrid.

Cleaned in 1981.

PROVENANCE: said to have belonged to Francisco Azebal y Arratia, Madrid; Conde del Quinto, Paris (no.45 in 1862 sale catalogue); bought by John Bowes.

EXHIBITED: Madrid, Liceo Artístico y Literario, 1846, no.8; 1901, Guildhall, no.66; 1913–14, Grafton Galleries, no.179; National Gallery, 1920–27; 1928, Burlington Fine Arts Club; *Yorkshire and Durham collections*, Leeds, 1936, no.35; 1947, Arts Council, no.5; Bowes Museum exhibition, Agnew's, 1952, no.13; *European Masters of the 18th century*, Royal Academy, 1954–55, no.356; Bowes Museum exhibitions, Arts Council 1959, no.43, and 1962, no.49; *Goya*, Musée Jacquemart André, Paris, 1961–62, no.50; 1963–64, Royal Academy, no.78; 1967, Bowes Museum, no.84.

REFERENCES: Loga, 1928, no.275; Mayer, 1924, no.345; Glendinning in Royal Academy 1963–64 exhibition catalogue, pp.40–41; Young, 1970, pp.35–37 (with full earlier bibliography); (Gudiol, 1971, no.372, Banco de España version); Gassier and Wilson, 1971, no.670; de Salas, 1979, no.670.

Figure 120

Francisco de GOYA (1746–1828)

69. *Don Francisco de Saavedra*

Courtauld Institute Galleries, Lee collection
Canvas, 207 × 121.3cm

Bought for Lord Lee in Amsterdam in 1928.

The portrait was apparently painted in 1798, when Saavedra, a 'liberal', was made Minister of Finance, at the same time as Jovellanos became Minister of Justice. In 1798 Goya also painted his famous full-length of Jovellanos (now Prado, Madrid), showing him bent forward contemplatively over his desk. Early in 1799 Saavedra was dismissed, but he emerged again with Jovellanos in 1808. An illuminating description of him in Seville was written by William Jacob, who stressed his integrity and benevolence and the 'well-regulated' English character of his household.

121 (No.69). Don Francisco de Saavedra, by Goya (Courtauld Institute Galleries, Lee collection). A 'liberal' who was briefly Minister of Finance in 1798, when this portrait was painted.

'Saavedra, the minister of finance, and a native of this city, though of an advanced age, discharges the duties of his office with integrity: but it is supposed that his faculties have been much injured by an attempt to destroy him by poison, administered at the instigation of the Prince of Peace. It has injured his health, and his memory, but he still retains his benevolent dispositions, and his patriotic abhorrence of the French. His house, the domestic arrangements of his family, and the whole economy of his establishment, more resemble those of a well regulated family in England, than is generally seen in this country . . . notwithstanding his age, [he] still displays his firmness and his patriotism; and the last days of the existence of the late government at Seville, gave the best proofs of his disinterestedness.'

In Goya's portrait the Minister gazes sternly away from the spectator, actively at work turning papers in his hand. He sits upright at the corner of a modest (almost military) table and rests on the edge of his chair, as if about to rise.

PROVENANCE: José María Cienfuegos, Gijón; A. Pidal, Madrid (Saavedra's grandson); Baron Denys Cochin sale, Paris, 26 March 1919, lot 14, bought by Knoedler; M. von Nemes sale, Amsterdam, 30 November 1928, lot 35, bought for Lord Lee; bequeathed to the Courtauld Institute.

EXHIBITED: 1951, Edinburgh, no.6; Goya exhibition, Basle, 1953, no.15; *European Masters of the Eighteenth Century*, Royal Academy, 1954–55, no.355; 1963–64, Royal Academy, no.82.

REFERENCES: Mayer, 1923, no.409; Desparmet-Fitzgerald 1928–50, no.371; catalogue of Lee bequest, 1958, p.40, no.78; Glendinning in Royal Academy 1963–64 exhibition catalogue, pp.44–45; Gudiol, 1971, no.400; Gassier and Wilson, 1971, no.676; de Salas, 1979, no.285.

Figure 121

Francisco de GOYA (1746–1828)

70. *Don Andrés del Peral*

The National Gallery
Poplar, 95 × 65.7cm

Bought in Paris in 1902 by Sir George Donaldson.

Almost certainly the portrait exhibited by Goya in 1798 at the Royal Academy in Madrid, 'by the incomparable Goya,' according to one critic, '[which] would be enough by itself to bring credit to a whole Academy, to a whole nation, to a whole contemporary period with respect to posterity, so sure is its draughtsmanship, its taste in colouring . . . in short so great is the skill with which this Professor carries out his works.' The sitter is probably identifiable with an Andrés del Peral who worked as a gilder and painter for the Court, and who formed a collection of paintings including works by Goya.

The traditional title of the portrait, 'Dr Peral' derived from a label on the reverse which described the sitter as being a doctor of law who acted as the financial representative of the Spanish government at the end of the 18th century. This probably refers to a Juan del Peral, who died in Paris in 1888 and who may have been the son of Andrés del Peral.

The character of the composition, modest in scope if not in its impact, is like that of several other portraits by Goya, including those of fellow-artists and craftsmen, headed by Goya's father-in-law, Francisco Bayeu (1795, Prado, Madrid).

PROVENANCE: bought from the grand-daughter of 'Dr Peral' in Seville by the Marqués de la Vega-Inclán, probably in the late 19th century; Gaston Linden, Paris; sold in 1902 by Dannat to Sir George Donaldson, by whom lent to the National Gallery, 1902–04, and bequeathed in 1904.

EXHIBITED: 1901, Guildhall, no.51; 1947, Arts Council no.4.

REFERENCES: Loga, 1921, no.299; Mayer, 1924, no.377; Desparmet-Fitzgerald, 1928–50, no.366; Glendinning in *Apollo*, March, 1969, pp.200–03 (identification of sitter); MacLaren and Braham, 1970, pp.14–16 (with further references); Gudiol, 1971, no.377; Gassier and Wilson, 1971, no.673; de Salas, 1979, no.282.

Figure 122

Francisco de GOYA (1746–1828)

71. *Doña Isabel de Porcel*

The National Gallery
Canvas, 82 × 54.6cm
Apparently signed on the reverse of the original canvas.

Bought for the National Gallery in 1896, the first of Goya's portraits to enter the collection.

Goya exhibited a portrait of the wife of Don Antonio Porcel at the Royal Academy in Madrid in 1805, and a painting of Porcel himself in the following year. It was discovered during restoration in 1980 that Doña Isabel de Porcel was painted directly over an earlier, male, portrait, presumably one of Goya's own paintings, which the artist had completed (or almost completed) and then abandoned.

The earlier painting is clearly visible in technical photographs, but the subject looks unlike any other known sitter by Goya. The unusually ample composition in Doña Isabel's portrait, and the presence of the mantilla, may have been intended in part to conceal the earlier sitter, though the stripes of his jacket are just visible beneath the mantilla, and his eyebrow creates a dark shadow on the chin of his successor on the canvas.

The identification of Doña Isabel de Porcel as the sitter was based on an inscription on the lining canvas of the picture. During its removal the original of the inscription was recovered on the back of Goya's canvas, together with what appears to be the signature of the artist. 'Lobo de Porcel' is given

122 (No.70). Don Andrés del Peral, by Goya (National Gallery). Painted probably in 1798, the sitter was a gilder and painter at the Court.

123 (No.71). Doña Isabel de Porcel, by Goya (National Gallery). Beneath the portrait of Doña Isabel is a male portrait as x-rays have recently shown.

as the surname of Doña Isabel, not 'Cobos de Porcel', as copied on to the lining canvas.

Goya's portrait of Antonio de Porcel, slightly larger than No.71 and on panel, showed the sitter accompanied by a dog and was one of the portraits signed by Goya as a friend of the sitter. It was, until destroyed, at the Jockey Club, Buenos Aires.

PROVENANCE: together with the portrait of Antonio de Porcel by descent in the Porcel y Zayas family until about 1887, when sold to Isidoro Urzaiz, from whose heirs it was bought for the National Gallery, in 1896.

EXHIBITED: 1947, Arts Council, no.6.

REFERENCES: Loga, 1921, no.309; Mayer, 1924, no.391; Desparmet-Fitzgerald, 1828–50, no.453; MacLaren and Braham, 1970, pp.12–14 (with further references); Gudiol, 1971, no.509; Gassier and Wilson, 1971, no.817; de Salas, 1979, no.416; Braham in *The Burlington Magazine*, September, 1981, and Wyld in *National Gallery Technical Bulletin*, 1981 (the discovery of the earlier sitter and the restoration of the picture).

Figure 123

Francisco de GOYA (1746–1828)

72. *Doña Antonia Zárate*

Beit Collection, Blessington
Canvas, 103 × 81.9cm

Acquired by Sir Otto Beit about 1911.

The sitter, twice portrayed by Goya, was one of the leading actresses of the day. She died young, in 1811, probably only a year or two after this portrait was painted. By posing the actress on a sofa, Goya introduced a range of new possibilities in portrait design, and a sense of greater intimacy and spontaneity, which was developed in the later 19th century in France.

124 (No.72). Doña Antonia Zárate, by Goya (Beit collection). The sitter was a famous actress and the portrait probably dates from a year or two before her death in 1811.

Goya's other portrait of Doña Antonia Zárate (now Hermitage, Leningrad) shows only the head and shoulders of the actress and is probably the later of the two.

PROVENANCE: Doña Adelaida Gil y Zárate, Madrid; Knoedler and Co.; in the Beit collection, about 1911.

EXHIBITED: *Obras de Goya*, Madrid, 1900, no.47; Old Masters, Grafton Galleries, 1911, no.52; 1920–21, Royal Academy, no.129; 1928, Burlington Fine Arts Club; 1947, Arts Council, no.7; South Africa National Gallery, Cape Town, 1948; *Goya*, Basle, 1953, no.23; *Stora Spanska Mästare*, Stockholm, 1960, no.145; *Goya*, Musée Jacquemart-André, Paris, 1961–62, no.60; 1963–64, Royal Academy, no.94.

REFERENCES: Loga, 1921, no.361; Mayer, 1924, no.237; Desparmet-Fitzgerald, 1928–50, no.446; Glendinning in Royal Academy 1963–64 exhibition catalogue, p.54 (with further references); Gudiol, 1971, no.562; Gassier and Wilson, 1971, no.892; de Salas, 1979, no.449.

Figure 124

Francisco de GOYA (1746–1828)

73. *Interior of a Prison*

The Bowes Museum, Barnard Castle.
Tin, 42.9 × 31.7cm.

Bought by John Bowes from the Conde del Quinto collection, Paris, in the 1860s.

One of a number of small paintings showing scenes of violence and warfare which Goya produced in 1793–94, and during the Spanish Wars of Independence (1808–14), when also working on the etchings of 'The Disasters of War'. The subject of prisons, and the underlying theme of the persecution of humanity, had preoccupied many artists of the later 18th century; in his etchings of prisons (1745), Piranesi used low arches to enhance the mood of oppression, though with less starkness of effect than in Goya's painting.

The picture corresponds in size, and in being painted on tin, with a series of twelve paintings executed in 1793–94, but Goya produced other prison interiors in two later series of small paintings (42 × 32cm and 32 × 58cm) in the Marqués de la Romana collection, Madrid, one of them an oblong panel showing prisoners silhouetted against an arched opening with a window. Other similar scenes of this later period are painted, like No.73, on tin, including a series of oblong scenes of which two are in the Prado, Madrid, 'The Massacre' and 'The Bonfire'. The exact dating of these closely-related paintings is uncertain.

Cleaned in 1979.

PROVENANCE: No.48 in the sale catalogue of the Conde del Quinto collection, Paris, 1862.

EXHIBITED: Madrid, Liceo Artístico y Literario, 1846, no.50; 1901, Guildhall, no.60; 1913–14, Grafton Galleries, no.178; National Gallery, 1920–27; *Yorkshire and Durham collections*, Leeds, 1936, no.36; 1947, Arts Council, no.10; *Goya*, Wildenstein's, New York, 1950, no.38; Bowes Museum exhibition, Agnew's, London, 1952, no.11; *The Romantic Movement*, Tate Gallery, 1959, no.11; Bowes Museum exhibitions, Arts Council, 1959, no.44, and 1962, no.50; *Goya*, Musée Jacquemart-André, Paris, 1961–62, no.57; *Primitives to Picasso*, Royal Academy, 1962, no.206; 1963–64, Royal Academy, no.102; 1967, Bowes Museum, no.85; 18th-century Spanish Court Art, Madrid, 1980 (and previously in Paris and Bordeaux), no.20.

REFERENCES: Loga, 1921, no.433; Mayer, 1924, no.544; Desparmet-Fitzgerald, 1928–50, no.207; P. Troutman in 1963–64 Royal Academy exhibition catalogue, pp.58–59 (dating: about 1810–15); X. de Salas in *Archivo español de Arte*, 1968–69,

125 (No.73). Interior of a prison, by Goya (Bowes Museum). One of many scenes of horror painted by Goya in the 1790s and during the Peninsula War.

pp.29–33 (reconstruction of the 'tin-plate' series of 1793–94); Young, 1970, 37–38 (dating: about 1810–15); Gudiol, 1971, no.470 (dating: about 1800); Gassier and Wilson, 1971, no.298 (dating: about 1808–14); de Salas, 1979, no.241 (dating: 1793); J. Baticle in 1980 Madrid exhibition catalogue (dating: 1794).

Figure 125

Francisco de GOYA (1746–1828)

74. *The Duke of Wellington*

The National Gallery
Mahogany, 64.3 × 52.4cm

Painted in Madrid in August 1812, and brought home by the sitter, probably in May 1814, after being altered by Goya.

Goya's image of the Earl of Wellington, as he then was, is one of the most complex of his portraits, showing many alterations in the costume and decorations, though the head, with sunburned face and white forehead, was little altered by the painter.

The sitter wears around his neck the Order of the Golden Fleece (given by the Spanish government after Salamanca) and the Peninsula Gold Cross with three clasps. On his chest are the ribbons and stars of the Order of the Bath (top), and of the Tower and Sword of Portugal, and the star of the Order of San Fernando of Spain (bottom right). Compared with a very similar drawing that Goya made of Wellington, the portrait appears slightly flattering in the concealment of his prominent front teeth, and in the enlargement of the right eye, a change clearly visible in the picture.

As originally painted, the portrait appears to have corresponded closely with the drawing (in the British Museum). Wellington wore a plain crimson jacket decorated with the stars of the three orders, and around his neck was the Peninsula Medallion, which is clearly visible beneath the clasps of the Peninsula Gold Cross. The sashes were added later, the lower two stars moved to the right and the black panel decorated with gold braid superimposed on the crimson jacket. These changes were probably introduced in honour of the Golden Fleece displayed so prominently in the portrait, which Wellington was awarded while in Madrid in August 1812.

The final alteration of the portrait must have been made in May 1814, when Wellington returned to Madrid. This was the addition of the Peninsula Cross and the clasps, which cover the Peninsula Medallion in Goya's portrait. These superseded the Medallion and were sent out to Spain in June 1813. By 1814 Wellington had earned no less than nine clasps (one for each battle, in addition to the four early victories that are commemorated on the Cross). Goya added to the portrait only three clasps, those to which Wellington was entitled after the battle of Salamanca. Most of the decorations shown in the portrait are on display in the Wellington Museum.

In addition to the drawing and this painting, two other painted portraits of Wellington by Goya are known, a half-length portrait showing the sitter in hat and cloak (National Gallery of Art, Washington), and an equestrian portrait (Wellington Museum, Apsley House) in which Goya superimposed Wellington over the likeness of an earlier sitter. The identification of the earlier portrait is uncertain, though it is likely to have been a figure of importance, and both Joseph Bonaparte and Godoy have been suggested as possible candidates.
PROVENANCE: first recorded in the Duke of Leeds collection at Hornby Castle, Yorkshire, in 1878, the picture had probably been given by Wellington to his sister-in-law, Lady Wellesley, or to her sister,

126 (No.74). The Duke of Wellington, by Goya (National Gallery). Painted in Madrid in 1812 after the victory of Salamanca and altered by the artist probably in 1814.

Louisa Caton, who married the Duke of Leeds in 1828; Duke of Leeds sale, Sotheby's, 14 June 1961, lot 191; purchased with aid from the Wolfson Foundation and a special Exchequer Grant, 1961; stolen and recovered, 1961–65.

EXHIBITED: Grafton Galleries, National Loans Exhibition, 1909–10, no.27; Naval and Military Works, Guildhall Art Gallery, 1915, no.4; Sheffield, Mappin Art Gallery, 1915, no.39; on loan to the National Portrait Gallery, 1930–49; *Goya*, Wildenstein's, New York, 1950, no.39; *Old Masters from Jersey Collections*, St. Helier, Barreau Art Gallery, 1962, no.14; *Goya*, Basle, Kunsthalle, 1953, no.26; *The Romantic Movement*, Tate Gallery, 1959, no.191.

REFERENCES: Mayer, 1924, no.449; Lord G. Wellesley and J. Steegman, *The Iconography of the first Duke of Wellington*, 1935, p.12; C. Scott Moncrieff in *The Armorial*, III, no.3 (August 1962); MacLaren and Braham, 1970, pp.16-23 (development and dating of portrait, with further references); Gudiol, 1971, no.556; Gassier and Wilson, 1971, no.897; de Salas, 1979, no.454.

Figure 126

Sculpture and Furniture

Though Spanish paintings are so well represented in Britain and Ireland, much less interest has been shown in the sculpture of the Peninsula and in its furniture. The four sculptures here displayed were all acquired in Spain by Sir John Charles Robinson in the mid-19th century. A distinctive feature of Spanish furniture, before the importation of French and British styles in the later 18th century, is that much of it is designed to be portable. The typical Spanish desk of the 17th century, the 'vargueño' (No.79), consists of a cabinet with a falling front placed upon an open pedestal.

Ascribed to Pedro de MENA (1628–88)

Born in Granada, Mena was the chief pupil of Alonso Cano, and the foremost sculptor of his generation in Spain. From 1658 he worked at Málaga, where he died.

75. *The Virgin of Sorrows*

The Victoria and Albert Museum (no.284 – 1871) Painted wood; height, 42.5cm.

Purchased through G.E. Street with various Spanish textiles and ceramics in 1877.

Probably an autograph work of about 1680. A

127 (No.75). The Virgin of Sorrows, ascribed to Pedro de Mena (1628–88) (Victoria and Albert Museum). Active in Málaga, Mena was a pupil of Alonso Cano.

128 (No.76). S. Francis standing, after Pedro de Mena (Victoria and Albert Museum).

sculpture in the Dreifaltigkeitskirche, Vienna, is one of a number of related works by Mena.

Sir Matthew Digby Wyatt commented in 1877 'This capital head and bust of the "Virgen de los dolores", the *favourite* Spanish type, should certainly be bought. It is full of character, and is cheap – since I have seen many of much less merit for which higher prices have been asked in Spain. It looks very much like the works of Montanes and is both interesting and rare of such artistic merit. Strongly recommended.'

REFERENCES: Victoria and Albert Museum, *Art Referee's Reports*, 18 April 1871 (Digby Wyatt's opinion); H. Aurenhammer in *Alte und neue Kunst*, 1954, 3, p.111 (sculpture in Vienna).

Figure 127

After Pedro de MENA (1628–88)

76. *S. Francis standing*

The Victoria and Albert Museum (no.331 – 1866)
Painted wood; height, 50cm
Purchased by Robinson from Cavaletti, Madrid, in 1865.

A small copy of Mena's masterpiece in the Treasury of Toledo Cathedral.

Writing from Spain to Henry Cole in 1863 (4 October) Robinson had said: 'From the little I have yet seen of Spain I am not without hopes of securing some interesting specimens in the class of decorative sculpture though there is at present (as in Italy) a great archaeological and conservative

129 (No.77). The Immaculate Conception, Spanish School (Victoria and Albert Museum). Probably of the early 18th-century.

130 (No.78). S. Joseph and the Christ Child, by José
Risueño (1667–1721) (Victoria and Albert Museum).
The leading sculptor of early 18th-century Granada.

movement in the country, royal commissions for
the conservation of ancient monuments, the establ-
ishing of local museums &c having been recently
instituted in every province.'

EXHIBITED: 1981, Nottingham University, no.72
REFERENCES: Victoria and Albert Museum, J.C.
Robinson, *Reports*, 1, p.83

Figure 128

SPANISH SCHOOL

77. *The Virgin of the Immaculate Conception*

The Victoria and Albert Museum (no.320 – 1864)
Painted terracotta; Height, 49cm

Purchased by Robinson from Gurguan, Granada,
in 1864 as a work by Risueño (see no.78).

Probably produced in Seville about 1700, the
sculpture is related to the small terracotta figures
and groups of Luisa Roldán.

The sculpture has been considered a copy after

Puget by an Italian artist, but this idea appears to
be without foundation.

REFERENCES: E. Maclagen and M. Longhurst,
Victoria and Albert Museum catalogue of Italian
Sculpture, 1932, p.163 (as possibly Italian, after
Puget).

Figure 129

José RISUEÑO (1667–1721)

Like Cano and Mena, a sculptor of the school of
Granada, where he was born and died.

78. *S. Joseph and the Christ Child*

The Victoria and Albert Museum (no.313 – 1864)
Painted terracotta; height, 50cm

Purchased by Robinson from Marin, Granada, as a
sculpture of the School of Cano.

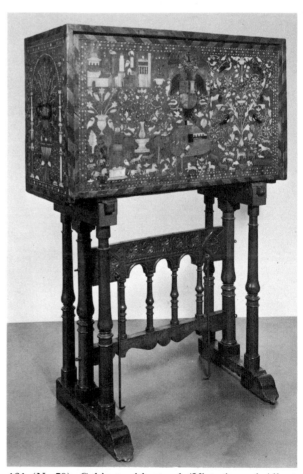

131 (No.79). Cabinet with stand (Victoria and Albert
Museum). A characteristic Spanish cabaret, of the type
known as a 'vargueño', probably dating from the end of
the 16th century.

The theme was popular in Spanish painting of the 17th century, and several times depicted by Murillo.

The sculpture is probably of about 1700, and closely related to a S. Joseph group formerly in the Convent of S. Anthony, Granada. Similar groups are also in the church of the Trinity, Córdoba, and in the Convent of the Augustines, Priego.

REFERENCES: E.O. Diaz in *Cuadernos de arte*, IV–VI, 1931–41, p.103, and in *Goya*, 14, 1956, p.76

Figure 130

79. *Cabinet with stand*

The Victoria and Albert Museum (no.294, 294a – 1870)

Purchased in 1870.

Of the late 16th century, the cabinet is of walnut with a falling front, inlaid with different woods or coloured bone. Inside are thirteen drawers and two cupboards.

REFERENCES: J. Hungerford Pollen, *Ancient & Modern Furniture and Woodwork*, 1874, p.74; Victoria and Albert Museum, *50 Masterpieces of Woodwork*, no.20.

Figure 131

80. *Table*

The Victoria and Albert Museum (no.W55 – 1980)

Purchased in 1980.

Probably of the early 17th century.

81. *Arm-chair*

The Victoria and Albert Museum (no.W46 – 1910)

Presented in 1910 by F.L. Lucas.

A 17th-century chair of walnut, with later upholstery of blue and purple velvet; the side uprights carved with a male and female head. The chair is said to have come from the palace of the Archbishop of Toledo.

Figure 132

82. *Trestle table*

The Victoria and Albert Museum (W58 – 1950)

Purchased in 1920; formerly in Florence.

A mid-17th century table, probably of Hispanic origin, painted in black lacquer with decorations in colours and gilt.

REFERENCES: Clifford Smith in *The Burlington Magazine*, 1916, pp.153–54 (as Italian).

Figure 133

132 (No.81). Arm-chair, (Victoria and Albert Museum). A 17th-century chair of walnut, said to have been in the palace of the Archbishop of Toledo.

133 (No.82). Trestle-table, (Victoria and Albert Museum). A decorated table, probably of the mid-17th century.

Notes

Page 3

Quotation from Jardine: 2, pp.21–22

Export of Spanish paintings: see Gaya Nuño, 1958; the catalogue runs to 3150 items, and only the entries for painters not otherwise adequately covered by monographic catalogues are given in the catalogue here; influence on French Romantics, Lipschutz, 1972.

Disraeli on Murillo: Monypenny, p.145.

Waagen on collecting: 1854, 1, pp.16ff. (Waagen admitted in 1854 that he had not visited Spain, 3, p.204). See also J.D. Passavant, *Tour of a German Artist in England*, 1836; Anna Jameson, *Handbook to the Public Galleries of Art in and near London*, 1842, and *Companion to the most celebrated Private Galleries of Art in London*, 1844, Francis Haskell, *Rediscoveries in Art*, 1976, Waagen, *Works of Art and Artists in England*, 1837.

Page 5

Inventory of Henry VIII: see W.A. Shaw, *Three Inventories of the years 1542, 1547 and 1549–50 of Pictures in the Collections of Henry VIII and Edward VI*, 1937, p.42 (p.46 for matching portrait of Ferdinand).

Somerset House portrait: see Roy Strong, *National Portrait Gallery, Tudor and Jacobean Portraits*, 1969, pp.351–53; on the attribution see de Salas in *Gazette des Beaux-Arts*, 1966, 2, pp.351–54 (the painting is not included in Kusche's catalogue).

Page 6

Pantoja portraits at Hampton Court: Kusche, nos.8 and 20.

Page 7

Labrador in Royal collection: see under No.56.

Page 8

Portraits of Spanish royal family: see Harris, 1967.

Hopton's portrait: see José López-Rey in *Gazette des Beaux-Arts*, 87, 1976, pp.29ff., where the picture is attributed to Juan Rizi.

Page 9

Buckingham's El Greco: see Vertue, *A Catalogue of the curious collection of Pictures of George Villiers, Duke of Buckingham*, 1758, p.3.

Page 10

Murillos in Flanders and at Bussy-le-Grand: see Gaya Nuño, 1958, p.14, and Edmond Bonnaffé, *Dictionnaire des Amateurs français au XVIIIe siècle*, 1884, p.48.

Evelyn on Murillo: see *The Diary of John Evelyn*, ed. E.S. de Beer, 1955, 5, p.145.

Walpole's collection: see Walpole, Horace, *Aedes Walpolianae*, 1767 (3rd ed.), pp.56,61,69,71, and John Kerslake in *The Antique Collector*, June 1980, pp.76–79.

Page 11

Murillo altarpiece at Belvoir: according to Waagen (1854, 3, p.402) 'one of the finest [Murillos] in all England'; Curtis, 1883, Murillo, no.150; Irvin Eller, *The History of Belvoir Castle*, 1841, p.273.

Hogarth's portrait: for the basic information see Martin Davies, *National Gallery Catalogues, The British School*, 1946, pp.67–68.

Page 13

Praise of Murillo: p.121 of *An Account of the Lives*, etc, 1739.

Vertue's notebooks: *The Walpole Society*, vols. XVIII (1), XX (2), XXII (3), XXIV (4), XXVI (5), XXIX (index), and XXX (6) (1929–50) – see index *s.v.* Murillo and Ribera.

Ribera: p.323 of *The Art of Painting*, 1695.

The English Connoisseur: 1, pp.14 (Gideon), 32,35 (Chiswick), 81,94 (Houghton), 2, pp.17,24 (Methuen), 49 (Guise).

Methuen: *DNB*, John and Paul Methuen. The majority of the other 18th-century collectors mentioned here are also entered in the *DNB*.

Travellers in Valencia: Stoye, p.368, and chapter 1 of part 4 for English embassies of the early 17th century in Spain.

Closterman: C.H. Collins Baker, *Lely and the Stuart Portrait Painters*, 1912, 1, pp.43ff; *The Walpole Society*, XXVI (Vertue, vol.5), p.61.

Page 14

Travellers to Spain: see the thorough survey by Robertson, who, however, omits Cumberland, Disraeli and Wilkie, none of whom published travel books. Many of these travellers are entered in the *DNB*.

Page 16

The country: Cumberland, 1807, 2, p.149 (Douro valley); Southey, p.75; Townsend, p.230 (country houses); Baretti, 2, p.256 (Madrid); Cumberland, 1807, 2, p.143 (Madrid).

Spaniards: Whittington, 1, p.145; Jardine, 1, p.85.

Bull-fighting: Clarke, p.111.

Religion: Whittington, 1, pp.28 and 133.

Cumberland on El Greco: 1782, 1, pp.155–56.

Page 17

Furniture: Twiss, p.255 (Cordova); Dalrymple, p.46 (carriages).

Painting: Clarke, p.154.

Page 18

Goya: Holland, 29 April 1809, noted by Glendinning, 1977, p.224 (the first known French reference is apparently of 1788 – see Lipschutz, p.20).

Mengs and Meléndez: Baretti, 2, pp.281,287.

Opinions of Velasquez: Swinburne, p.227; Beckford, 1834, p.310; Twiss, p.147; Swinburne, p.174; Townsend, p.266.

Page 19

Opinions of Murillo: Swinburne, pp.37–38; Twiss, p.285; Jardine, 2, p.207.

Twiss on Seville, and lazy friars: pp.310–11,313.

Twiss on Valdés Leal and Zurbarán: pp.308–09,311.

Cumberland on Coello: 1807, 2, p.79.

Jacob on Cano and Zurbarán: pp.50 and 128–29.

Page 20

Export control: Gaya Nuño, 1958, p.15; Cumberland, 1782, 2, p.103.

The Campbell collection: the existence of which was kindly mentioned to me by Michael Levey, was sold at Christie's on 9 July 1814.

Reynolds on Murillo and Velasquez: *Letters of Sir Joshua Reynolds* (ed. F. Whiley Hilles), 1929, pp.145,148,152.

Page 21

Joseph Bonaparte: see the useful biography by Michael Ross, *The Reluctant King*, 1976, chapters 10–14 (quoting Napoleon on the confiscation of paintings, p.167, and Wellington on the pillaging after Vitoria, p.214).

Joseph's confiscation of paintings: see M. Lasso de la Vega, *Mr Frédéric Quilliet Comisario de Bellas artes del Gobierno intruso*, 1933; Lipschutz, pp.49–51 (Goya may privately have sought to thwart Joseph's plans).

The paintings assembled in the Alcázar, Seville: see M. Gómez Imaz, *Inventario de los cuadros sustraídos por el Gobierno intruso en Sevilla*, 1917 (2nd ed.); on Soult in Seville, see Lipschutz, pp.31–37.

Page 22

'The Boar Hunt': see MacLaren and Braham, 1970, pp.101–08.

The Sebastiani collection: *The Athenaeum*, 29 May 1852 (offer to Prince Regent).

Wallis in the Peninsula: Buchanan, 2, pp.203ff., p.214 (2 May uprising), p.229 (Spanish painters).

Page 23

Bankes: see Waagen, 1857, p.383; Viola Hall, *A Dorset Heritage*, 1953, pp.124ff.; and A.L. Rowse in *Encounter*, March 1975, pp.25–32.

Byron in Spain: P.H. Churchman in *Bulletin hispanique*, XI, 1909, 1, pp.55–95, and 2, pp.125–71; *Byron's letters and journals*, ed. Leslie A. Marchand, 1, 1798–1810, 1973.

Page 24

Portrait of Massimi: E. Harris in *The Burlington Magazine*, 1958, p.279.

Portrait of Pareja: Curtis, 1883, Velasquez, no.180.

Page 25

Spain in the early 19th century: Atkinson, chapter 13.

Quin in the Prado: pp.347–51.

Page 26

Lord Heytesbury: Waagen, 1857, pp.386–88; Heytesbury and the majority of the 19th-century collectors are entered in the *DNB*.

Wilkie in Spain: Cunningham, 2, pp.461–530 (pp.472,486,505, views on Velasquez), 516 (Murillo in Seville), 522 (Lawrence on Velasquez)); Irwin, 1974; on the four paintings begun in Spain, see O. Millar, *The later Georgian pictures in the collection of Her Majesty the Queen*, 1969, pp.139–41; the volumes of Palomino in the National Gallery Library (2nd ed., 1795–97) were acquired by Wilkie in Madrid in May 1828.

Wilkie at the Prado: 'Los Borrachos' is said to have especially attracted him by Stevenson, 1899, p.103, and in *The Athenaeum*, 21 May 1853; on his purchase of Velasquez, see MacLaren and Braham, p.135.

Page 27

Quin on Seville: pp.309 and 305.

Disraeli in Spain: Monypenny, pp.136 (effect on Disraeli), 153 (his ignorance of Spain, and view of Murillo), pp.144 (Seville, Brackenbury), 152 (fans).

Brackenbury collection: sales 26 May 1848 and 25 June 1850.

Hall Standish: obituary in *The Gentleman's Magazine*, June 1840, giving year of death as 1839 ('in his 42nd year') and with quotations from will; also *The Athenaeum*, 4 and 11 June 1853; and also *DNB*, though his dates appear to be a year too late there.

Page 28

Disraeli on Standish: Monypenny, p.146.

Ford's education: Stirling, 1891, pp.101–02.

Ford in Spain: see Sutton and Ford in 1974 Ford exhibition catalogue; Ford, 1905.

Ford on Seville: 1905, pp.12–23, *passim*.

Page 29

Ford on paintings in Spain: 1905, pp.60,76,96 (1974 exhibition catalogue, p.88, for his view of collecting).

Editions of Ford's *Hand-book*: see 1974 Ford exhibition catalogue, pp.80–84.

Page 30

References to paintings in the *Hand-book*: 1847, pp.420 (David), 421 (Madrazo, Goya, Velasquez and Murillo), 424 ('Surrender of Breda').

Waagen at Ford's: 1854, 2, p.223. Waagen also comments in his book on English cooking and 'plum pudding', 1854, 2, pp.287–88.

Ford on Lewis: 1905, p.95.

Roberts in Spain: see James Ballantine, *The Life of David Roberts, RA*, 1866, pp.42ff.; Irwin, 1974.

Delacroix and Mrs Ford: see 1974 Ford exhibition catalogue, p.18.

Eden collection: sales of 15 June 1889, 15 July 1899, 1 and 8 March 1918, 5 July 1918, 28 November 1922, 17 July 1923, 17 December 1926, 11 February 1927, 5 November 1930, 26 July 1933, 19 December 1945.

Page 31

Ford on Head: 1905, p.139.

Stirling: fullest biography in *DNB*; see also William Fraser, *The Stirlings of Keir*, 1858, p.82; Enriqueta Harris, in *Apollo*, January 1964, pp.73–77; *Country Life*, 7,14 and 28 August 1975 (Keir).

Page 32

Quotations from the *Annals*: pp.ix (Ford's *Hand-book*), 13,31,34 (portraiture), 7 (Raphael), 31 (religious art).

Stirling's collection: see Waagen, 1857, pp.448ff.; Caw; Auld; sales of 26 June 1946, 3 July and 21 October 1963, 5 May 1964, 11 November, 2 and 16 December 1977.

Page 33

Louis-Philippe collection: see the catalogue of the *Galerie espagnole*, 1838–48; catalogue of sales at Christie's, 6 to 21 May 1853; *The Athenaeum*, 14,21 and 28 May 1853; Lipschutz, pp.123–37; Gaya Nuño, 1958, p.26 (giving figure for total receipts, compared with £27,000 given in *The Athenaeum*, 28 May 1853) and forthcoming catalogue of Louvre exhibition on the collection, autumn, 1981, by Jeannine Baticle.

Clarendon collection: amongst the many Clarendon sales (1908–56) that of 15 May 1908 included, lots 109–113, paintings by Goya.

Meade collection: sales of 24 June 1847 and 6–8 March 1851.

Hoskins collection: Waagen, 1854, 2, p.259.

Aguado: see Gaya Nuño, 1958, p.25; 1837 catalogue of collection.

Brackenbury sales: see earlier note, and, on his Goyas, Glendinning, 1964, p.10.

Salamanca collection: see Gaya Nuño, 1958, p.28 – sales, 6 March 1852 (London), 3–6 June 1867 (Paris), 25–26 January 1875 (Paris).

Soult collection: sale catalogue, 19–22 May 1852; see *The Athenaeum*, 1 May 1852; Curtis, 1883, Murillo, no.1; Lipschutz, pp.31–38.

Page 34

National Gallery 'Adoration of the Shepherds': see MacLaren and Braham, 1970, p.75. Though the attribution to Murillo has not been pursued in subsequent books, the paintings still accepted as early works by Murillo, as illustrated by Angulo Iñiguez, 1981, make little sense in relation, for example, to the early 'Peasant Boy' in the Louvre, which shows an obvious debt to Velasquez.

Page 35

Letters about Zurbarán: *The Times*, 10 and 14 May 1853.

Early opinions of Murillo: William Hazlitt, *Essays on the Fine Arts*, ed. W. Carew Hazlitt, 1873, p.397; *The Athenaeum*, 14 May 1853.

Ruskin on Murillo: *The Works of John Ruskin*, ed. E.T. Cook and A. Wedderburn, 3, 1903, pp.635–36, and 670–72; 10, 1904, pp.228–29; 16, 1905, p.298. On Velasquez, 7, 1905, p.414, and 20, 1905, p.vii.

Whistler's 'At the Piano': see Young, MacDonald, Spencer and Miles, *The Paintings of James McNeill Whistler*, 1980, 2, pp.8–9 (One of Whistler's later antagonists was the son of Ford's friend, Sir William Eden, see Timothy Eden, *Tribulations of a Baronet*, 1933).

Page 36

Millais on Velasquez: see M.H. Spielmann, *Millais and his Works*, 1898, pp.61 and 66.

Page 37

Browning, Hawthorne and George Eliot on Spanish paintings: *Letters of Robert Browning to Elizabeth Barrett Browning*, 1913, 1, p.518; Hawthorne, *English Notebooks*, 1941 and G. Haight, *George Eliot*, 1968, pp.400–02, and 439.

Henry James on Murillo and Velasquez: *The Painter's Eye*, 1956, pp.78 and 84.

John Philip in Spain: Irwin, 1974, pp.356–57; two other paintings about Spanish artists have been mentioned to me by Michael Levey – 'Philip IV knighting Velasquez', by A.J. Herbert (R.A. 1856), and 'Alonso Cano bestowing charity', by C. Goldie (R.A. 1858).

Page 38

Murillo and his mistress: Lipschutz, pp.69–71.

Bell Scott on Murillo and Velasquez: pp.72 and 59.

Robinson: *DNB*, supplement 1912–21.

Cook collection: see *A Catalogue of the Paintings at Doughty House, Richmond*, ed. Herbert Cook, 1912.

Conde del Quinto: see Gaya Nuño, 1958, p.28.

Robinson on El Greco and early Velasquez: *Memoranda . . .* , 1868, p.35, and *The Burlington Magazine*, 10, 1906–07, p.176.

Page 39

Curtis: see *Who's Who in America, 1897–1942;* quotations pp.v (Spain), xxi–xxiii, and xxv (Velasquez and Murillo); more recently on the two artists. see Michael Levey, *Velasquez and Murillo*, (National Gallery Slide Books), 1978.

Stevenson: *Velasquez*, ed. 1899, quotations pp.2–3 (Prado), pp.69,79,92 (Velasquez's style), pp.32,94–95,99 and 124 (reactions to Velasquez).

Page 40

The reputation of Goya: see Glendinning, 1964, and 1977, pp.14–15 (etchings in England), 96ff. (later 19th century), 111 (Ruskin's attitude).

Rothenstein: *Goya*, pp.28–29 (quotation).

The character of Spanish painting: Hagen, 1943, *passim*, and Licht, *Goya*, *passim*, and pp.58,60,101 and 278.

Protestant view of Spanish art: *The Athenaeum*, 14 May 1853; also Stirling, 1848, 1, p.16.

Page 43

Fry on El Greco and Velasquez: *Vision and Design*, 1937, p.175 (first ed., 1920); *A Sampler of Castille*, 1923, pp.9 and 25.

Huxley on El Greco: *Music at night*, 1931, p.55 (1st ed. 1930).

Campbell on El Greco: Laurie Lee, *As I Walked Out . . .* , 1979, pp.114–15 (1st ed. 1969).

Page 44

Stevie Smith 'Spanish School': *Selected Poems*, ed. James MacGibbon, 1978.

Page 45

El Greco: see especially Wethey, 1962; opinion of Ford, 1847, p.487.

Page 54

Stirling on Tristán: 1848, p.442.

Page 55

Velasquez: see Justi, 1889; Stevenson, 1899; Trapier, 1948; López-Rey, 1963; Madlyn Millner Kahr, *Velázquez*, 1976; and the forthcoming book on the painter (1982) by Enriqueta Harris Frankfort.

Page 61

Ribera: see Trapier, 1952, and Spinosa; opinion of Ford, 1847, p.426.

Page 64

Painting at Court: see Michael Levey, *Painting at Court*, 1971, pp.136–49; Elliott, 1972 (16th-century background), and 'Philip IV of Spain, Prisoner of Ceremony' in *The Courts of Europe*, ed. A.G. Dickens, 1977, pp.169–89; and Brown and Elliott, 1980.

Sánchez Coello: Francisco de B. de San Román, *Alonso Sánchez Coello*, 1938; analogy with Velasquez, Stirling, 1848, p.231.

Page 66

Pantoja: see Kusche; opinion of Stirling, 1848, p.270.

Page 75

Zurbarán: Soria, 1953; Guinard, 1960; and Jonathan Brown, *Zurbarán* [1975]; opinion of Ford, 1847, p.427.

Page 85

Murillo: Gaya Nuño, 1978; Young, 1980; Angulo Iñiguez, 1981.

Page 95

Landscape and Still-life: Ford on landscape, 1847, p.431; Spanish still-life has not been adequately surveyed, but the forthcoming book on Spanish painting from El Greco to Goya by Eric Young will contain sections devoted to the subject.

Page 101

Goya: see especially Gassier and Wilson, 1971; Licht, 1980; Glendinning, 1977 (his reputation); also de Salas, 1979, and S. Symons in *The Burlington Magazine*, 1971, pp.508ff. (Flaxman's influence).

Bibliography and Exhibitions

Bibliography, and list of principle exhibitions of Spanish painting in Britain.

Angulo Iñiguez, Diego, *Murillo*, 1981
– and Pérez Sánchez, A.E., *Historia de la Pintura española. Escuela Madrileña del primer tercio del siglo XVII*, 1969.

Atkinson, William C., *A History of Spain and Portugal*, 1960.

Auld, Alasdair, catalogue of paintings in *The Stirling Maxwell Collection, Pollok House*, n.d.

Baretti, Joseph, *A Journey from London to Genoa*, 1770.

Beckford, William, *Italy, with sketches of Spain and Portugal*, 1834.
The Journal of William Beckford in Portugal and Spain, 1787–1788, ed. Boyd Alexander, 1954.

Bell Scott, William, *Murillo and the Spanish School of Painting*, 1873.

Braham, Allan – see MacLaren and Braham.

Brigstocke, Hugh, *Italian and Spanish Paintings in the National Gallery of Scotland*, 1978.

Brown, Jonathan, and Elliott, J.H., *A Palace for a King, The Buen Retiro and the Court of Philip IV*, 1980.

Buchanan, W., *Memoirs of Painting*, 1824.

Clarke, Edward, *Letters concerning the Spanish Nation*, 1763.

Camón Aznar, José, *Dominico Greco*, 1950.

Caw, James L., *Catalogue of Pictures at Pollok House*, 1936.

Ceán Bermúdez, Juan Augustín, *Diccionario histórico de los más ilustres professores de las bellas artes en España*, 1800.
Carta . . . sobre el estilo y gusto en la pintura . . . sevillana, 1806.

Cossío, Manuel B., *El Greco*, 1908 (reprinted, 1972).

Cumberland, Richard, *Anecdotes of Eminent Painters in Spain*, 1782.
Memoirs, 1807.

Cunningham, Allan, *The Life of Sir David Wilkie*, 1843.

Curtis, Charles B., *Velazquez and Murillo*, 1883.

DNB – Dictionary of National Biography.

Dalrymple, William, *Travels through Spain and Portugal in 1774*, 1777.

Desparmet-Fitzgerald, X., *L'oeuvre peinte de Goya*, 1928–50.

Disraeli, see Monypenny.

Elliott, J.H., *Imperial Spain*, 1972 (1st ed. 1963)
– see also Brown and Elliott.

Ford, Brinsley, – see Exhibitions, 1974.

Ford, Richard, *A Hand-book for travellers in Spain*, 1847 (1st ed. 1845).
The Letters, ed. R.E. Prothero, 1905.
– see also Exhibitions, 1974.

Gassier, Pierre, and Wilson, Juliet, *Goya*, 1971.

Gaya Nuño, J.A., *La pintura española fuera de España*, 1958.
L'opera completa di Murillo, 1978.

Glendinning, Nigel, 'Goya and England in the Nineteenth Century', *The Burlington Magazine*, 1964, pp.4–14
Goya and his critics, 1977.
– see also Exhibitions, 1963–64.

Gudiol, José, *Goya*, 1971 (translation of Spanish edition, 1970).

Guinard, Paul, *Zurbarán et les peintres espagnols de la vie monastique*, 1960.

Hagen, Oskar, *Patterns and Principles of Spanish Art*, 1943.

Harris [Frankfort], Enriqueta, 'Velázquez and Charles I', *Journal of the Warburg and Courtauld Institutes*, 1967, pp.414–20.
– see also Exhibitions, 1938 and 1980.

Holland, Lady, *The Spanish Journal*, ed. Earl of Ilchester, 1910.

Irwin, Francina, 'The Scots discover Spain', *Apollo*, May 1974, pp.353–57.

Jacob, William, *Travels in the South of Spain*, 1811.

[Jardine, Alexander], *Letters from Barbary, France, Spain, Portugal . . .*, 1788.

Justi, Carl, *Diego Velazquez und sein Jahrhundert*, 1888 (English translation, 1889).

Kubler, George, and Soria, Martin, *Art and Architecture in Spain and Portugal . . . 1500–1800*, 1959.

Kusche, Maria, *Juan Pantoja de la Cruz*, 1964.

Licht, Fred, *Goya – The Origins of the Modern Temper in Art*, 1980.

Lipschutz, Ilse Hempel, *Spanish Painting and the French Romantics*, 1972.

Loga, Valerian von, *Francisco de Goya*, 1921.

López-Rey, José, *Velasquez*, 1963 (and various later editions).

MacLaren, Neil, and Braham, Allan, *National Gallery Catalogues, The Spanish School*, revised edition, 1970
– see also Exhibitions, 1947.

Mayer, August, L., *Murillo, Klassiker der Kunst*, 1923 (1st ed., 1913).
Francisco de Goya, 1924
Dominico Theotocopoli, El Greco, 1926
Velazquez, 1936.

Monypenny, William Flavelle, *The Life of Benjamin Disraeli, Earl of Beaconsfield*, 1, 1804–1837, 1922.

Palomino, Antonio, *El Museo Pictórico*, 1715–24.

Pérez Sánchez, A.E., see Angulo Iñíguez, and see Spinosa.

Ponz, Antonio, *Viage por España*, 1772–84.

Quin, Michael J., *A Visit to Spain*, 1824.

Robertson, Ian, *Los curiosos impertinentes, Viajeros ingleses por España 1760–1855*, 1975.

Salas, Xavier de, *Goya*, 1979 (translation of 1st [Italian] ed., 1978).

Soria, Martin, *The Paintings of Zurbaran*, 1953.
– see also Kubler and Soria.

Southey, Robert, *Letters written during a journey in Spain*, 1808 (3rd ed.).

Spinosa, Nicola, *L'opera pittorica completa di Ribera*, 1978 (with introduction by A.E. Pérez Sánchez).

Stevenson, R.A.M., *The Art of Velasquez*, 1895 (reprinted in *Great Masters in Painting and Sculpture, Velasquez*, 1899).

Stirling, William (Sir William Stirling Maxwell), *Annals of the Artists of Spain*, 1848.
'Richard Ford' in *Miscellaneous Essays and Addresses*, vol.6 of *The Works of Sir Wm. Stirling Maxwell*, 1891, pp.101–17.

Stoye, John Walter, *English Travellers Abroad, 1604–1667*, 1952.

Sutton, Denys – see Exhibitions, 1974.

Swinburne, Henry, *Travels through Spain in the years 1775 and 1776*, 1787 (2nd ed.).

Townsend, Joseph, *A Journey through Spain in the years 1786 and 1787*, 1792.

Trapier, Elizabeth du Gué, *Velazquez*, 1948
Ribera, 1952.
'Sir Arthur Hopton and the interchange of paintings between Spain and England in the seventeenth century,' *The Connoisseur*, 1967, 164, pp.239–43, and 165, pp.60–63.

Troutman, Philip – see Exhibitions, 1963–64, and 1980.

Twiss, Richard, *Travels through Portugal and Spain*, 1775.

Waagen, Gustav, *Treasures of Art in Great Britain*, 1854 *Galleries and Cabinets of Art*, 1857.

Wethey, Harold E., *El Greco*, 1962.

Whittington, Matthew, *Travels through Spain and part of Portugal*, 1808, (1st ed., 1806).

Wilson, Juliet, see Gassier and Wilson.

Young, Eric, *Catalogue of Spanish and Italian Paintings*, The Bowes Museum, Barnard Castle, County Durham, 1970 *Die grossen Meister der Malerei, Bartolomé Murillo*, 1980 – see also Exhibitions, 1967.

Exhibitions

1895–96 The New Gallery, *Spanish Art*, organized by Sir [John] Charles Robinson.

1901 Guildhall Gallery, *Exhibition of the Works of Spanish Painters*, catalogue by A.G. Temple.

1913–14 Grafton Galleries, *Spanish Old Masters*, catalogue by M.W. Brockwell.

1920–21 Royal Academy of Arts, *Exhibition of Spanish Paintings*, catalogue notes by F.J. Sánchez Canton.

1928 Burlington Fine Arts Club, *Exhibition of Spanish Art, including Pictures, Drawings, and Engravings, by Goya*, catalogue by W.G. C[onstable].

1931 Tomás Harris Galleries, *Old Masters by Spanish Artists*.

1938 The Spanish Art Gallery, *From El Greco to Goya*, catalogue by Enriqueta Harris Frankfort.

1947 The Arts Council, The National Gallery, *An Exhibition of Spanish Paintings*, catalogue by Neil MacLaren (a selection of the pictures included in the exhibition had previously toured several regional cities; the catalogue numbers of this earlier exhibition are not given in the catalogue here).

1951 National Gallery of Scotland, *An exhibition of Spanish Paintings from El Greco to Goya*, catalogue by Ellis Waterhouse.

1963–64 Royal Academy of Arts, *Goya and his Times*, entries for Goya paintings by Nigel Glendinning and Philip Troutman.

1967 The Bowes Museum, Barnard Castle, *Four Centuries of Spanish Painting*, catalogue by Eric Young.

1974 Messrs. Wildenstein, *Richard Ford in Spain*, catalogue by Brinsley Ford, with introduction by Denys Sutton.

1976 Royal Academy of Arts, *The Golden Age of Spanish Painting*.

1976 The British Museum, *Spanish Drawings from the 17th to the 19th centuries*, no published catalogue.

1978 Courtauld Institute Galleries, *Spanish Drawings from the Witt Collection*, catalogue [by Philip Troutman].

1980 Nottingham University Gallery, *The Golden Age of Spanish Art*, catalogue by Enriqueta Harris Frankfort and Philip Troutman.

Index of Artists and Lenders

Figures refer to catalogue entries

José Antolinez 42,59
Juan de Arellano 57,58

Vincente Carducho 36
Juan Carreño de Miranda 29
Claudio Coello 30(ascribed),38

Juan Fernández 56

Francisco de Goya 63,64,65,66,67,68,69,70,71,72,73,74
El Greco 3,4,5,6,7,8,9

Juan Bautista del Mazo 28
Francisco Antonio Meléndez 31(ascribed)
Luis Meléndez 60,61
Pedro de Mena 75(ascribed),76(after)
Luis de Morales 1,2
Bartolomé Esteban Murillo 41(ascribed),43,44,45,46, 47,48,49(ascribed),50,51,52,53,54

Juan Pantoja de la Cruz 22(ascribed)
Luis Paret 62
Francisco Ribalta 11
Jusepe de Ribera 17,18,19
José Risueño 78

Alonso Sánchez Coello 20,21
School of Seville 55
Spanish School 77

Luis Tristán 10

Juan Valdés Leal 37
Diego Velasquez 12,13,14,15,16,23,24,25(studio),26,27 (circle),39

Francisco de Zurbarán 32,33,34,35,40

Lenders

Her Majesty the Queen 31,56

The Visitors of the Ashmolean Museum, Oxford 1,94

The Beit collection, Blessington, Co. Wicklow 48,72

The Bowes Museum, Barnard Castle 5,29,68,73

The Trustees of the Chatsworth Settlement 17,27,53
Courtauld Institute Galleries, Lee collection 69

Mr and Mrs R.E.A. Drey 19
The Governors of Dulwich Picture Gallery 45,46
The Bishop of Durham and Church Commissioners 35

The Trustees of the Faringdon collection 50
The Fitzwilliam Museum, Cambridge 10

The Glasgow Art Gallery and Museum 18
The Glasgow Museums and Art Galleries, Stirling
Maxwell collection, Pollok House 7,30,64,65

The Earl of Harewood 8

Mrs E.P. Johnson-Taylor 57,58

The Trustees of the National Gallery 3,6,11,12,16,23,
 26,33,39,41,43,44,49,51,54,66,67,70,71,74
The National Gallery of Ireland 20,22,34,40
The Trustees of the National Galleries of
 Scotland 13,36,63
The National Trust, Bearsted collection, Upton House 4,62
The National Trust, Blathwayt collection, Dyrham Park 47
The National Trust and H.M. Treasury, Bristol
 collection, Ickworth 25

Private collectors 9,21

Mrs G. B. Springell 60
Lt Colonel William Stirling of Keir 2,55,59

The Victoria and Albert Museum 75,76,77,78,79,
 80,81,82

The Walker Art Gallery, Liverpool 52
The Wellington Museum, Apsley House 14,15,38
The Duke of Westminster 24,32

York City Art Gallery 28,37,61

Illustrations

H.M. The Queen (copyright reserved), 1,4,5,6,7,8,
30,31,83,108; Anderson, Rome, 2,11,12,21,22,23,29,
32,37; Archives Photographiques, 42; Ashmolean
Museum, 53,94; Barber Institute, 16; Blinkhorns, 114;
Bowes Museum, 57,81,109,110; Coopers, 28,46; Country
Life, 27; Courtauld Institute, 34,35,36,69,71,76,77,79,
84,87,99,105,121; Downside Abbey Trustees (Derek
Balmer), 38,39; Dulwich College Picture Gallery, 98,99;
English Life Publications, 13; Fitzwilliam Museum
(Stearn and Sons), 62; Forbes collection, 47; Glasgow
Museums and Art Galleries, 59,70,82,116,117;
Hermitage, Leningrad, 13; Hildyard, 9; Marlborough
Fine Art, 51; Merseyside County Art Galleries, 104;
National Gallery, 17,18,19, 20,25,26,33,40,43,48,52,55,
56,58,63,64,65,68,75,78,85,91,93,95,96,100,101,103,
106,118,119,120,122,123,124,125,126; National Gallery
of Ireland, 72,74,86,92; National Galleries of Scotland
(Tom Scott), 54,61,88,107,111,115 (Annan); National
Portrait Gallery, 3,49; Sydney W. Newbery, 102; Royal
Academy, 45,50,112; Tate Gallery, 15,24; Victoria and
Albert Museum, 66,67,90,127,128,129,130,131,132,
133; Wallace collection, 41; York city Art Gallery,
80,89,113.

© 1981 The National Gallery and Allan Braham

ISBN: 0 901791 74 1

Catalogue designed by James Shurmer

Printed in England by Eyre & Spottiswoode Ltd, Thanet
Press, Margate, Kent.

(*Back Cover*) Goya, *Doña Isabel de Porcel* (detail), No.70